THIS IS
KENYA

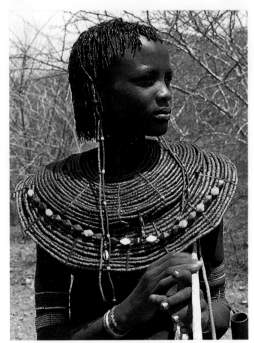

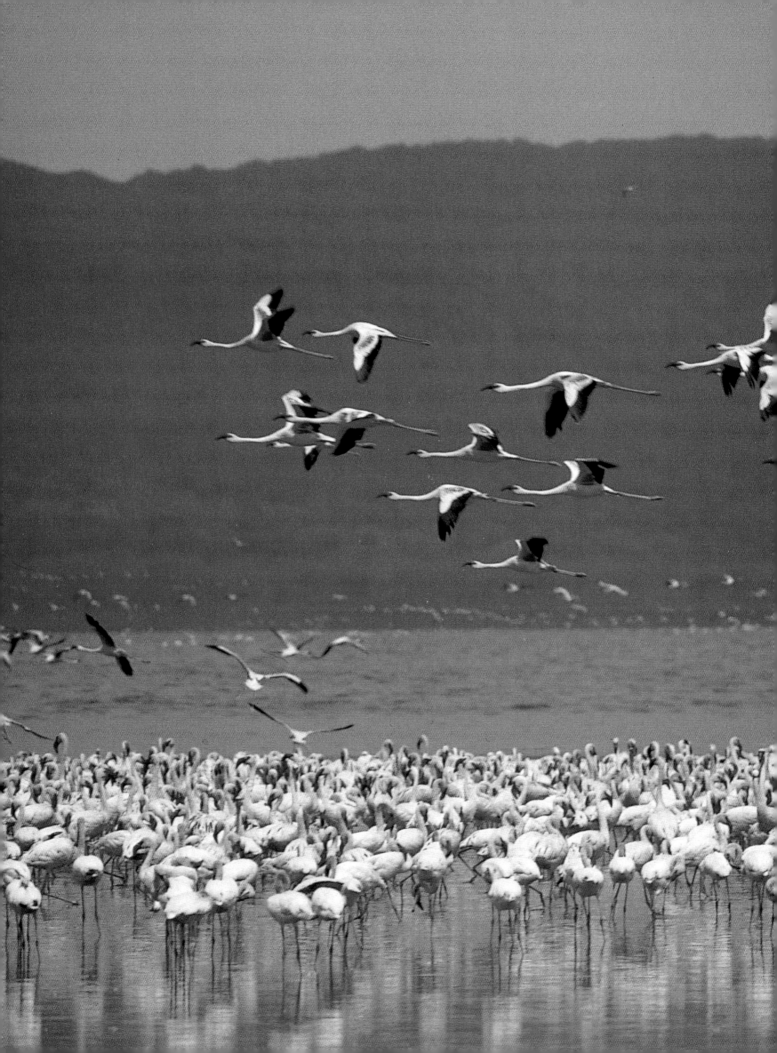

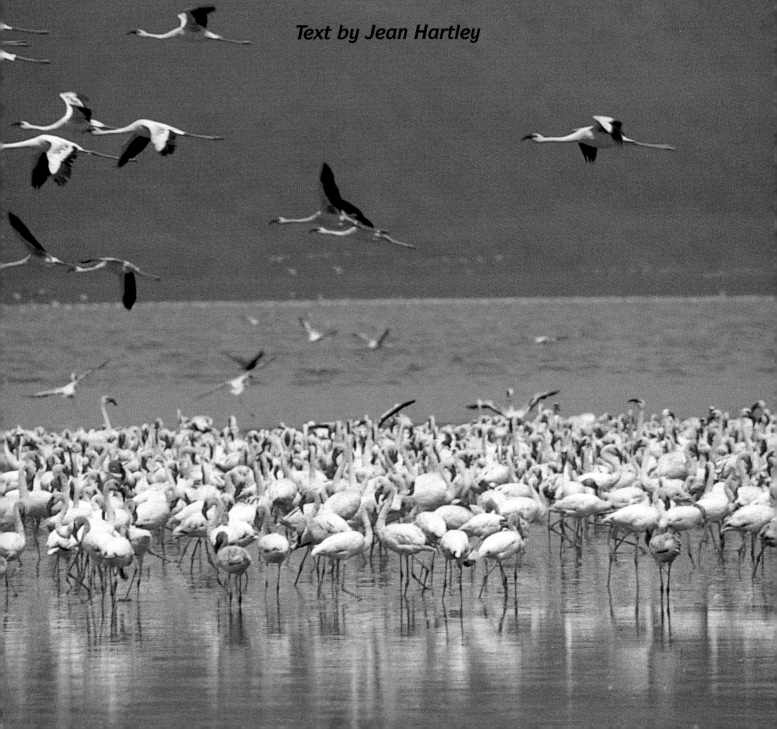

THIS IS
KENYA

Text by Jean Hartley

First published in 1995 by
New Holland (Publishers) Ltd
London • Cape Town • Sydney • Singapore

New Holland (Publishers) Ltd
24 Nutford Place,
London W1H 6DQ

ISBN 1 85368 377 9

Managing editor: Mariëlle Renssen
Editor: Christine Riley
Design manager: Petal Palmer
Design and DTP: Darren MacGurk
Map: Loretta Chegwidden
Reproduction by Unifoto (Pty) Ltd,
 Cape Town
Printed and bound in Singapore by Tien Wah
 Press (Pte) Ltd

PHOTOGRAPHIC CREDITS

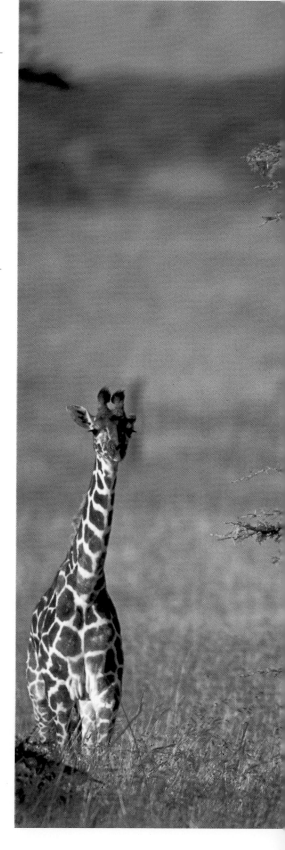

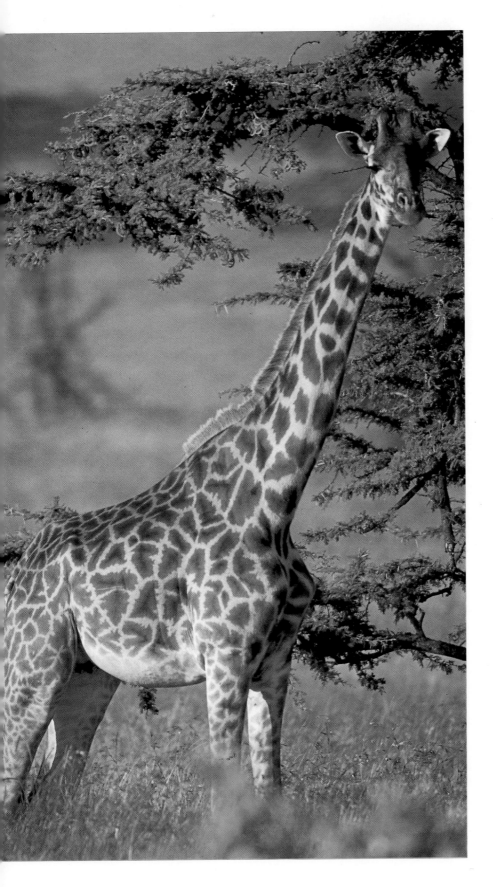

CONTENTS

Frontispiece: *Girls of the Pokot tribe wear an array of bead necklaces, earrings and armbands.*
Title page: *Lake Nakuru supports thousands of both Greater and Lesser Flamingos.*
Left: *A Masai giraffe and youngster on the plains of the Masai Mara National Reserve.*

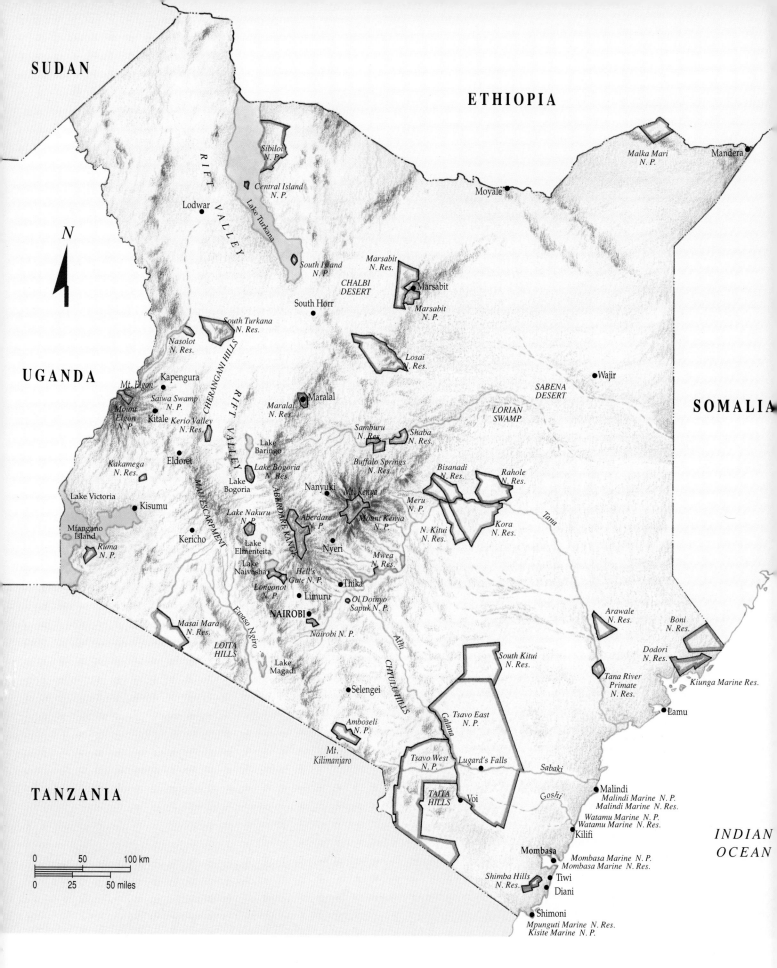

SUDAN

ETHIOPIA

SOMALIA

UGANDA

TANZANIA

INDIAN
OCEAN

N

RIFT VALLEY

Lake Turkana

Lodwar

Sibiloi
N. P.

Central Island
N. P.

South Island
N. P.

South Horr

*CHALBI
DESERT*

Malka Mari
N. P.

Mandera

Moyale

Marsabit
N. Res.

Marsabit

Marsabit
N. P.

Losai
N. Res.

Wajir

*SABENA
DESERT*

*LORIAN
SWAMP*

South Turkana
N. Res.

Nasolot
N. Res.

CHERANGANI HILLS

Mt. Elgon

Kapengura

Saiwa Swamp
N. P.

Mount
Elgon
N. P.

Kitale

Kerio Valley
N. Res.

Maralal
N. Res.

Maralal

RIFT VALLEY

Kakamega
N. Res.

Eldoret

Lake
Baringo

Samburu
N. Res.

Shaba
N. Res.

Lake Bogoria
N. Res.

Buffalo Springs
N. Res.

Bisanadi
N. Res.

Rahole
N. Res.

Lake Victoria

Kisumu

Lake
Bogoria

MAU ESCARPMENT

Lake Nakuru
N. P.

Nanyuki

Mt. Kenya

Meru
N. P.

Tana

Mfangano
Island

Kericho

ABERDARE RANGE

Aberdare
N. P.

Mount Kenya
N. P.

N. Kitui
N. Res.

Kora
N. Res.

Ruma
N. P.

Lake
Elmenteita

Lake
Naivasha

Nyeri

Mwea
N. Res.

Longonot
N. P.

Hell's
Gate N. P.

Limuru

Thika

Arawale
N. Res.

Boni
N. Res.

Masai Mara
N. Res.

Ewaso Ngiro

Ol Doinyo
Sapuk N. P.

NAIROBI

Nairobi N. P.

Dodori
N. Res.

*LOITA
HILLS*

Lake
Magadi

Athi

CHYULU HILLS

South Kitui
N. Res.

Tana River
Primate
N. Res.

Kiunga Marine Res.

Selengei

Lamu

Amboseli
N. P.

Mt.
Kilimanjaro

Galana

Tsavo East
N. P.

Tsavo West
N. P.

Lugard's Falls

Sabaki

Malindi
Malindi Marine N. P.
Malindi Marine N. Res.

Goshi

TAITA
HILLS

Voi

Watamu Marine N. P.
Watamu Marine N. Res.

Kilifi

Mombasa

Mombasa Marine N. P.
Mombasa Marine N. Res.

Shimba Hills
N. Res.

Tiwi

Diani

Shimoni

Mpunguti Marine N. Res.
Kisite Marine N. P.

0 50 100 km

0 25 50 miles

6

KENYA PROFILE

Lying on the eastern side of Africa, Kenya's 600 000 square kilometres are bisected from east to west by the equator. A far more dramatic division, the Great Rift Valley, passes from north to south on its way from Jordan to Mozambique. In the far west is Lake Victoria, Africa's most extensive lake and fabled source of the Nile. The lake is shared with Uganda and Tanzania, on Kenya's western and southern borders respectively. Ethiopia lies to the north and Somalia to the northeast. More than 400 kilometres of beach and palm trees border the Indian Ocean in the east.

Kenya's temperature and climate are governed by altitude and rainfall. There are two principal rainy seasons, the 'long' rains in April/May and the 'short' rains in October/November. However, these rains do not occur over the entire country, and dry areas in the north may receive no rain at all for several years.

The highest temperatures are experienced from December to March, while June and July can be surprisingly cool, particularly in the highlands. From the sea, the northeast monsoon (*kaskazi*) blows from October to March, and the southeast monsoon (*kusi*) brings cooler weather and rougher sea conditions from April to September. These winds have for centuries propelled the Arab dhows from the Gulf and returned them safely home. They also determine the weather on the eastern side of the country. In the west, the massive area of Lake Victoria creates a weather system of its own. As Kenya is situated on the equator, the hours of daylight are fairly constant throughout the year, varying by no more than half an hour. There are twelve hours of daylight every day.

Kenya's capital, Nairobi, lies south of the equator to the east of the Rift Valley. A hundred years ago, the ground on which Nairobi is situated was an inhospitable swamp. Today, Nairobi is a busy, cosmopolitan centre – taxis jostle for position with handcarts piled high with mangoes, and Maasai warriors dressed in red *shukas* share the crowded streets with Japanese businessmen, American tourists and Indian housewives.

To the west of Nairobi, the Ngong Hills form part of the eastern wall of the Rift Valley. The name of the five gently rounded peaks comes from the Maasai word for 'knuckles', as, from the east, the hills resemble the back of a fist. The Ngong Hills inspired Karen Blixen to write the book *Out of Africa*, on which the well-known film of the same name was based. The suburb Karen is named after her and is on the site of her doomed coffee farm.

Further north along the wall of the Rift Valley, the Aberdare mountains form the western edge of the central highlands. To the east of this eroded range Mount Kenya's permanently snow-capped peaks can be seen from tall buildings in the city of Nairobi, more than 160 kilometres away.

Kenya has many faces, most of them friendly. The combination of wildlife, mountains, forests, lakes and coral reefs make this land tantalizingly beautiful.

THE LAND

Kenya is a diverse land, with an unexpected variety of scenery and terrain. Altitudes range from sea level to higher than 5 000 metres, vegetation from coconut palms to giant groundsel. Much of the far north is desert or semi-desert, vast tracts of arid wind-blown sand, sparsely populated by hardy nomadic peoples whose worldly goods can be carried on the back of a camel.

Rolling savanna grasslands cover much of the southern part of the country, giving way in lower areas to bushy scrubland dotted with stunted trees. There is evidence everywhere of ancient geological upheavals, from the Great Rift Valley itself to perfectly formed volcanic cones and solidified lava flows.

Kenya's lakes are as diverse as its hills and a string of them lines the Rift Valley. Some of these are fiercely alkaline, others mildly so, and two of the lakes contain fresh water. All support a wealth of birdlife, from tiny iridescent sunbirds to efficient carrion eaters.

Much of the country's hydroelectric power comes from rivers, particularly the Tana, while a small amount of power is generated at a geothermal source near Lake Naivasha.

Agriculture is a principal source of income for the country, with large plantations of tea, coffee and sisal. Where adequate water is available for irrigation, cut flowers and vegetables are grown, and exported by air on a daily basis. But the mainstay of the economy is tourism, and about 900 000 holiday-makers come to Kenya each year, either to visit the famous wildlife parks and reserves, or to enjoy a tropical beach holiday.

Central highlands

The central highlands are dominated by Mount Kenya. At 5 200 metres, this ancient volcano is but a shadow of its former self. It was once even higher than Everest, but over time the peaks have been eroded, leaving only the jagged central core. The twin peaks of Batian and Nelion offer some of the most demanding climbs in the mountaineering world. Even the third highest point, Lenana (4 633 metres), presents quite a

The forest on the slopes of Mount Elgon obscures Mackingeny Cave. Elephants enter the nearby Kitum Cave at night in search of salt, which seems to be absent in the surrounding soils. This is the only area in the world where elephants are known to go underground.

challenge to climbers. Mount Kenya has its dark side, and should be treated with respect, for there is a very real risk of falling victim to mountain sickness. This is caused by ascending too quickly and can lead to pulmonary – and more rarely cerebral – oedema. The only cure for this is to descend to a lower altitude immediately. The condition can strike at random, and can be fatal.

To the west of Mount Kenya, the Aberdare range harbours some spectacular waterfalls where slender-billed Chestnut-winged Starlings fly through the falling water to their nests on the rock face. In the forests there are nighttime game-viewing opportunities: floodlit waterholes and salt licks are overlooked by three well-known luxury forest lodges, namely The Ark, Treetops and Mountain Lodge. The Aberdare peaks of Kinangop and Lesatima, at 3 657 and 3 962 metres respectively, are rounded from centuries of erosion and are surrounded by high moorland.

South of the Aberdares, on the floor of the Rift Valley, are two extinct volcanoes, Longonot and Suswa, both visible when driving from Nairobi to the Masai Mara National Reserve or towards Lake Naivasha. Mount Longonot is one of Kenya's most recently created national

parks. It is 2 743 metres high and is a fine example of a perfect volcano, with a steep-sided and completely circular crater. Mount Suswa, although not as high, covers a greater area. The peak has collapsed, creating a crater within a crater. The erosion of lava flows has created underground tunnels.

Kenya's second highest mountain, Mount Elgon (4 321 metres), sits majestically astride the border between Kenya and Uganda. Its eastern slopes were proclaimed a national park in 1949. One of Kenya's most beautiful parks, it is also one of the least visited. Giant groundsel and lobelia can be found on its forested slopes. Mount Elgon is the only known place where elephants enter caves in search of minerals.

North and west of Nairobi to the high eastern edge of the Rift Valley is some of the most fertile land in the country. Altitudes of up to 2 438 metres ensure a nightly cover of cool low cloud and an annual rainfall of 1 300 millimetres makes this a rich area for agriculture. The red forest soil drains well, unlike the sticky 'black cotton' soil found in lower areas. From Kiambu to Nyeri the principal crop is coffee, and the higher ground around Limuru is where the first tea bushes were planted in 1904.

Today vast plantations stretch over the rolling hills, neat and always green. Tea is still picked manually, and the hands of the women move in blurred motion as they deftly pluck the top 'two leaves and a bud', throwing handfuls over their shoulders into baskets on their backs. These then go to the factory for drying. Coffee is a more unreliable crop, with a fluctuating market very much dependent on the frosts in Brazil. The plants are also prone to 'coffee berry disease', which makes the fruit unsaleable. The red berries are also picked by hand, usually during the months of December and January.

Great Rift Valley

The western edge of the Rift Valley, particularly the part known as the Kerio Valley, offers some of the most spectacular scenery in Kenya. Vertical walls drop several hundred metres to the floor below. In the 1920s, the photographer and mountaineer Arthur Firmin photographed three small African children looking out over the vastness of the valley from a spot known as World's End. The photograph has since become famous although World's End is not to be found on any map.

The best known feature of the Rift Valley is its string of lakes – Turkana (formerly Rudolf), Baringo, Bogoria, Nakuru, Elmenteita, Naivasha and Magadi. Of these, only lakes Baringo and Naivasha are freshwater. The others are alkaline in varying degrees, the most caustic being Lake Magadi, almost on the Tanzanian border. There is a theory that Lake Magadi was once connected to Lake Natron in Tanzania, which is even more encrusted. It is on Lake Natron that millions of flamingos breed, in conditions that are so inhospitable to other forms of life that they are troubled by few potential predators. These birds raise their young on Lake Natron but on occasion have been known to try and breed at Magadi, Elmenteita, Nakuru and Bogoria although not with great success. When not breeding, the birds migrate between the soda lakes and at different times of the year huge numbers can be found either at Lake Nakuru or Bogoria. They have also been known to breed on Lake Shala in Ethiopia and on the Makgadikgadi saltpans of Botswana.

Lake Turkana Lying in the desert at the far north of Kenya's Great Rift Valley, this is a 240-kilometre-long inland ocean in an arid and windswept land. Years ago, it fed the White Nile, but the receding shoreline has ensured that it now has no outlet. Irrigation schemes on the Omo River and a hydroelectric dam on the Turkwel River have decreased the supply of water flowing into the lake. Alkaline and slightly 'soapy', the water is home to crocodiles, many birds and the enormous Nile perch. On the northeastern shore, the Sibiloi National Park is the breeding ground of a huge population of crocodiles. There are three islands in the lake, unimaginatively named North, Central and South islands. The latter, which is the sunken tip of a volcanic crater, is a national park.

Teleki's volcano lies to the south of Lake Turkana, acting as guardian to the inhospitable Suguta Valley. To the east, Mount Kulal (2 286 metres) is a volcano that has been split into two, the parts being separated by a deep gorge; not far away stands a little hill with an endearing name, Kuskuslepussi.

Lake Baringo Next in the string of Rift Valley lakes, Baringo is an ornithological paradise, with over 450 species having been recorded in the area. The resident crocodiles are said to be harmless to man, but hippos come out of the water at night to feed on the lush lawns of the Lake Baringo Club and should not be approached. There are several islands in the lake, some of them uninhabited except for nesting herons and a few feral goats. The Ilchamus or Njemps people who live here still fish in the traditional way, using coracle-like boats of ancient design and made of the locally abundant ambatch tree. The southern end of the lake is fed by the El Molo River, where crocodiles lie on the banks ignoring the passing tourist boats. It is thought that the lake's outlet is underground at the northern end of the lake, emerging at the Karpedo Spring.

Ol Kokwe Island at the southern end of the lake is home to Island Camp, built by Jonathan Leakey in the late 1960s. This is a popular weekend getaway, with many charming features, such as the dining and bar area being built around an ancient bao board carved into the rock. Bao is a traditional African game, played with counters such as stones or seeds. The board consists of two parallel lines of holes, the objective of the game being similar to that of draughts, namely to 'take' your opponent's pieces. The rules differ slightly in different areas, but there are few books of instruction. The Kikuyu version was well described by

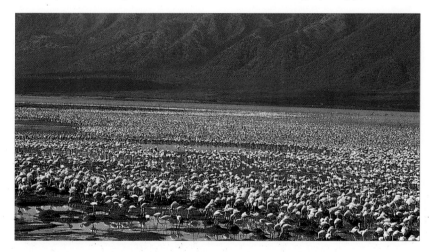

Thousands of flamingos feed seasonally in Lake Bogoria, at the foot of the eastern wall of the Great Rift Valley. It is also possible to have good sightings of Fish Eagles at this lake, despite the fact that the lake does not contain any fish.

Louis Leakey in his book *White African*. The game was once widespread throughout Africa, and similar boards have been found carved into kopjes in Tanzania's Serengeti. If a suitable rock is not available, boards are carved from wood.

Lake Bogoria Nestled at the foot of the eastern wall of the Great Rift Valley, Bogoria was formerly known as Lake Hannington, after the missionary explorer. Millions of flamingos come to this alkaline lake when the water level at Lake Nakuru is low. It is probably also the only place where the rare and shy greater kudu can be seen in any significant numbers – a herd of 120 live within the Lake Bogoria National Reserve. Like the flamingos, the kudu come to drink in the hot springs, which contain fresher water than the soda lake. There are dramatic gushing geysers at the southern end of the lake, and the water is hot enough to poach an egg. Care should be taken not to get too close to the edge as the ground is fragile and severe burns could result from falling into the geysers.

Lake Nakuru This lake is famous for its flamingos, that live and feed at Lake Nakuru for much of the year. Lake Nakuru National Park also contains a rhino sanctuary, as well as the rare Rothschild's giraffe that has thrived since being relocated here in the 1970s. The rhino sanctuary is a Kenya Wildlife Service project, and contains both black and white rhino – the latter imported from South Africa. Lions have also been introduced in an effort to reduce the vast numbers of waterbuck and warthog.

Lake Naivasha It is a mystery that Lake Naivasha remains fresh as no-one has yet proved that it has an outlet. It is also an illustration of nature's resilience, as many plants, fish and animals have been introduced without significantly upsetting the balance. These include the Nile perch, a voracious 90-kilogram fish more commonly found in lakes Victoria and Turkana, and the coypu, a species of South American rodent that escaped from an experimental fur farm. The coypu have almost totally destroyed the waterlilies which were home to jacanas

The shrinking Kakamega Forest contains many endemic species of birds, plants and insects. Once it was part of the great West African rainforest that spread across the width of the continent; now it is an isolated forest island.

and gallinules. Another introduction was the Louisiana swamp crayfish, a small lobster-like creature which appeared briefly on the menu in a few upmarket restaurants. It is thought that the crayfish can be used to control the freshwater snails that carry bilharzia.

The lake is used for water-skiing and fishing, and a sailing club is situated on one of the small islands on the southeastern edge. Around the lake there is extensive farming and horticulture, from cattle to strawberries, grapes to cut flowers. All the agricultural enterprises draw water from the lake to feed their crops and livestock, but it is thought that evaporation is responsible for the dropping of the water level, not irrigation.

The road around Lake Naivasha has recently been improved, and so a visit to the home of George and Joy Adamson, Elsamere, is now an easy drive. The house, made famous by the book and film *Born Free*, has been converted into accommodation for 12 people, and it contains a small museum of Adamson memorabilia. Visitors stop for lunch or tea, or to stay overnight. A recent addition is a conservation centre for students from all over the world to study various aspects of wildlife conservation. The colobus monkeys and Verreaux's Eagle Owls that Joy wrote about in her book

Friends from the Forest can still be found at Elsamere. There are two hotels on the southern edge of the lake, Safariland and the Lake Naivasha Club, both with beautifully laid out gardens. The birdlife is spectacular, with nearly 500 species having been recorded in the area.

Lake Elmenteita The small soda lake between lakes Naivasha and Nakuru is known as Lake Elmenteita, in the centre of Delamere Estates. Both flamingos and pelicans have used this lake to breed, but neither has been successful because of predation by Marabou Storks. There is a variety of animals in the area, and guests at the Delamere Camp are taken on night drives to see leopard, bushbabies, and other nocturnal species.

Lake Magadi South of Nairobi just inside the Tanzanian border, this is the most caustic of all Kenya's lakes. Soda, or trona, has been harvested here for over 70 years by the Magadi Soda Company. The company has its own rail link from Lake Magadi via Kajiado to Konza on the Mombasa to Nairobi line which facilitates exporting the wagons of soda. Some of the hottest temperatures in the Rift Valley have been recorded here. Accommodation is at the Magadi Club, owned by the Soda Company.

On the road to Magadi from Nairobi is a prehistoric site, Olorgesailie, excavated by the renowned archaeologists Dr Louis and Mary Leakey in the 1920s. The now dry lake is the site of one of the richest discoveries of Aechulian hand axes, dating back half a million years. The site has been declared a National Monument, and guides from the small museum show visitors around.

Lake Victoria and the Mau Escarpment

The western part of the country is the most heavily populated. It is dominated by Lake Victoria, the largest freshwater lake in Africa and the world's second largest lake, covering an area of nearly 70 000 square kilometres. Kenya lays claim to just under 4 000 square kilometres, the rest being shared between Tanzania and Uganda. The bustling town of Kisumu on the lake shore was once called Port Florence, for it was here that Florence Preston hammered in the final sleeper of the railway in 1901. Kenya's third largest town, it is the stronghold of the Luo, a Nilotic group that came south from the Sudan some five hundred years ago. Fishing is their traditional livelihood, although they supplement this with agricultural crops, taking advantage of the fertile soils and regular rainfall. Kisumu was once a thriving port, with a

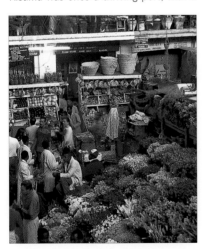

The interior of Nairobi's city market throbs with life. Fresh fruit, eggs, vegetables and flowers compete for space with baskets, curios and carvings.

sizable shipbuilding industry, until the railway from Kisumu to Kampala took the business away. The Arab traders introduced boats to Lake Victoria during the nineteenth century, and the Luo fishing boats are in fact improvised versions of the Arabic design.

The area east of Kisumu, rising to the top of the Mau Escarpment, is particularly suited to tea growing, and Kenya's first tea factory was built at Kericho in 1927. Mile upon mile of tea plantations now supply the many factories in the area, and the quality of the leaf rivals that of all other producing countries. When the railway from Kisumu to Kampala was built, the ascent up the eastern face of the Mau Escarpment involved 27 viaducts – the most difficult section of the entire route.

South from Kisumu is Kisii, famous for its soapstone carvers at Tabaka. The Gusii people from this area have the highest population growth rate in the country, well over the national average. North of Kisumu is the market town of Kakamega, and nearby, the shrinking relict of West African rainforest. This unique woodland is of enormous interest to ornithologists and botanists, and there are numerous species of birds, mammals, snakes and insects that are endemic to the area.

Nairobi, capital city

The ramshackle collection of buildings that sprang up around a railhead is now a bustling city of more than two million people. Nairobi's Central Business District seethes with activity, parking spaces are hard to find, and the pavements are crowded with pedestrians. Beware of the conmen and the handbag snatchers, and do not wear gold jewellery. When driving, keep the doors locked, and don't dangle an arm out of the window if you are wearing an expensive watch. As in most major cities, it is not advisable to walk around at night.

If you find yourself with a few hours or a day free in Nairobi, there are plenty of things you can do. Tours to the Nairobi National Park are easily arranged. This park, although small, contains a wealth of animals, including leopard, lion and cheetah. There is a sizable population of

Daphne Sheldrick has raised many orphaned animals. This black rhino has now grown up, and wanders freely in the Nairobi National Park.

black rhino, but no elephant. Buffalo, eland, impala, kongoni (Coke's hartebeest), giraffe, Grant's and Thomson's gazelle and wildebeest can all be seen on the grass plains. A pair of Verreaux's Eagles nests on the cliffs to the west of Leopard Cliffs, and the stretch of river that includes the hippo pools, frequented by hippo, crocodile and waterbuck, is also one of the easiest places to see the elusive African Finfoot.

Daphne Sheldrick's orphanage is in the park although it is only accessible from the Magadi Road. This remarkable woman is world famous for raising orphaned elephants, but she has raised many other animals as well, including rhino. Each calf has its personal attendant, who spends every minute of the day with his charge, and sleeps with it at night. When the baby elephants are old enough, they are reintroduced to the wild in the Tsavo East National Park. At the park, the matriarch elephant, called Eleanor, once an orphan herself, adopts Daphne's waifs and strays and teaches them how to survive in the wild.

On the same side of town, and included in most of the tours, is Karen Blixen's house, now a museum. The house was renovated for the film *Out of Africa*, and contains much of Karen

Blixen's original furniture. A visit to Giraffe Manor is also worthwhile, to see the Rothschild's giraffes, descendants of 'Daisy', who was rescued from near extinction and made famous by the Lesley-Melvilles. A circular building houses an education centre, and visitors may climb to a platform from which they can feed the giraffe at eye level.

Utamaduni, a shopper's paradise, is on the route back to the city. Seventeen shops and a small restaurant are housed in one building, and offer curios, clothing, and souvenirs of particularly high quality. A percentage of takings goes to the Kenya Wildlife Service, thus benefiting conservation.

For horse-racing fans, meetings are held on most Sunday afternoons at the Ngong Road Racecourse. Punters call the odds and racegoers place their bets in a curiously English setting. This is one of Nairobi's eccentricities, and it is hard to believe that this is in Africa. Just down the road is Jamhuri Park, scene of the annual Agricultural Show held in late September. A major event on the country's calendar, the show attracts an international array of participants. Manufacturers of tractors, cars, irrigation sprinklers and fertilizers display their wares, and in the central arena farmers

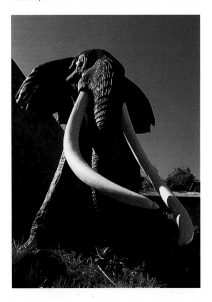

A life-size model of the legendary elephant Ahmed now stands in the courtyard of Nairobi's National Museum.

show off their prize bulls. Other entertainment includes displays by the antistock theft unit and the Kenya Wildlife Service antipoaching team, as well as gymnastics and dancing.

For those who enjoy good food, Nairobi has many restaurants. It is possible to eat Japanese, Thai, Korean, Italian, French, Mongolian, Chinese, Ethiopian and Greek food, and there is a wide choice of Indian restaurants for the curry connoisseur. Many of the hotels serve an African buffet specializing in local dishes such as *githeri* (beans), *irio* (maize) and *sukuma wiki* (spinach).

The National Museum is open daily from 08:00 to 17:00. There are displays of faithfully reproduced rock art, the original paintings of Kenya's people, and flora by Joy Adamson and musical instruments. There are also displays of animals, birds and insects. In the courtyard at the entrance stands a life-size model of the legendary elephant, Ahmed, who was protected by presidential decree at the height of the poaching war in the 1970s. Ahmed died of natural causes at Marsabit and was succeeded as 'king of the mountain' by a lesser elephant named Mohamed.

Tucked away behind the National Museum's main building is the East African Herbarium, whose staff is always ready and willing to help the public to identify plants. Opposite the main entrance to the National Museum is a snake park, with many of Kenya's snakes on display. Near the entrance to the administration block stands a statue of Dr Louis Leakey, whose archaeological research has brought fame to East Africa as the 'cradle of mankind'.

Another interesting place to visit is the Railway Museum, on the main Uhuru Highway and approached from the Nairobi Railway Station. Steam locomotives are so lovingly polished that they will bring tears to the eyes of train buffs. At the museum, too, is the carriage, with claw marks still visible, from which Lieutenant Ryall was pulled by a lion at Tsavo during the building of the railway.

The City Market, between Muindi Mbingu and Koinange streets, is an entertaining place to spend an hour or two. The centre of the main building is

crowded with stalls selling fruit, vegetables and flowers, each vendor harassing those who walk past. Around the edge, a balcony has more stalls selling everything from eggs to batiks. Housed in the same building and situated close to the main entrance are several butchers and a fish market, selling both lake fish and seafood, fresh daily. On the other side, in an open area, are more stalls, specializing in soapstone carvings, baskets, banana fibre items, and a wide variety of wooden carvings. Prices are fairly flexible and visitors are expected to bargain. The popular *ciondo* basket has become so sought after in America and Europe that cheap imitations made out of plastic are now being produced in Taiwan and Korea. Kenyan *ciondos* are made from sisal, in a multitude of colours using natural dyes. From the traditional basic design, perfected by both Kikuyu and Kamba women, the baskets have now become more sophisticated with leather straps, drawstrings, zips, and fancy buckles. Natural fibres are used widely in Kenya, and a shop worth looking at is The Spinner's Web in Kijabe Street, behind the Norfolk Hotel. The shop sells handwoven woollen and cotton fabrics made by women's cooperative groups. Top of the range for curios and souvenirs of all types is African Heritage, a small and overcrowded shop on Nairobi's Kenyatta Avenue which has a spacious showroom on the road to the airport. Owner Alan Donovan is an expert in the field of African arts and crafts, and his shop displays items from all over Africa. They are expensive, but genuine, and always of very high quality.

Nairobi has become a popular conference venue since the building of the Kenyatta International Conference Centre in 1973. This impressive building has simultaneous translation equipment, and has hosted conferences of 4 000 delegates. The roomy plenary hall is often used for exhibitions, and the amphitheatre can hold 800 people. There are smaller meeting rooms which can be connected, giving considerable flexibility. Smaller conferences, from 100 to 400 people, can be arranged in the Hilton and Inter Continental hotels, and just outside the town the Safari Park

Hotel can handle up to 1 000 people. Conference facilities are also available at Kilaguni Lodge in Tsavo West National Park, the Aberdare Country Club at Mweiga, and at several coastal hotels. With such a wide choice of leisuretime attractions, Kenya has become a popular conference destination, and currently hosts about 50 conferences each year.

Nairobi has a wide range of hotels to suit every pocket, from those classed within the 'Leading Hotels of the World' category to the most basic guesthouse tucked away in a back street. Excellent hotels in the city are the Norfolk, Serena, Nairobi Safari Club, Grand Regency, Hilton and Inter Continental,

each of which holds a five-star rating. Outside the city centre are the Windsor Golf and Country Club and the Safari Park Hotel. Each of these has several restaurants, a health club and a beauty parlour. Next are those more popular with businessmen such as the Fairview, Jacaranda, New Stanley, Mayfair Court, Boulevard and Panafric.

There is also the Utalii Training College and Hotel, which is unique in Africa. Established in 1975 by the Swiss government, the college trains students in all aspects of hotel management. The 700 students, 100 of whom are from African countries other than Kenya, learn their trade within a proper hotel

environment, with paying guests on whom to practise. The Utalii Training College also runs the IATA/UFTAA training courses for travel agents, as well as various courses for drivers and guides.

To the south and east of Nairobi are the Kitengela and Athi plains, wide open spaces supporting a considerable number of plains game such as Thomson's and Grant's gazelle, wildebeest and giraffe. The town of Athi River, once a few buildings constructed around the Kenya Meat Commission processing plant, has become an overflow for light industry. The black-cotton soil occurring here is ideal for growing roses, which are exported mainly to the Netherlands. To the south of the main Mombasa road, to the east of Athi River town, is David Hopcraft's ranch, where wild animals and cattle graze alongside each other. The ranch supplies restaurants and hotels with game meat, especially the Tamarind Group's Carnivore Restaurant. One of Nairobi's most popular eating places, the Carnivore serves ostrich, eland, gazelle, zebra, giraffe and kongoni steaks from Hopcraft's ranch, as well as crocodile from the Mamba Village crocodile farm at the coast.

Kenya is fairly rich in semiprecious stones, many of which are on sale in curio shops and jewellers in Nairobi and Mombasa. In addition to those that are locally produced, these shops also display malachite from Zaïre, verdite and sodalite from southern Africa, and rather poor quality quartzes from Madagascar and Brazil. One company, Rockhound, specializes in the hand-cutting and polishing of local stones, and its work is of a very high quality. The workshop and showroom are in the suburb of Karen, and a visit can easily be included within a tour to the Karen Blixen Museum. Rockhound has a wide range of eggs, bookends, ashtrays and solitaire sets made from petrified wood and blue-lace agate from Lake Turkana, purple fluorite from the Kerio Valley, and the Tanzanian green zoisite which contains ruby crystals and inclusions of black amphibole. Amethyst and rose quartz also occur locally, and calcite is found in white, pink and blue. In addition to the semiprecious or ornamental stones that can be found

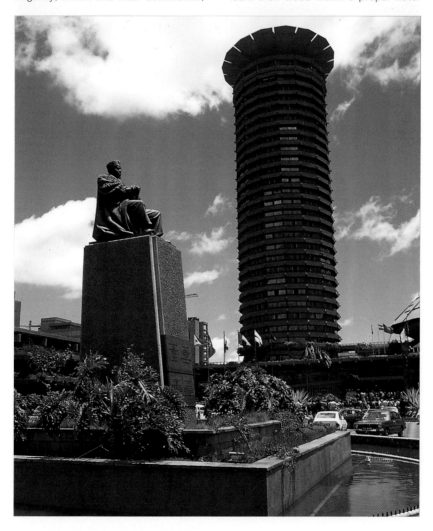

The Kenyatta International Conference Centre has a revolving restaurant and helipad on the roof, and towers over a statue of the country's first President, Jomo Kenyatta. He is buried in a mausoleum in the grounds of the parliament buildings.

in Kenya, there are also deposits of gemstones such as ruby, sapphire, aquamarine and several garnets. Of these, the most spectacular is the rich-green chrome garnet known as 'tsavorite', only discovered in 1970. Brighter and harder than emerald, this local speciality occurs only within the Tsavo area of Kenya, although there may be further deposits in neighbouring Tanzania.

Sea and shore

Kenya's coast is protected by a fringing coral reef, in most places visible from the shore. Between the shoreline and the reef, the sheltered lagoon is free of sharks, and outside monstrous breakers crash against the fragile coral. The water temperature is a comfortable 26°C, and the sun shines almost daily.

The coast is divided into north and south, to either side of Mombasa. The town of Mombasa sprawls over an island, connected to the mainland by a causeway which carries both the road and railway westwards. The road to the north crosses a new Japanese-built bridge; getting to the south coast, however, still involves the use of a somewhat antiquated ferry system.

Mombasa is Kenya's second largest town and is a cosmopolitan mixture of cultures. Before the advent of the aeroplane, it was the gateway to mainland East Africa. Passenger trains arrive from

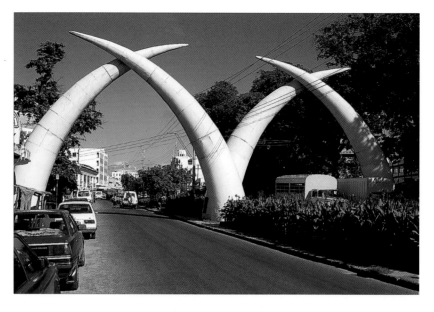

The now famous tusks over Mombasa's busy Moi Avenue were constructed in steel to mark the visit of Princess Elizabeth of England in 1952.

Nairobi each morning, and leave in the evening. Mombasa's old harbour is constantly seething with activity, especially between the months of November and March when the traditional dhows are moored. The new modern harbour on the other side of the island accommodates naval, cruise and container ships. Just a short distance away is the Mombasa Yacht Club. The main part of the town is overcrowded and somewhat

rundown, with supermarkets and offices, restaurants and travel agencies, curio shops and tailors all jumbled together.

Towards the seafront and through Treasury Square to one side of Fort Jesus, lies the Old Town. This is where the city breathes, for it is the heart of Mombasa and has hardly changed in hundreds of years. Narrow streets are filled with pedestrians and bicycles, carved Arab doors touch the edge of the street, and some of the older buildings still feature ornately carved hanging balconies. There are little perfume shops, offering their own special blend made from ylang ylang, cloves and cardamom, or charismatic eating houses so small that customers sit at tables on the pavement to eat dishes such as *kuku paka*, delicious chicken stewed in coconut milk with fresh tamarind.

The fort itself, built in 1593 by the Portuguese, is now a museum. Some of the original cannons are there, as are the fairly recently excavated bones of an unknown Portuguese sailor from that time. Talkative guides will be pleased to show you around, telling tales of how the fort became a prison and showing the well from which water was drawn when the fort was under siege. Some of the most beautiful of carved Arab doors can

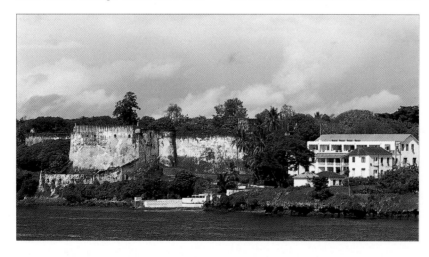

The Portuguese-built Fort Jesus dominates the entrance to the old Mombasa harbour where traditional Arab dhows still anchor. A modern port for container and cruise ships is located on the other side of Mombasa Island.

be found in the fort. A long room houses artefacts found by divers in the harbour just yards from the main ramparts. These came from the wreck of the Portuguese galleon, the *Santa Antonia d'Atanna*, which was sunk in battle in 1697 and remained undetected until the early 1970s. For four years, teams of divers spent weeks at a time excavating the wreck of the galleon, bringing up objects such as Chinese porcelain, Indian coins, old compasses and sextants, even leather containers holding ink, grains and personal jewellery. The ship itself was badly damaged by cannon fire and could not be raised, but it was still a good enough specimen to excite the marine archaeologists who mapped out grids and studied it in great detail.

A little way seawards from the fort is the State House which was built for President Jomo Kenyatta. Nearby, the scenic Mama Ngina Drive is a favourite park area for Mombasa's residents. Named after President Kenyatta's wife, it offers a wonderful view of the ocean, and it is tempting to stop and buy a coconut (*madafu*) to quench one's thirst.

At the end of the drive, near the Likoni ferry ramp, is an extensive stand of ancient baobab trees which are sacred and cannot be cut down. There is much superstition among the coastal peoples about these trees, which are believed to be home to spirits and

djinns. During the building of the railway, the British engineers ordered one of the baobabs to be cut down, and the railway workers immediately downed tools and refused to work. No amount of persuasion from the engineers would change the situation; it was explained that the tree contained spirits and that cutting it down would bring bad luck, as the spirits would have nowhere to live. To avert a potentially disastrous state of affairs, one of the engineers reached a compromise. He wrote a clear sign, giving notice to the residents of the tree that they must find alternative accommodation by the end of the week, failing which the tree would be felled. The end of the week came, and all the workers resumed work without complaint!

South coast The sleepy town of Vanga is the first a traveller will come to if travelling by road from the Tanzanian border town of Lunga Lunga. Local industry relies on the area's mangrove swamps, but tourism has hardly touched this part of the coast. A little further north, however, things begin to change. Turning off the main road in the sugar plantations near Ramisi, a track leads to the old slave village of Shimoni. For many years, this village was the premier base for big game fishing and the charming Pemba Channel Fishing Club appears frequently in the record books.

When Africa's first marine reserves were established, the Mpunguti Marine National Reserve and Kisite Marine National Park near Shimoni became popular bases for divers and snorkellers. In those early days, the marine environment was totally untouched, and the warden did not even have a boat. The shallow, clear waters around the sandspit known as Kisite Island were ideal for first-time divers to gain open-water experience. A myriad coral fishes swam around the delicate corals that had yet to be subjected to the pressure of hundreds of heavy trainer-clad feet. Moray eels, dolphins and turtles, unaccustomed to visitors, allowed themselves to be approached and photographed. One Norwegian diver, snorkelling at Kisite for the first time, summed it up. As he surfaced, he removed his mask and snorkel, and with a smile stretching from ear to ear said: 'It's fantastic ... just like being inside a gin and tonic.'

Across the channel from Shimoni is Wasini Island, a place that has been overlooked by the rest of the country. Fishermen eke out a living, and a women's project makes baskets for sale to tourists, but there is not much to see or do. Except, that is, to visit one of the most idyllic restaurants in the world. After a dhow trip round the coral gardens, visitors go to the Wasini Island Restaurant for a very leisurely lunch. The beers served here (on an island with no electricity) are the coldest on the coast, and the seafood lunch is a gargantuan array of the best seafood available, fresh from the Indian Ocean: sea fish, octopus, squid, prawns, lobster and crab, cooked in mouthwatering coastal style using fresh coconut and exotic spices, followed by fresh tropical fruit.

North from Shimoni, the once ignored fishing village of Msambweni has now come to life with holiday cottages and two hotels. Like Shimoni, it was once a slave centre. On nearby Funzi Island is a secluded fishing resort camp. The northern end of Msambweni Bay is known as Chale Island, although it is only a headland. This is a sacred *kaya* or worshipping place, and marks the southern tip of Kenya's longest stretch of beach. From here the beach runs from Kinondo

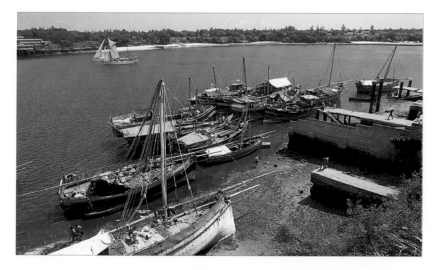

Traditional dhows still follow the ancient trade routes. Despite most of the modern dhows being motorized, their captains prefer to travel with the monsoon winds in their sails.

Four mosques have been excavated at the Jumba la Mtwana (meaning 'house of slaves') ruins. This lost city was abandoned in the fifteenth century and lay undisturbed for 400 years before being rediscovered in the 1960s.

and Galu north towards Diani, one of the major tourist resorts. In Diani there are several restaurants and a wide range of luxury hotels offering air-conditioned rooms, watersports and swimming pools. One of the most unusual restaurants is Ali Barbour's, established in an underground cave. The food is wonderful and lights that have been cunningly hidden in holes within the coral walls create quite a romantic atmosphere.

North of Diani, among large coconut plantations, nestles Tiwi Beach, cut off from Diani Beach by the Mwachema River. A hotel has been built on the southern bank of the estuary, near the ancient Mwana Mosque, the oldest mosque in Kenya still in regular use. Tiwi has no hotels, but there are several campsites and holiday cottages.

On the other side of the road is a turning to Kwale and the Shimba Hills National Park. This small park was established principally for the sable and roan antelopes, introduced from other areas. The sable have done well, but the roan are not easy to see. The park also boasts elephant, buffalo, leopard and lion. A lodge has been built with an elevated balcony along which visitors can walk and enjoy a tree-top view of the forest birds and colobus monkeys. It has also become a popular place in which to get married. The Shimba Hills National

Park is small and not overcrowded, and an overnight stay makes a welcome change from the beaches.

From Tiwi, the road travels through the village of Waa before approaching Likoni, boarding point for the ferry which cruises across the harbour to the island of Mombasa. The ferries are built to carry both vehicles and passengers, and are often loaded beyond their capacity. There has been talk of a bridge or a tunnel as an alternative, but these plans are as yet unconfirmed.

North coast The road leaving the northern side of Mombasa Island is a modern Japanese-built dual carriageway which crosses Tudor Creek to Nyali, a suburb of Mombasa. The original residential area, Nyali has some of the oldest hotels on the coast, as well as many large and impressive residences.

Overlooking Tudor Creek and the old harbour is the famous Tamarind restaurant. Diners can either sit outside and enjoy the breeze, or eat inside the restaurant in air-conditioned comfort. The Tamarind restaurant specializes in fresh seafood, and the deep-fried crab claws are delicious and thoroughly recommended. It is also possible to take a trip around the harbour on the *Tamarind Dhow*. A full buffet meal is served on board the dhow, and is accompanied by

generous quantities of the Tamarind's special 'Dawa cocktail', a potent combination of lime juice, honey and vodka.

Not far away from Nyali is Kenya's only crocodile farm, Mamba Village. Started by Israeli experts, the farm rears crocodiles for both their meat and their skins, on the understanding that a percentage of eggs hatched are returned to the wild. Mamba Village is a popular tourist attraction and, as well as seeing the crocodiles at the farm, visitors can eat, drink and dance.

Further north is the Bamburi Portland Cement Factory, which has been in existence for nearly 80 years. Quarries and conservation are not usually compatible, but the cement factory is an example of how man's destruction can be repaired. Once, hundreds of acres of quarries scarred the landscape. Due to the vision and the skill of one man, Bamburi has become one of the world's best examples of reclaiming land in nature's own way. The Swiss ecologist, Rene Haller, had a dream of converting the bleak quarries into a natural paradise, and what he has achieved is little short of a miracle. It may be difficult to believe that limestone dust can be made into fertile soil, but where once there were huge gaping pits in a barren treeless desert, now there are shaded green glades between tranquil pools. Starting from scratch, Haller planted casuarina trees, which drop their pine-like needles. He then imported many fat, glossy black millipedes with scarlet legs. The millipedes ate and recycled the casuarina needles and in time rich soil began to cover the barren dust. More trees were planted, and the millipedes thrived. Over time, yet more trees were planted, and a water supply was installed using waste water from the factory. This was channelled through cleansing aquatic plants without the use of chemicals.

Today the Bamburi Nature Trail is an oasis, inhabited by both exotic and local birds, giant tortoises, porcupines, and some orphaned animals that have been released in the area: Sally the hippo, originally adopted by film maker Alan Root; Indy, a baby buffalo who starred in *The Young Indiana Jones*; and a herd of eland. The nature trail is now self-

financing, its income derived from tourists and from the commercially run fish and crocodile farm. Further land reclamation is continually being carried out in newly exposed areas. The Bamburi Nature Trail is well worth a visit – spend a morning walking round, then drive north and look at the newly excavated quarries and try to imagine that they too will one day be green and lush.

North of Bamburi is Shanzu Beach, Shimo la Tewa Prison, and a new bridge crossing Mtwapa Creek. To the right, just off the main road, is Kenya Marineland, boasting a marine aquarium and a restaurant, as well as recreational boats. To the left, a sign announces the Jumba la Mtwana ruins, four ancient mosques that have been painstakingly unearthed.

Yet further north are wide areas of cultivated sisal, a fibrous plant used in the manufacture of string and rope. The side of the road is also planted with neem trees – a traditional cure for malaria. Insufficient research has been done to capitalize on this resource, but many coastal residents swear that an infusion of neem-leaf tea once a week will ward off malaria. Dried leaves in a linen cupboard will also keep 'silver fish' and other insects away. The tree, known locally as 'marubaini' (meaning 40 – the number of ailments it is supposed to be able to cure), is at last receiving scientific attention and a grant has been received from Finland to enable further research on the tree to be carried out.

The road crosses another creek, this time Kilifi. As with Mtwapa, this used to be crossed by means of a 'singing ferry', a ferry hand-punted across the creek by singing ferrymen. Today another new bridge spans the creek and marinas line the shore. One or two hotels offer boat rides up the creek in the early evening, specifically to see the flocks of Carmine Bee-eaters coming in to roost, attracted by the swamp vegetation. These beautiful birds nest in Kenya's barren northern area near Lake Turkana. However, from November to April, they roost in the mangroves along the Kenyan coast, particularly at Kilifi and Mida Creek. The sight of thousands of these striking birds flying into the mangroves at sunset to roost is quite spectacular.

The tourist visiting the coast seeks shady palm trees over a white sandy beach, such as at the Baracuda Inn at Watamu, a short step from the warm blue waters of the Indian Ocean.

To the west of the road, before reaching the seaside resort of Watamu, is the Arabuko-Sokoke Forest Reserve. This little patch of forest is extremely special as it is a remnant of the great tropical forest that once stretched across the width of Africa. It is famous for harbouring the endangered 15-centimetre-high Sokoke Scops Owl (the smallest owl in Africa) and Clarke's Weaver, as well as the endemic Sokoke four-toed mongoose and the golden-rumped elephant shrew. Naturalist guides take walking

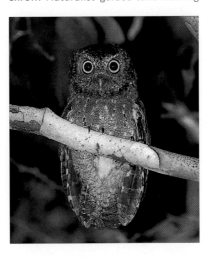

The Sokoke Scops Owl is endemic to the Arabuko-Sokoke Forest Reserve.

tours in the forest in the evening. Some of the guides have the ability to call the Sokoke Scops Owl, which is a real treat for visitors as the bird is seldom seen.

On the other side of the road, Mida Creek comes in from nearby Watamu Bay. Mida Creek is another area rich in birdlife, and forms the southern boundary of the Watamu Marine National Reserve. In the creek are the Big Three Caves, named after the three giant groupers who inhabited the caves when they were first discovered by divers. The caves are still home to grouper as well as a multitude of other fish. It is disconcerting to see them swimming upside down, nibbling at the roof of the cave. The timing of currents and tides is critical, but a visit to these caves is worthwhile for the experienced diver.

Out to sea, Whale Island is home to thousands of nesting Roseate Terns from June to September. From Mida Creek, Watamu Bay stretches north to a rocky headland, then turns into the Blue Lagoon. There are two hotels at the northern end of Watamu Bay, and yet another at Watamu Village on the shores of the Blue Lagoon. Many private houses occupy the shoreline. There are diving centres and the national parks' boats will take visitors to the coral gardens. This can be done in a glass-bottomed boat,

or with a mask and snorkel. The fish around the protected coral heads are extremely tame, and have come to expect food from snorkellers.

Inland from the beach is the ruined city of Gedi, decaying proof that there was once an advanced civilization living here much earlier than was initially believed. The city contained approximately 2 500 people, who inexplicably disappeared in the seventeenth century. The sultan's palace and several houses have been uncovered. It is quite an eerie place, and is now occupied by some rare birds and small mammals.

North of Watamu is Kenya's oldest coastal resort, Malindi. It was visited by Vasco da Gama in 1498 on his way to India, and a pillar in his memory stands on a headland overlooking the Malindi Marine National Park. The town was built to attract visitors during the 1930s when Ernest Hemingway discovered that the big game fishing in the area was exceptional. Today international fishing competitions are regularly held in Malindi. The quiet and typically Swahili town of 50 years ago is now unrecognizable. Mass tourism has spoiled Malindi's lazy charm, and today ice-cream parlours and casinos dominate, and the peaceful nights are shattered by the thump of disco music.

Few people go further than Malindi by road, and so tourists are not aware of the satellite-launching pad that is located in the middle of the magnificent Formosa Bay. It is at this spot that the Tana Delta spills the waters of the country into the sea, and if in flood causes the road to become impassable. It is not the safest area, and north of here there have been instances of buses and their passengers being attacked by bandits.

Lamu archipelago To the north of Malindi is Lamu – an archipelago, an island and a town. To reach the Lamu archipelago it is best to fly – there are regular services from Malindi, Mombasa and Nairobi. The group of seven islands and tiny islets is approximately 80 kilometres south of the Somali border. Said to have been founded in 1370, Lamu was a busy port in the eighteenth and nineteenth centuries and historical sites

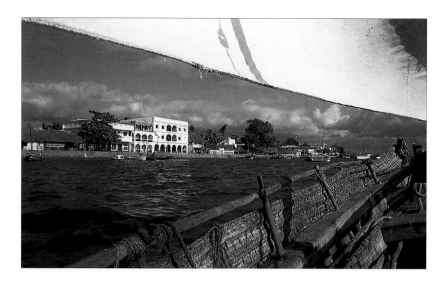

The island town of Lamu can only be approached by boat. Visitors arriving by air have to land on an adjacent island and take a small ferry across the water.

dating back a thousand years have been discovered. Mangroves are harvested for building poles, and carpenters still make boats and carve doors – an art for which they have since become renowned. Tucked away in the narrow streets, jewellers work with silver and women extract coconut oil for cooking. In the centre of the town is the Old Fort, built in 1812, which is now a cultural centre.

Nearby, what used to be the District Commissioner's house is now the Lamu Museum. Situated directly on the waterfront, this house was originally built for Queen Victoria's consul, Jack Haggard, the brother of the author Rider. Prize exhibits in this museum are the two *siwas*, or side-blown horns. This extraordinary African musical instrument has been found across the breadth of Africa south of the Sahara, and is made of wood, animal horn, ivory or brass. Probably intended as a ceremonial trumpet rather than a melodious instrument, the *siwas* have been in use in eastern Africa for several hundred years. After his first visit to Malindi in 1498, Vasco da Gama described them as 'trumpets of ivory, richly carved and the size of a man, which were blown from a hole in the side'. The ivory *siwa* in the Lamu Museum is unique. *Siwas* are still used today on certain occasions such as the Muslim Maulidi celebration.

Petley's Inn, at the waterfront, is the oldest hotel, while Peponi's Hotel and the Island Hotel occupy better sites on the sand dunes at Shela, some way from the town. The 19 kilometres of pristine beach have no protecting coral reef and are thus open to the ocean. On nearby islands, the Kiwaiyu Safari Village and the Blue Safari Village are expensive hotels. There is only one vehicle on Lamu Island, belonging to the District Commissioner. Everyone else either walks or rides a donkey or bicycle.

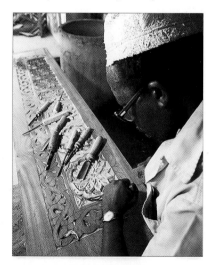

Ornate door frames and furniture are intricately carved by Lamu craftsmen.

THE PEOPLE

Kenya's people are somewhat of a mixture resulting from a series of migrations from other parts of the continent of various peoples, mainly Cushitic, Nilotic and Bantu. The nomadic Cushitic group came from Ethiopia and Somalia some 4 000 years ago, followed some 2 000 years later by Bantu cultivators from West Africa. At the same time, the Nilotic pastoralists travelled from Sudan and Egypt. The Nilotic pastoralists were the ancestors of today's Maasai, Kalenjin, Luo and Turkana people.

Migration along the coastline began earlier with the ancestors of today's Waliangulu (Wata) and Boni people, whose language is similar to that of the Bushmen of southern Africa. The coastal strip was also settled by sailors and traders from Persia, Arabia and India. The Bantu people of the coast include the Bajun from the Lamu archipelago and the Shirazi from Persia.

The nine tribes of the coastal Mijikenda are of Bantu origin. However, they have been so influenced by coastal history that they have little in common with their inland relatives. The small coastal group of Cushitic hunter-gatherers, the Waliangulu, also known as 'the elephant people', have become agriculturists since the tribe is no longer allowed to hunt elephants. Another Bantu group live around Lake Victoria and comprise the Luhya and Gusii people.

The largest Bantu group today consists of the Kikuyu who have settled around the fertile highland area to the west and southwest of Mount Kenya, the Embu and Meru on the eastern side of the mountain, and the Kamba who live in the drier, lower altitudes to the southeast. The Kikuyu are the largest tribe in Kenya, to whom land is all-important. The closely related Meru and Embu peoples are also successful farmers.

The Kamba are skilled carvers and hunters, and many of them enter the police or armed forces. They are also respected witch doctors and herbalists. Before plans for the railway had been finalized, their leading seer, Masaku, predicted that the 'long snake' would divide the country, a prediction that was

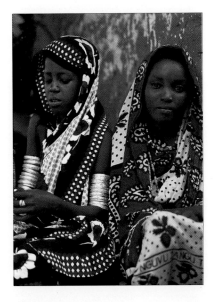

Left: *Young Orma women wear colourful khangas, each bearing a Swahili proverb.*
Right: *Maasai women wear special finery for wedding parties. In Maasai country this jewellery is available for sale at every village.*

subsequently realized with the construction of the railway. The small town of Machakos, located within the centre of Kamba country and the place where John Ainsworth wanted to base Kenya's capital city, is a corruption of his name.

Another Bantu group lives around Lake Victoria and comprises the Luhya and the Gusii people. On the coast, the Bantu people include the Bajun from the Lamu archipelago and the Shirazi who originated in Persia.

Arguably the best known of Kenya's people are the Maasai, usually pictured as proud and fearless warriors striding across the southern plains dressed in loose, flowing red robes. They have been the most successful in resisting change and cherish their age-old culture. The Maasai roam the whole of southern Kenya and much of Tanzania, while their cousins, the Samburu, live in the northern deserts. A small offshoot of the Maasai is the Njemps group, which lives in the Rift Valley around Lake Baringo.

Traditionally fishermen, the Luo live in the fertile lowlands to the west, around Lake Victoria, and are the second largest tribe in Kenya. The Kalenjin group, consisting of Kipsigis, Tugen, Marakwet, Nandi and Pokot, comes from the heights of the western Rift Valley. The

altitude here has been given as one of the main reasons for the astonishing success of Kenya's athletes.

A small group of Kalenjin-speaking hunter-gatherers, the Ndorobo or Okiek, live in the highland forests. They are known for collecting honey and using poisoned arrows.

The Cushitic nomads of the northern deserts, among them the Somali, Boran, Gabbra, Rendille, Turkana and the tiny el-Molo tribe, occupy almost one-third of the country's area, yet number less than five per cent of the country's total population. Those around the lake are fishermen who also used to hunt crocodile and hippo, while others wander with their livestock looking for pasture. The el-Molo people have now intermingled with the Samburu people.

The modern immigrant population is another combination of peoples, and there are now approximately 50 000 Kenyans of Arabian, Saudi Arabian, Indian, Pakistani, and various European origins. Two national languages exist – English and Kiswahili – and most people speak both of these in addition to their individual tribal language.

Each tribe has its own culture and customs, and in rural areas many of the old traditions live on. However, the demands

The hunter-gatherer Okiek people are looked down upon by the Maasai who call them Il torobo *('poor people').*

of modern life are harsh and only in the very remote areas does life remain unchanged. Most employment is found in the urban areas, and modern youth inevitably heads for the bright lights and job opportunities. The cities are crowded with people seeking work, and there is a huge unemployment problem. It is common for families to be separated, the husband working in a city or town and the wife remaining at home to look after the *shamba*, or farm.

The gap between rich and poor is enormous, and seems to increase as the cost of basic necessities spirals ever upward. Living conditions in the city demonstrate what a problem this is: luxurious mansions in the suburbs give way to low-cost housing estates and overcrowded blocks of flats, both of which are in appalling contrast to the shanty towns made of plastic, paper and scraps of metal sheeting.

Kenya is a melting pot of religions. The country is predominantly Christian, and Judaism is also practised. But most of the people of the coastal and northeastern regions are Moslem, reflecting their Arabic heritage. Indeed Islam is the largest of the non-Christian groups, with the remainder being mostly Sikhs and Hindus. Traditional African religious beliefs are still apparent and medicine men, healers and witch doctors still practise their ancient rituals.

Given the predictable and consistently good weather conditions, it is perhaps understandable that Kenya is a sporting nation. The country's runners are at the forefront of world-class athletics. In 1955 a sports teacher was the first to realize the potential of indigenous Kenyans competing on the world stage. At the school's sports day, he arranged for the staff to compete against each other. An untrained guard, running in bare feet with no proper track, launched himself into the long jump's sandpit. To the teacher's amazement, the jump was a mere six centimetres below the world record. Ten years later, Kipchoge Keino beat all participants in the 1 500 metres at the very first All Africa Games, held in Brazzaville. Many theories have been put forward to explain the Kenyan athletes' prowess: Kenyan children run to and from school, many live at high altitudes (particularly on the western edge of the Rift Valley, centre of Kalenjin country), and most have a healthy diet of maize, beans and green vegetables with little meat. Whatever the reasons, Kenyan runners continue to break records. Kenya also has world-class boxers, many of whom have regularly been winning medals since 1982.

If there is a national sport in Kenya, it must be football. The national team, the Harambee Stars, always attracts a full stadium. Hockey and cricket are also gaining in popularity, and are no longer dominated by Asian players. Golf has an enormous following, and the many championship-class golf courses around Nairobi are always full at weekends. Each February the Kenya Open, played at the Muthaiga Golf Club, attracts an international entry. In tennis, Kenya has a team in the Davis Cup, but there are too few players to make a significant impact on the world scene. Other games such as rugby, basketball, volleyball and squash all have a local league, and competition between clubs is fierce.

HISTORY

The name Leakey is synonymous with archaeological discovery in East Africa, since the work done by Dr Louis S B Leakey and his wife Mary established the area as the 'cradle of mankind'. This somewhat eccentric couple spent much of their married life searching for and identifying the remnants of bygone eras. In remote places of the Great Rift Valley, where the hottest temperatures in Africa have been measured, they painstakingly researched the origins of man, working in harsh and uncomfortable conditions while they tried to piece together 25 million years of history. Their most important discoveries were made at Olduvai Gorge in Tanzania, where they increased the extent of man's present knowledge of his ancestry by more than one and a half million years. It was at Olduvai Gorge that 'Handy Man' was unearthed, who, due to the skull being bigger, was assumed to have a greater brain capacity than the previously found 'Nutcracker Man'. The Leakeys considered 'Handy Man' to be modern man's immediate ancestor.

In the late 1960s the Leakeys' son, Richard, started exploring the northeastern shore of Lake Turkana, near Koobi Fora in the Sibiloi National Park. He found Stone Age tools similar to those found at Olduvai, which inspired him to search further. In 1972 a team from the National Museum of Kenya discovered part of another skull, which was labelled simply '1470'. Like 'Handy Man', the cranium of this skull was large, confirming it to be hominid, but it was found in sediments believed to be 2.9 million years old (far older than the sediments in which 'Handy Man' was found). This estimate of the age was later revised to 2.2 million years. Another skull was found in 1976, of the species now known as *Homo erectus*, and further exciting discoveries were made in Ethiopia and Tanzania. Modern man, *Homo sapiens*, evolved from *Homo erectus*, and was present in the East African Rift Valley some 100 000 years ago. *Homo erectus* did not evolve entirely until the Stone Age, some 40 000 years ago, at which time he was making tools

from flakes of stone which he used to kill animals. Twenty thousand years ago he was constructing yet more advanced tools by tying sharp pieces of stone to bones using strips of skin.

The history of modern Kenya has been documented for nearly 2 000 years. Diogenes visited Mombasa in AD110, and Ptolemy's map dated AD150 is remarkably accurate. Shirazi Arabs from the Persian Gulf began to settle on the coast from about the twelfth century and interaction between the African and Islamic cultures resulted in a new culture and people – Swahili. The Portuguese started exploring the Kenyan coast in the fifteenth century, and opened up trade with Goa and India. Vasco da Gama's arrival in 1498 was the beginning of the domination of Mombasa by the Portuguese – a reign of terror for more than a hundred years.

The original owners of the Djinn Palace on the shores of Lake Naivasha were part of the notorious 'Happy Valley' set, and this was the scene of many wild parties.

European influence and the Lunatic Line

In the second half of the nineteenth century, the German missionaries Johan Krapf and Johann Rebmann from the Church Missionary Society mission at Rabai worked to end the slave trade and convert Africa to Christianity. The pair travelled inland, and were the first to report snow on Mount Kilimanjaro and Mount Kenya. This discovery, initially ridiculed as not being possible, led to a wave of explorations with the aims of both finding the source of the Nile and obtaining more accurate maps. Joseph Thomson set out at the request of the Royal Geographical Society, soon to be followed by James Hannington, Count Teleki and others. In 1886, the land that is now Tanzania became the German colony of Tanganyika and Britain took over Kenya and Uganda. The Imperial British East Africa Company established headquarters in Mombasa, and men such as Lugard, Mackinnon and Ainsworth carved out a road to Uganda.

The road was followed by the railway, the idea of which was considered to be foolhardy and expensive. Laying over 900 kilometres of track in uncharted bush before the turn of the century was nevertheless a remarkable engineering feat. The politicians in London lambasted the project, and Henry Labouchère's irreverent verse in a London magazine of the time sums up their feelings:

What it will cost no words can express;
What is its object no brain can suppose;
Where it will start from no-one can guess;
Where it is going to nobody knows.
What is the use of it none can conjecture;
What it will carry there's none can define;
In spite of George Curzon's superior lecture,
It clearly is naught but a lunatic line.

The first rail was laid in Mombasa in August 1896, and three years later the railhead had reached mile 327, at a swamp named *Ewaso Nyrobi*, or 'place of cold water'. During the wait for an operational base to be built, a chaotic camp sprang up around the railhead. The base was never established and what was to become Nairobi rapidly expanded as the railway headed west. The track continued, up and over the eastern wall of the Rift Valley, across the flat valley floor and the equator, heading unerringly for Lake Victoria. The lake was reached in December 1901; the railway had taken five and a half years to traverse the country, and the final cost was nearly double that of the original estimate. Countless lives had been lost to diseases such as malaria and dysentery, and many workers had been eaten by lions in the area around Tsavo.

The indigenous people of Kenya had watched the 'iron snake' making its way inexorably through their country, and

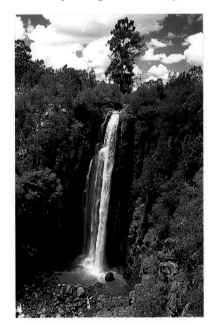

The Ewaso Ngiro River plunges over the spectacular Thomson's Falls, on the Laikipia Plateau.

they now made it clear that they would not give up their land to the white man, or anyone else. The advent of the railway had opened up the country, and a steady stream of settlers started to arrive from Britain. Many of them were true pioneers, men such as the third Lord Delamere who bought land and started farming, forcing employment on a reluctant populace. Having no idea of the conditions, many of his farming projects failed. After mortgaging his British properties, and unsuccessfully sinking substantial amounts of money into sheep farming, Delamere turned instead to cattle farming. The cattle fell to East Coast Fever, but Delamere was saved by the proud cattle-keeping Maasai tribe, who offered to manage his herds for him.

The struggle for independence

In other parts of the country, particularly the central highlands, areas of the best agricultural land were taken for white settlement, and Africans were moved to less fertile 'reserves'. The British created the all-white legislative council to govern the country. In 1918 at the end of World War I, war veterans were offered land in Kenya at a nominal cost, encouraging a further influx of settler-farmers, most of whom knew nothing about farming and even less about Africa. With them came some aristocratic rejects, who for one reason or another were an embarrassment to their families 'back home'. This minority formed the core of the *White Mischief* era, during which wild parties, infidelities, marital intrigues and other scandals prevailed. Not only did these self-indulgent gadabouts make themselves unpopular with the genuine settlers who wanted to learn and succeed in farming but they also created an unfortunate impression on the African people.

After World War II, several influential African nationalists emerged. Among them were Jomo Kenyatta, Harry Thuku, James Gichuru, Jaramogi Oginga Odinga and Mbiyu Koinange. These nationalists began campaigning for representation on the all-white legislative council, resisting white autonomy. Jomo Kenyatta became secretary of the Kikuyu Central Association in 1928 and took Kikuyu grievances to the British government two

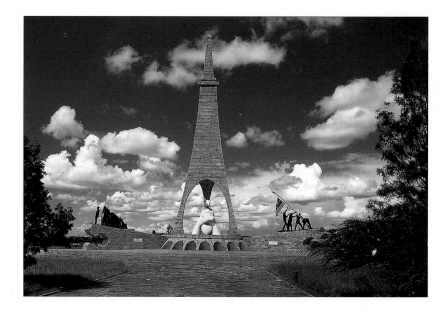

The Uhuru Monument, situated in the Uhuru Gardens near Nairobi's busy Wilson Airport, symbolizes the struggle for independence and the peace of the nation.

years later. It was only in 1944 that the first African, namely Eliud Mathu, was elected to the legislative council.

Three years later Kenyatta became the president of the Kenya Africa Union (KAU). Under Kenyatta, political pressure increased, but the colonial authorities still refused to recognize African demands and the Kikuyu-dominated Mau Mau uprising in the 1950s was the result. Now known as the 'struggle for freedom', the uprising was a violent war against the white man, but in actual fact a greater number of Africans than Europeans were to lose their lives. A state of emergency was declared, lasting until 1960. Kenyatta and his colleagues were arrested in 1952 and confined in the remote north of the country.

Uhuru

So began a long period of negotiation towards an independent Kenya, governed by Kenyans. The two major political parties, the Kenya African National Union (KANU), of which Jomo Kenyatta had been nominated president during his imprisonment, and the Kenya African Democratic Union (KADU), could not agree on constitutional smallprint. Kenyatta was released in 1961 and agreed to form a coalition government

until independence. In the elections, KANU won a landslide victory, and internal self-government was then granted on 1 June 1963 with Jomo Kenyatta as the first prime minister. Six months later, on 12 December, full independence was granted, and the Union Jack was lowered forever. Just a year later, Jomo Kenyatta became president of the new Kenyan republic. So followed a period of restructuring, rebuilding and reorganizing for Kenyatta and his government, supported by the British. The priorities of social services, economic diversification and, more important, land acquisition were dealt with. The East African Community was formed, forging new commercial links with Tanzania and Uganda. In November 1964, KADU leader Ronald Ngala joined the ruling party KANU, and the country effectively became a one-party state. One year after official independence, in December 1964, Kenya became a republic.

The end of an era

In August 1978, Jomo Kenyatta died at the age of 87 and weeks of official mourning followed. World leaders and heads of state came from far and wide for the funeral, and the coffin was carried on a British gun carriage through

the streets of Nairobi to its final resting place, a specially constructed building in the grounds of the national parliament. Kenya, and the world, had lost a great statesman, a wise man who had helped steer his country to mature independence from a detention cell.

The constitution then decreed that Kenyatta's successor should be his vice president, Daniel Toroitich arap Moi, who was sworn in to lead the nation for three months pending general elections. In November, Moi was returned unopposed as president of KANU and of Kenya. Moi's rallying call in the lead-up to the elections was 'fuata nyayo', or 'follow my footsteps'. The nyayo age began, and one of Moi's first moves was to dissolve all tribal organizations in the interests of national unity. Moi still leads Kenya today, and has been continually re-elected in his own constituency of Baringo South. In the early 1980s he was chairman of the Organization of African Unity (OAU) for an unprecedented two terms, and he survived a coup attempt in 1982.

A wave of political action rippled throughout Africa and 'democracy' was being called for. Too many countries seemed to have slipped into one-party rule, and opposition parties did not exist. President Moi initially opposed the idea of multiparty politics, but his was a lone voice in a tumultuous throng, and

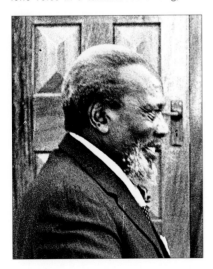

Jomo Kenyatta, Kenya's founding father, led the fight for self-government in Kenya.

finally he conceded, although with the warning that he did not believe the system would work for Kenya. He argued that KANU, for so long the ruling party, was a way of life in Kenya and that there was no opposition party capable of forming a government and running the country. Opposition parties were registered throughout the country, and campaigns began for the country's first multiparty elections, held in December 1992. As election day drew nearer, there were obvious signs of disunity among the three main opposition parties. Had they banded together, KANU may easily have been voted out; as it was, the opposition votes were split and KANU once again won the elections.

Kenya today

The government of Kenya today still wears the clothes of British influence. The civil service filing system with its many categories of classification remains unchanged. The cities' mayors wear the ceremonial hat, robes and chain of office on official occasions, the High Court judges wear robes and long white wigs. On public holidays when the president addresses the nation, the massed brass bands of the armed forces, resplendent in their scarlet uniforms, play British marching tunes. The provincial commissioners (of which there are eight) wear the colonial pith helmet with obvious pride on high days and holidays. Since the advent of 'multiparty democracy', the constitution has been amended to allow for the existence of opposition parties, but does not go so far as to identify the role of the opposition. The country has been a one-party state for so long that noticeable change is slow in coming. Tribalism is deep-rooted, and political parties tend to draw their support using their tribal influence. The loss of one of Kenya's prominent opposition leaders, Jaramogi Oginga Odinga in 1994, was a bitter blow to any hope of a unified challenge. On becoming Kenya's second president, Daniel arap Moi spoke of 'peace, love and unity'; Kenyatta called for harambee, or 'pulling together'. Only by uniting the many peoples of this burgeoning nation can effective national development in the country go ahead.

ECONOMY

In the 31 years since independence, Kenya has made significant strides in the economic sector. Geographically it is ideally situated to act as the hub of East Africa with the spokes of communications, airline services and trade reaching out to neighbouring countries. The major challenge to the government is to keep pace with the rapidly increasing population and to provide the services required for a fast growing nation. Hospitals, schools, roads, housing, and electrification of rural areas are vital issues that have to be addressed. Since only a small proportion of the population earns enough to pay taxes, other ways have to be found to raise the required sums to both maintain and improve the necessary infrastructure.

Overseas investment has always been encouraged, but until recently was made unattractive due to the restrictions on the movement of foreign exchange. Investors have been discouraged by having to wait several years for the remittance of dividends, and also by the long, drawn-out procedures involved in getting the process moving. In 1993, the situation began to improve, and a gradual reduction of controls was implemented, largely at the insistence of the World Bank and the Paris Club of international donors. The tour operators, hotels and travel agents were allowed to keep half of their foreign exchange earnings within retention accounts for a period of three months. They could then open accounts in foreign currency, and make payments in dollars or sterling without reference to the Central Bank. In 1994 the Central Bank's exchange control department was abolished altogether, its former responsibilities being handed over to the commercial banks. For a time there was confusion, with several different rates of exchange being quoted, but the situation was stabilized by a devaluation of the Kenya shilling. Import licences have since been abolished, and travellers are allowed to take Kenya shillings out of the country. They are also allowed to take reasonable sums of foreign currency on overseas trips (no longer does an ordinary Kenyan risk arrest for having

a five-dollar bill in his pocket). The result has not been, as many people feared, a massive outflow of hard currency into hidden Swiss bank accounts, but an increased flow of capital into the country. Investment is flowing into many sectors of the Kenyan economy, particularly from South Africa now that trade sanctions have been lifted.

Industry

Traditionally, Kenya's main exports have been agricultural and for many years tea and coffee were the principal earners. Pyrethrum, sisal, cut flowers, mushrooms, beans, mangoes and pineapples have long been exported to Europe and the Arabian Gulf countries. The country strives to be self-sufficient in wheat, maize and sugar, but when crops fail due to drought these commodities have to be imported from elsewhere.

Since the late 1980s, tourism has taken over as the prime income earner, and some 800 000 tourists are flocking to Kenya each year. For sheer numbers, the coast takes the prize, with planeloads of tourists on package tours arriving every day, mostly from Europe. The unpolluted beaches, sunshine and many

activities offered by the beach hotels continue to attract visitors year after year, despite occasional hiccups such as water shortages. Although beaches offer similar attractions the world over, there are few countries that also offer the opportunity to observe wild animals in their natural habitat. With as many as 24 national parks and 30 national reserves occupying over five per cent of the country's area, there is an extensive choice of wildlife destinations.

The main industrial centres in Kenya are Nairobi and Mombasa, although the towns of Kisumu, Nakuru and Thika also have small industrial areas. Saloon cars, minibuses, Land-Rovers and trucks are locally assembled, using imported kits. Trailers and containers are manufactured locally, as well as agricultural machinery and tyres, and many of these items are exported to neighbouring countries. Cookers, refrigerators, telephone switchboards, and computers are also assembled under licence to foreign investors. Products such as soap, cosmetics, medicines, toothpastes, cereals, tinned food, plastic containers, and textiles each play a part in contributing to both local and export markets.

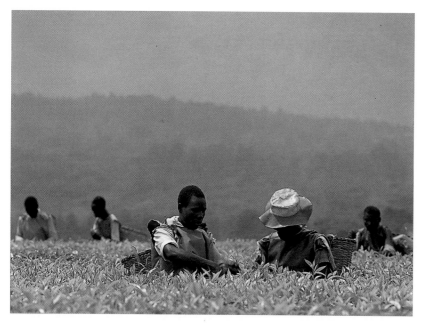

At a tea plantation near Kericho, centre of the tea-growing industry, the top 'two leaves and a bud' are still plucked by hand rather than machine, and are thrown over the shoulder into a basket strapped on the wearer's back.

Railways

The transport and communications network within the country is constantly being expanded. The 100-year-old railway still functions, but delays due to derailments do occur. The Nairobi to Mombasa train journey is a memorable experience, although the original steam engines have been retired to the Railway Museum. These days the diesel-engined trains start their journeys at 17:00 and 19:00 daily, travelling overnight to arrive early the next morning. Attendants come round with bedding, and announce with a musical gong that dinner is being served. Both sleeping and dining carriages have been updated, and they no longer have quite the charm of the original Victorian mahogany-panelled coaches. Nevertheless, it is certainly a relaxing way to travel.

Motoring

The roads, on the other hand, can be hazardous, particularly at night. Many accidents occur when a vehicle rams into the back of an unlit, broken-down truck. It is the law that every vehicle should carry reflective warning triangles, but in practice there are many which do not. A broken-down bus will often be decorated with strips of paper from the bus's ticket machine. The Kenyan warning for a broken-down vehicle ahead is to spread rocks, sticks, branches or anything else all over the road on both sides of the vehicle. When the offending vehicle has been removed, the rocks and branches frequently remain, creating another potential hazard for unsuspecting drivers. Many of the roads, particularly those roads that carry heavy goods vehicles, are in a poor state of repair. The tarmac surface can be full of vicious potholes, and the sides of the road typically fall away, leaving a dangerous drop for passing vehicles. Street lights do not exist outside of the bigger towns, and Kenyan drivers are also not known for dimming their headlights. Speed bumps are invariably found in the most unexpected places, frequently without any warning that they exist.

Unofficial taxis, known as *matatus* or *manyangas* (a bigger version), are a law unto themselves. They are notorious for

The Kichwa Tembo airstrip is one of several in the Masai Mara National Reserve. Both scheduled and private charter flights fly visitors in and out of the airport, the most regular aeroplane used being an ancient DC3 (at rear) which has been in the air since World War II.

overloading to the extent that the driver has little control, and they race each other to the following 'stage' or pick-up point. These colourful vehicles are generally in appalling mechanical condition, and are frequently the cause of fatal accidents. They should be treated with extreme caution – defensive driving is certainly recommended.

Visitors may encounter the presidential motorcade while they are driving, and should know that they are expected to pull off the road and stop immediately. An advance guard of police frontrunners on motorcycles will precede the motorcade, waving to all vehicles along the route, indicating that they should pull over. The motorcade itself can comprise up to 20 fast-moving cars, usually Mercedes Benz, and drivers should not move their vehicles until the whole motorcade has passed.

The funeral procession in Kenya is fairly unusual. The cost of transport is high, and there are few proper hearses, so it is not uncommon to see a coffin being carried in the back of a pick-up truck, with several mourners sitting or standing around it. All the vehicles in a Kenyan funeral procession are adorned with pieces of red ribbon tied to the wing mirrors or radio aerial.

Four-wheel-drive vehicles are useful in some areas, especially during the rains. Land-Rovers, Landcruisers, Troopers and Pajeros are the most commonly used, and many safari operators use them for transporting clients round the wildlife reserves. Local residents believe they can control these vehicles better than most, and an off-road rally has become a regular event on the local calendar. Designed as a fundraiser for wildlife conservation, the Rhino Charge takes place on the long weekend of the first day in June. The location, usually on a private ranch, is kept as a secret until the last minute, and the competitors arrive with tents, food, families and as much financial sponsorship as they can raise. The route, designed to be completed in just a few hours, takes them over inaccessible terrain around a circuit of control points. The aim is to visit all the checkpoints on the course while covering the minimum distance. There are no recognizable roads, or even tracks, and completing the route generally involves the extensive and imaginative use of winches, ropes and rocks, not to mention bravado (and, most will agree, a dose of sheer madness). This insane vehicle-wrecking exercise has raised millions of Kenyan shillings each year, and guarantees a

weekend of adventurous driving and fun. The funds raised are put towards the cost of erecting an electric fence around the Aberdare National Park.

A much better known motoring event, attracting international attention, is the Safari Rally. Originated by a few individuals in 1953 as the Coronation Safari, this rally has become a prominent event on Kenya's motoring calendar. The original idea was for local drivers to cover a route of several thousand kilometres through Kenya, Uganda and Tanzania over several days, using standard cars. The Safari Rally attracted overseas drivers, and as time went by the vehicles became less 'standard'. Today major car manufacturer-sponsored teams such as Toyota, Lancia, Peugeot, and Subaru use the rally to prove the endurance and power of their latest models. With the collapse of the East African Community in the 1970s, the event became purely Kenyan, and the route of the rally now covers a distance of 5 000 kilometres over Kenya's roughest roads.

Airways

There are many small aircraft in Kenya, most of them based at Nairobi's Wilson Airport. This is said to be the busiest airport in Africa, harbouring everything from a three-seater Cessna to an ancient DC-3. Local charter companies operate efficient scheduled services to Masai Mara, Amboseli, Nanyuki and the coral coast from this airport, and there are several private charter companies for those wishing to fly anywhere in the republic or to neighbouring countries.

The annual air show in September is well supported, with displays of aerobatics and skydiving being the main attractions. Pilots come from all over Africa to compete against each other in crosscountry navigation, for Kenya is said to be the birthplace of the bush pilot. Pilots have been exploring Kenya's remote areas since Beryl Markham flew over the hunting areas spotting elephants for Dennis Finch Hatton and Bror Blixen in the 1920s. The African Research and Medical Foundation (AMREF), better known as the Flying Doctor Service, operates from Wilson Airport and is headquartered there.

WILDLIFE SAFARIS

While many tourists come to Kenya on package tours, hardly leaving the palm-shaded gardens of their luxury beach hotels, the majority of visitors come to enjoy and photograph the wildlife. Since sport hunting was banned in 1977, tourists come armed only with binoculars and cameras, their 'ammunition' being rolls and rolls of film.

There are many ways of discovering Kenya's wildlife, from the traditional private, luxury tented safari to the overland truck, from a minibus tour to a camel safari, an ox-wagon to a hot-air balloon. Although Kenya has some five-star hotels, the traveller with a more constrained budget will find that it also has youth hostels and campsites. The choice depends on personal preference and the funds available.

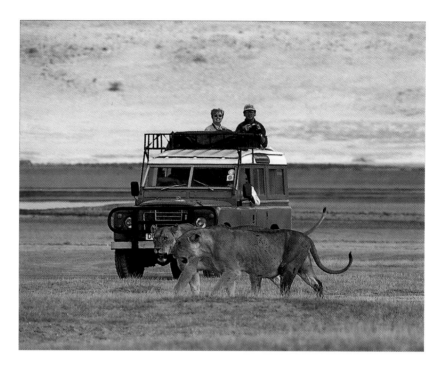

Top of every visitor's list of animals to see when visiting the game parks and reserves of Kenya are lions, which exist in large numbers in some areas. The Masai Mara is well known for its very large prides, and indeed it is unusual not to see lion.

The lodge safari

Probably the most popular is the 'lodge safari', which includes a stay of two to three nights at one of several national parks or reserves, or in a private lodge. The first national park was created half a century ago, and there are now over 50. Visitors are either driven or flown to their lodge, usually arriving around lunchtime. After being shown to their rooms, they are given a sumptuous meal, generally a buffet with plenty of fresh salads and fruit. After lunch there is time to explore the lodge, browse through the gift shop and wander around the garden. An afternoon game drive is usually next on the agenda, affording guests the opportunity to see wild animals within the park. The drivers are all English-speaking, and they know the area extremely well.

After about a two- or three-hour drive, guests are taken back to the lodge to shower and prepare for dinner. Various forms of evening entertainment may follow, possibly a group of red-ochred Maasai dancers or a slide presentation given by the resident naturalist. Some of the lodges offer a night game drive to observe the nocturnal animals; these are the private lodges, as night driving is not allowed in the national parks. After an early night, it's up at dawn for an early morning game drive, returning to the

lodge in time for a swim before lunch. Most animals take shelter during the heat of the day, so game drives are always in the early morning or late afternoon. The basic routine of each lodge will be much the same, but the locations and the wildlife will differ.

The tented safari

There are companies that specialize in tented safaris, from the luxurious to the inexpensive. To undertake an expensive safari is to follow in the footsteps of Ruark, Roosevelt and Hemingway. The private tented safari is based on the old hunting-camp routine: hot water in the shower, ice in the drinks round a roaring camp fire, crisp white sheets on a comfortable bed, good wine to accompany a cordon bleu meal; and an attentive personal guide who knows every animal spoor and can name every bird or wildflower that you see. This kind of safari is comparable to a mobile five-star hotel, with a retinue of well-trained staff who will look after the laundry, bake fresh bread every day, or mix your favourite cocktail to your personal taste.

At the other end of the scale you can choose a do-it-yourself tented safari with no frills. Take your own sleeping bag (these can be provided), be prepared to pitch your own tent and help to wash up the dishes after each meal. Transport depends on the number of people on the safari and the destination; it is most likely to be a four-wheel-drive truck that has crossed the Sahara. Setting up camp takes place in designated campsites in the parks where the availability of water is not guaranteed. This kind of safari is fun if you are with a compatible group of people, but it is likely to be dusty, and does not offer much luxury.

The hot-air balloon safari

To break the routine of either a tented or a lodge safari, there are several ways of spending an hour or a night in the wildlife reserves. Hot-air balloon rides are popular, if expensive, and balloon companies exist in Masai Mara and Taita Hills. Rides take place very early in the morning, actual lift-off being just as the sun appears over the horizon. The experience of floating over the animals,

drifting with the birds, is unforgettable and is certainly worth doing at least once. About 45 minutes after take-off, the pilot will start looking for somewhere to land, hoping that the back-up vehicles have found a good spot. Usually they will already be unloading tables and chairs because, on landing, a traditional champagne breakfast is certain to be served. Miraculously, in the middle of nowhere, piping hot croissants will appear with plates of bacon and eggs, ham and thin cheese slices, fresh fruit, cereals, tea and coffee. And ice-cold champagne makes the exhilaration of the flight last a while longer.

The camel safari

For the fit and hardy, a camel safari in the far north of the country could be the fulfilment of a lifelong dream. Safari-goers ride or walk on a two- or three-day trip beside trained camels carrying light camping equipment and food supplies. The time to travel is in the early morning when it is cool, resting at lunchtime to avoid exertion in the midday heat. When the sun begins to lose its heat, the safari continues to the overnight camp which is often on the banks of a river. Dinner is prepared while sitting around the camp fire listening to the sounds of the night. A camel safari makes a welcome change from sitting in a vehicle, and affords the adventurous tourist the opportunity to experience the African outdoors first-hand. Be well prepared for the hot sun with a hat, effective sunscreen and repellent cream to discourage the insects.

The 'special interest' safari

Many companies offer 'special interest' safaris. These can be tailormade, and cater for particular interests such as bird-watching, fly-fishing, geology, golf, plants, mountain climbing, horseback riding, or even sailing.

Viewing the wildlife

There is such a profusion of wild animals and birds to be seen that the visitor may easily be overwhelmed and confused. A number of guidebooks is available, the most popular being the Collins field guides, and a good pair of binoculars is essential. Game-viewing is best in the early morning or late afternoon, when the light for photography is also less harsh. Keep in mind that the animals are wild, however harmless and tame they might appear, and some can be dangerous, so visitors should obey the rules. Stay in your vehicle at all times unless there is a signpost indicating that you may get out to look at the view. Do not try to approach an animal too closely, particularly if it is an adult with a young calf or cub. Do not ask the driver to position the car in such a way as to interfere with the animal's behaviour or block its retreat. There have been instances of cheetahs losing their prey as tourist vehicles have also given chase, blocking the cat's line of sight. A cheetah has only one chance to catch a gazelle, and she may have cubs to feed.

Dress code

Kenya is an informal country, and there are only a very few restaurants and clubs in the bigger towns that insist on jacket and tie in the evenings. At the coast, where the population is mostly Muslim, it is polite to cover up a bathing costume with a shirt or kikoi in dining

Conditions in the Masai Mara are ideal for flying, and the largest passenger balloons in the world operate in the area.

rooms and bars. Most lodges and hotels expect their visitors to be respectably dressed, but the emphasis is on casual and comfortable wear. Shorts are suitable during the day, but slacks or skirts are preferable in the evenings. Some places can be surprisingly cool in the evenings, and it is always advisable to have a sweater if you are going on a safari anywhere away from the coast.

Precautions

Most lodges and hotels have an expensive gift shop, where it is possible to buy shampoo, sunscreen, toothpaste and film. Few will have any medicines stronger than headache pills, so bring your own personal medication. Malaria is a very real problem and in some areas is resistant to chloroquine. The recognized preventative drug is the quinine-based Paludrine – one or two should be taken daily, preferably around 19:00. Most people augment this with a weekly tablet such as Malaprim. This dosage should be continued for at least six weeks after leaving the malarial area.

In Kenya, malaria-carrying mosquitoes occur in areas below 1 829 metres in altitude – they are not considered dangerous in Nairobi. Hotels and lodges in malarial areas have mosquito nets in all the rooms, and tents are usually insect-proof. Mosquitoes are most active in the evenings, and the use of repellent cream is strongly recommended. The most effective way of preventing malaria is to avoid being bitten in the first place.

Another ailment that can ruin a safari is sunstroke. Because the sun may not be particularly hot, visitors forget the high altitude – the rays of the sun at 1 500 metres are considerably more powerful than those at sea level. You are advised to wear a wide-brimmed hat when in the sun, and also to apply sunscreens liberally. In the event of succumbing to sunstroke, a dose of vitamin A will help to relieve the condition.

In rivers and lakes there is a danger of contracting bilharzia, a debilitating disease that is transmitted by a small freshwater snail. Symptoms may take several years to develop, and the disease is not often a fatal one, but it is wise to check whether it is safe to swim.

SANCTUARIES

Kenya's national parks and reserves continue to draw visitors in their thousands. Many of these sanctuaries were created half a century ago, when a wildlife safari was still a major expedition into the unknown. Now the parks boast a number of tourist lodges and permanent tented camps offering four- and five-star luxury. Scheduled air services fly both visitors and fresh supplies in daily, and telephones and fax machines are available even in the more remote areas.

The wildlife is protected within these areas, but remains truly wild despite the fact that the animals appear to ignore the many vehicles that crowd around them. Poaching, which was rampant in the 1970s and 1980s, is under control and numbers of both elephant and black rhino are increasing.

In addition to the famous, and sometimes crowded regions of Amboseli, Samburu, Tsavo and Masai Mara, there are many smaller sanctuaries. Some of these are equally beautiful, and harbour species of animals and birds not found elsewhere. Others are less frequently visited because they have only limited lodge accommodation, or because they are too far from the recognized tour circuits. It is still possible to visit a variety of wildlife areas without following in the dust of a dozen minibuses, and to take memorable photographs of scenic vistas that do not appear in every guide book.

Masai Mara National Reserve

This is arguably Kenya's most popular reserve, for it is here that one of the greatest wildlife spectacles takes place every year. The wildebeest migration which originates in Tanzania's Serengeti around July each year may consist of two million animals, not counting the other animals that follow, such as zebra and several types of gazelle.

The Masai Mara is also the best place to observe prides of lion. Leopard and cheetah are present, but infrequently seen. The rhino population is once again increasing fairly steadily after the numbers of individuals had fallen dramatically, and elephant and buffalo are again plentiful. The Masai Mara's rolling grasslands also support an abundance of plains game, including topi, kongoni, gazelle, eland, zebra and impala.

Lodges that are inside the reserve are: Keekorok Lodge, Mara Serena Lodge, Governors' Camp and Little Governors' Camp, Mara Sopa Lodge, Mara Intrepids Club and Mara Sarova. It is also possible to stay just outside the reserve, at Kichwa Tembo, Fig Tree Camp, Mara River Camp, Mara Buffalo, Mara Safari Club, Mara Paradise Lodge, Sekanani Camp, Siana Springs, Ol Kurruk Lodge and Oseur Camp.

Amboseli National Park

Kenya's second most popular destination is Amboseli, the landscape of which offers the perfect backdrop for any photograph, in the form of the magnificent snow-capped Mount Kilimanjaro, just across the border in Tanzania. Like the Mara this is Maasai country, although very different. The park is small, and appears to be covered in a perpetual blanket of white dust. A sizable area to the west of the park is taken up by a seasonal lake, and there are permanent swamps in the southeast. Amboseli National Park contains the most studied group of elephants in Africa, a total of approximately 700 individuals. For more than 20 years, these have been carefully observed by researchers Cynthia Moss and Joyce Poole and their colleagues, who can identify each animal individually.

There are three lodges located inside the boundaries of the reserve. Amboseli Lodge, the Kilimanjaro Safari Lodge and the Amboseli Serena. There are also self-contained cottages at Ol Tukai, which are cheap if basic, and you take your own food. The cottages were built in 1948 for Paramount Pictures, and have recently been renovated. The Kimana Safari Lodge and the Kilimanjaro Buffalo Lodge are outside the park.

Tsavo National Park

Tsavo is Kenya's largest national park, and is divided into two parts – east and west. The boundary between Tsavo West and Tsavo East is formed by the Mombasa to Nairobi road between the towns of Mtito Andei and Voi. Tsavo West also includes the comparatively new Chyulu Hills National Park.

Tsavo East This wildlife sanctuary is predominantly flat, the landscape broken by scattered volcanic outcrops. The Athi and Tsavo rivers join to become the

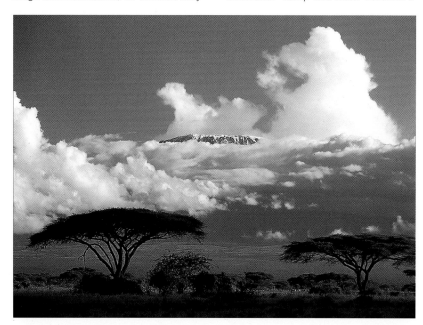

On the slopes of the Chyulu Hills in Tsavo West, flat-topped acacia trees, neatly nibbled by browsing giraffe, stand in the foreground of Kibo, Mount Kilimanjaro's main peak.

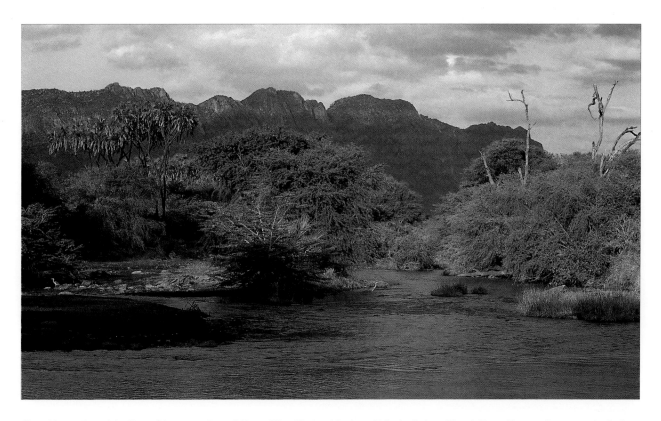

The wide reaches of the Tsavo River pass through Tsavo West National Park and join the Galana River in Tsavo East on the way to the Indian Ocean. In years of drought the river is reduced to a sluggish trickle, yet when floods occur the waters rise dramatically.

Galana River, which then becomes the Sabaki River and flows into the Indian Ocean just north of Malindi. Much of the northwestern part of the park has been closed to the public for over 30 years, having been rife with poachers.

North of Mtito Andei is the Tsavo Tsafari Camp. It is reached by a road which takes travellers to the south bank of the Athi River, from where it is necessary to continue by boat, or by air.

Tsavo Tsafari Camp's double tents situated alongside the water's edge (above the flood level) offer secluded comfort and in the evenings visitors may see porcupines, which are tempted into the open with bits of vegetable peel from the kitchen. These shy nocturnal animals are surprisingly large and rarely seen. The speciality of the camp is the 'sundowner drive', a memorable experience. Bar orders are taken in advance, and visitors are driven in one of the camp's four-wheel-drive vehicles to the top of the nearby Yatta Plateau. Visitors then relax with their sundowners, admiring

the panoramic view over the river and the extensive reaches of Africa's largest national park stretching to Mount Kilimanjaro in the distance.

The seasonal Tiva River Camp in the far northwest of the national park has recently opened, offering accommodation for 10 people. The surrounding area is not very accessible to vehicles, and the camp offers walking trips to visitors under the safe protection of two armed Kenya Wildlife Service rangers.

The Tsavo Inn at Mtito Andei is a good base from which to explore the park on a daily basis but is situated directly on the busy main road. The only tourist hotel in the eastern part of the park is the Voi Safari Lodge next to the park headquarters. This popular lodge is cut into the rock, giving an elevated view of the waterhole below. There is also the Aruba Lodge, a self-catering camp east of Voi, and the more luxurious Crocodile Camp on the banks of the Galana River near the Sala Gate in the northeastern corner of the park.

Tsavo West There are three principal lodges, two self-catering camps and one luxury camp here. The first wildlife lodge to be built in Kenya, Kilaguni has been completely rebuilt and refurbished following a devastating fire in 1990. In the northeast is the Ngulia Lodge built high up on a cliff. This lodge is particularly well known to ornithologists, who come to the area to spend several nights each November and December studying migrant birds. Thousands of birds are attracted to the lights of the lodge, and are caught in mist nets, ringed and released. As a result of this annual exercise, much has been learned about the routes the birds take in their annual migratory journeys across the world.

Between these two lodges is the main attraction of the vast Tsavo National Park – Mzima Springs. This crystal clear freshwater spring is thought to have its origins in the snows of Kilimanjaro. The supply of water is so enormous that it has been harnessed to supply piped water to the coastal port of Mombasa.

Alan Root's film *Mzima, Portrait of a Spring* remains one of the best wildlife documentaries in existence.

Near Ngulia Lodge is the Ngulia Safari Camp, a self-catering establishment. The other self-catering base is Kitani, on the western border, not far from the luxurious Dennis Finch Hatton Camp just outside the park's borders. Boasting a crystal chandelier in the dining room, damask table cloths, crystal glassware, and silver cutlery, the camp is exclusive and very expensive. What it does offer, though, is a safari such as the Prince of Wales, Ernest Hemingway and Winston Churchill experienced decades ago.

In the far south of the park is Lake Jipe, and the Lake Jipe Safari Lodge. Looking at the map, the eastern side of Tsavo West has a 'bite' taken out of it, and the road passes from the Maktau Gate through Mwatate to Voi. In this area lie the Taita Hills Wildlife Sanctuary and the twin lodges of Taita Hills and Salt Lick, both owned and managed by the Hilton chain. Taita Hills resembles a German fort and it is enveloped in bougainvillea; Salt Lick, one of the best lodges in the country, consists of rondavels on stilts linked by aerial walkways. The charmingly informal Zawani Camp is positioned just outside the Maktau Gate.

Aberdare National Park

This weathered volcanic range of mountains forms part of the Rift Valley's eastern wall, and is most famous for its lodges that specialize in night-time game-viewing – Treetops and The Ark. The original Treetops was little more than a simple treehouse, with room for only three or four people to sit uncomfortably watching the waterhole. This became so popular that it had to be extended. Sadly, during the state of emergency, the tree house was burned to the ground by the Mau Mau freedom fighters. A year before it was razed, the original Treetops became part of history, for Princess Elizabeth of England stayed there on the night that her father King George VI died. The much-quoted line in the press tells how she 'climbed the tree a princess, and came down the next morning as Queen of England'. In 1957 Treetops was rebuilt on precisely the

Kenya's original tree hotel, Treetops, was built in the Aberdare salient by Major Eric Sherbrooke Walker, then owner and manager of the Outspan Hotel in Nyeri.

same site on a much grander scale, and was subsequently enlarged to cater for nearly a hundred guests.

The forest that once surrounded the Treetops waterhole was for years under considerable pressure from farmers in the area. Recently, an ambitious long-term project has been instigated by Major R J Prickett, the armed hunter-guide on duty when Princess Elizabeth stayed at Treetops in 1953, to plant additional indigenous forest.

The Outspan Hotel in Nyeri acts as the headquarters for Treetops. It is here that the founder of the Boy Scout movement, Lord Baden-Powell, spent his final years. His cottage, Paxtu, is now a museum. Baden-Powell is buried in the nearby Nyeri Cemetery, his grave bearing surely the simplest epitaph ever – the boy scout sign of a circle and a dot in the centre, meaning 'gone home'.

Not very far from Treetops is a self-catering fishing camp with rustic log cabins, where keen anglers can comfortably reside while fishing in the Aberdares' clear trout streams and rivers.

Still in the eastern arm of the park (known as 'the salient') is The Ark, built to resemble a great ship. Visitors can look over the floodlit waterhole and admire elephant, buffalo, rhino, lion and leopard. More rarely seen is the giant

forest hog, whose population has been so decimated by lion that the Kenya Wildlife Service had to launch an operation to capture several lions and resettle them elsewhere. The Aberdare Country Club forms the Ark's headquarters and is situated outside the park boundaries at Mweiga. The club is a comfortable place to stay at, set in magnificent gardens with a private game sanctuary, a golf course and horse-riding facilities.

Higher up the Aberdares the forest turns to moorland which is divided by fast-flowing rivers, some of them with spectacularly deep waterfalls. The most frequently visited is the Queen's Cave Waterfall – Queen Elizabeth II had lunch there during her visit in 1953. Also in the Aberdares are the highest falls in Kenya – the Gura Falls (457 metres).

Mount Kenya National Park

Those parts of Mount Kenya above 3 200 metres constitute the Mount Kenya National Park, with forest giving way to moorland, glaciated scree and high peaks. The highest points are the twin peaks of Batian and Nelion, both over 5 000 metres high. These are mere shadows of their former glory – it has been calculated that Mount Kenya was once several hundred metres taller, higher even than Mount Everest.

Batian and Nelion offer some of the most challenging climbs on earth, and mountaineers often come here to acclimatize themselves in preparation for ascents in the Himalayas. The third peak, Point Lenana, is far more easily accessible to the majority, and can be scaled without ropes and pitons.

There are several routes up the mountain, the most popular being the Naro Moru track on the western side. The Naro Moru River Lodge provides guides, porters and appropriate clothing for climbers and hikers. Climbers drive to the park headquarters, and from there start their walk up through the forest to the Meteorological Station. There are wooden cabins at the station, and most people stay overnight to acclimatize themselves to the high altitude of the mountain (3 017 metres).

The following morning the serious ascent begins, through the forest of ancient hagenia trees to the start of the moorland. As abruptly as the forest ends, the dreaded vertical bog begins, 300 metres of ankle-twisting torture as walkers struggle to find footing on the tussocks of grass that seem to float in a sea of icy mud. At the top of this bog the slope becomes less steep, and the long trail up the Teleki Valley seems easy in contrast. At the head of the valley is Mackinder's Camp, named after the Victorian alpine climber, Sir Halford Mackinder, who made the first ascent of the mountain in 1909. Established by the Mountain Club, the permanent buildings at the camp are the base from which to tackle the peaks. Usually starting at two or three o'clock in the morning, climbers undertake the ascent of the steep volcanic scree to Curling Pond, a pool at the foot of the Lewis Glacier, then up the edge of the glacier to Point Lenana. In order to allow time for altitude acclimatization, this trip should take a minimum of two days travelling up and one day down.

Do consider taking an extra couple of days to explore and enjoy the exquisite tarns that encircle the peaks like a necklace. The Mountain Club has huts for climbers to sleep in, and having made the effort to get this far, it seems a pity to go back down the mountain too soon.

On the eastern side of the mountain, the Chogoria route is longer but scenically more beautiful, and it has no vertical bog. This route is approached from Chogoria, and the Meru Mount Kenya Lodge near the park gate.

On the northern slopes of Mount Kenya is the frontier town of Nanyuki, not far from which is the famous Mount Kenya Safari Club. Originally built by actor William Holden as an exclusive retreat for the wealthy, the club is set in exotic gardens with a small golf course and heated open-air swimming pool. In the grounds there is also the Mount Kenya Game Ranch and the William Holden Wildlife Education Centre. The bongo, a rare antelope, can be seen at Mount Kenya Safari Club's animal orphanage. In the town of Nanyuki it is possible to have a drink in the bar of the Sportsman's Arms with one foot placed in the southern hemisphere and the other in the northern, as the line of the equator is marked on the floor.

Accessible also from Nanyuki is the exclusive Ol Pejeta Ranch House, formerly owned by the millionaire Adnan Kashoggi; it has two swimming pools, a sauna, giant beds, and solid gold bath taps. Sweetwaters Tented Camp is situated on the same ranch. The camp has a magnificent view of Mount Kenya's peaks. Every tent overlooks the floodlit waterhole, and there is a hippo hide and leopard blind, which can be approached

The late 'Bwana Simba' (lion man), George Adamson, spent many hours relaxing with his pipe on the banks of the Tana River.

on foot but with an armed guard. The birdlife is exceptional, particularly along the banks of the river – a tributary of the northern Ewaso Ngiro River.

On the southern slopes of Mount Kenya is another tree lodge. Owned and managed by African Tours and Hotels, Mountain Lodge is similar to Treetops. A gas fire in the main lobby and bar area generates a welcoming ambience, and each room overlooking the floodlit waterhole has its own private veranda. Giant forest hogs are more easily seen here than at Treetops or The Ark, as lion are not so numerous in this area.

On the road to Mountain Lodge from Karatina is the Sagana Lodge, which was given to Queen Elizabeth during her visit. The ownership of the lodge has now reverted to the Kenya Government.

Meru National Park

Meru can be reached by following the road around the northern side of the mountain, from Naro Moru through Nanyuki and then eastwards. The park is perhaps best known for being Adamson country. In 1956 George Adamson, then a game warden in Meru, was forced to shoot a charging lioness in self-defence. The lioness had been guarding her three newborn cubs, and George brought them back to his wife at the camp. Joy named the smallest cub Elsa. Little did the Adamsons know that eventually Elsa's story, *Born Free*, would be translated into 33 languages, would sell several million copies, be made into a film and have a lasting impact on the world's awareness of the vital importance of wildlife conservation. The story of *Born Free* also gained worldwide recognition for Meru National Park.

The park is spared enormous numbers of visitors as the only accommodation available is in the Meru Mulika Lodge and one camp. Although in the shadow of Mount Kenya, the Meru National Park lies below 900 metres. The wooded grasslands of the western part of the park give way to drier bush country in the east. The Tana River skirts the southern boundary and when picnicking on its banks at Adamson's Falls, it is easy to imagine George Adamson, the grand old 'Bwana Simba', appearing from behind a

bush at any moment, Elsa at his side. On the other side of the river is the Kora National Park, where George met his tragic death at the hands of Somali poachers in 1989.

For a time, Meru National Park was home to Kenya's only white rhino, five of which had been imported from South Africa. They lived under guard, and were kept in pens at night, but poachers with chain saws succeeded in wiping out the entire group in one fell swoop. Now more white rhino have been acquired, and are flourishing in a few national parks and on various private ranches.

To the south and east of the Meru National Park, acting as a buffer zone, are the Kora National Park and three national reserves, namely Bisanadi, Rahole and North Kitui. There are no facilities for visitors in these areas, and access is not easy.

Samburu, Buffalo Springs and Shaba national reserves

North towards Isiolo where the foothills of Mount Kenya dip beneath the sand, the beginning of the Northern Frontier District stretches ahead into the barren badlands that reach into Ethiopia. Isiolo would be the perfect setting for an old cowboy film, and has little to boast of other than its role as gateway to the north as it is the start of the Great North Highway to Addis Ababa.

Driving northwards for 64 kilometres, Samburu and Buffalo Springs national reserves appear to the left of the road, and Shaba National Reserve to the right. Samburu and Buffalo Springs are divided by the northern Ewaso Ngiro River, its banks lined with dense riverine bush and stands of doum palms. The river continues across the main road to form the northern boundary of the Shaba National Reserve. Some of the animals to be seen in these northern parks are specific to these dry lands, such as the delicately striped Grevy's zebra, the handsomely marked reticulated giraffe and the beisa oryx. Accommodation is available at the Samburu Lodge, the Samburu Intrepids Club, Samburu Serena Lodge, Buffalo Springs Lodge, and Larsen's Camp, all built along the river. Crystal clear water wells forth from the Buffalo Spring. It

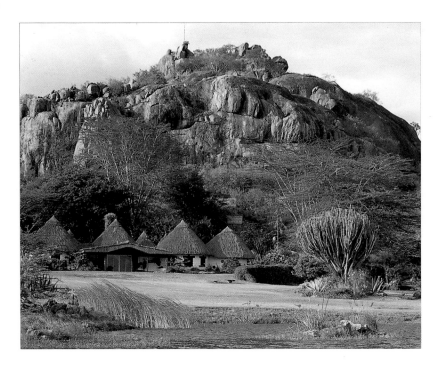

Many ranchers on the Laikipia Plateau have built cottages not only for their own guests but also to serve as a small-scale tourist enterprise.

may appear as though the spring forms part of the Ewaso Ngiro River system but it is more likely that it flows underground from Mount Kenya.

Shaba is a recent addition to the list of national reserves, and there is only one place to stay – the Shaba Sarova Lodge built on the banks of the river, with a natural waterfall supplying water to the lodge. It was in Shaba that Joy Adamson successfully reintroduced Penny the leopard back to the wild, the tale of which is described in her book *Queen of Shaba*. It is at Shaba that Joy was brutally murdered.

Lake Nakuru National Park

One of Kenya's smallest national parks (188 square kilometres), Nakuru is also one of the best known for its ornithological spectacle of up to two million flamingos. Five hundred other species of birds have also been recorded here, including many migrant waders on their annual passage from colder climes.

Nakuru was chosen as being a safe place to relocate the remnant herd of Rothschild's giraffe from their home area around Kitale, and they have adapted

well to these very different conditions. Following the intense poaching that took place in Tsavo during the 1980s, some black rhino were introduced to a special sanctuary in Lake Nakuru National Park. More recently, white rhino have been acquired from South Africa. Lions have also been introduced into the area from the Aberdares where they were overwhelming the populations of the resident animals such as forest hog, bush pig and warthog. In Nakuru it is hoped that the introduction of carnivores may help to control these populations .

Many visitors only spend a day at Nakuru, but for those wishing to stay for a longer period, there are two lodges, Lion Hill Camp and the Lake Nakuru Lodge, as well as several nicely situated campsites. Lake Nakuru has in fact been declared a Ramsar Site (a protected wetland area) as it is considered to be of international importance.

The more remote sanctuaries

Kenya has many more national parks and reserves, some of them in remote areas and away from intense tourist pressure. One of these is the Maralal

Game Sanctuary, on the way to Lake Turkana. The town of Maralal is situated on the northern limits of the Laikipia Plateau. Maralal Safari Lodge is two and a half kilometres out of the town, within the Maralal Game Sanctuary. A large variety of animals comes to drink at the safari lodge's waterhole, and a wry sign written by the owners promises visitors that they will receive their money back 'if leopard are not spotted'!

On the western circuit, not far from Homa Bay, is the delightful Ruma National Park (formerly the Lambwe Valley National Reserve). This park is home to Jackson's hartebeest, redder in colour than the more commonly seen Coke's hartebeest, and herds of roan antelope. Oribi and lion are also found in the park. Ruma National Park has no accommodation, but there is a hotel in Homa Bay 34 kilometres away.

Near to Lake Naivasha are two national parks, namely Mount Longonot and Hell's Gate. It is possible to walk up Longonot, an extinct volcano, and the energetic may choose to continue walking around the crater's rim, the whole trip taking about six hours. One can also

walk around in Hell's Gate, and explore the base of vertical cliffs and the Njorowa Gorge with its steam jets.

Fischer's Tower, a pinnacle of friable rock inhabited by rock hyraxes, dominates the surrounding plains. Named after the German naturalist who reached the gorge in 1883, this volcanic plug's presence is explained in a Maasai legend about a chief's daughter who left home to be married. Tradition decreed that she should not look back at her former home, but she turned for one last look and was instantly changed to stone.

Fischer was curious about the steam jets, and collected samples of the steam for analysis. For nearly a hundred years the resource went untapped. Today a geothermal operation at Olkaria harnesses the steam and produces more than 10 per cent of Kenya's electricity.

On the northern side of the Tana River is the Arawale National Reserve which was established to protect the unusual Hunter's hartebeest. This rarely seen animal only occurs north of the river. In appearance it is similar to the other species of hartebeest except that it sports the graceful horns of an impala.

Further downstream is the Tana River Primate National Reserve, where two primates are protected – the crested mangabey and the red colobus monkey. This small park contains many rare plants and insects, and deserves to be studied much more thoroughly. Both Burchell's zebra and Grevy's zebra can be found here, as well as the Masai giraffe and the reticulated giraffe.

All situated in the eastern part of the country, Kenya's three most remote reserves are the Boni National Reserve on the Somali border, the Dodori National Reserve and the Kiunga Marine National Reserve. The Boni reserve is named after the people of the area; it is isolated from the sea by a coastal strip. The Dodori National Reserve is positioned on the coast and its creeks and inlets serve as ideal breeding grounds for marine animals such as the dugong and the green turtle. Dodori is named after the river that passes through it and enters the sea near the town of Kiwaiyu. As Kiunga reserve is the least developed of all the marine reserves in Kenya, it is also the least spoilt, and is the ideal spot to escape from the more developed areas along the coast.

Marine national parks

Kenya was the first country in Africa to establish marine national parks and reserves, recognizing the value of preserving a beautiful and fragile national asset. In these areas spear-fishing and the collection of shells, starfish and coral are banned. The reef along the East African coast runs almost parallel to the shore from Somalia down to southern Mozambique. It is broken in places where rivers empty out into the sea, and a number of natural harbours were used by sailors as long ago as the fourteenth century. These natural harbours include the Lamu archipelago, Mombasa Island and Dar es Salaam in Tanzania.

On the landward side of the reef, the lagoons offer safe bathing and ideal conditions for visitors to view the underwater scene, either from glass-bottomed boats or with mask and snorkel or aqualung. The lagoons vary in depth and width; some contain coral gardens while others are flat and sandy.

Pterois radiata *is one of three varieties of feather fish, or lion fish, that occur in Kenya's coastal waters. The dorsal spines of this species have poison sacs at their base.*

The corals within the lagoons are protected from the ocean's buffeting by the reef itself, and there is a great variety of soft corals as well as the fragile stag's horn and lettuce leaf corals and the massive brain coral. Anemones abound, each with its resident clown fish enjoying a symbiotic relationship with their host. These fish are immune to the toxicity of the anemone's tentacles, and earn their keep by luring unsuspecting prey closer. Many fish are very colourful, and two of the most graceful fish to be seen are the similar but unrelated species, namely the Moorish Idol (*Zanclus cornutus*) and the Coachman (*Heniochus acuminatus*). Both have extended pennant-like dorsal fins, and vertical black, white and yellow stripes. A highly recommended book for basic identification of the marine life is *A Guide to the Common Reef Fishes of the Western Indian Ocean* by Dr K Bock, published by Macmillan.

The first reserve to have been established comprises both the Malindi and Watamu marine national parks. The marine reserve extends from just south of Malindi town to Watamu, the southern shore of Mida Creek. The boundary extends five kilometres out to sea, and on the shore to 30 metres above the high-water mark. Traditional fishing is allowed in the reserve, but not in the parks. Since the local people have been catching their food in this way for centuries, the practice cannot be said to deplete fish populations significantly providing that only traditional methods of fishing are used. Seine nets and power-headed spearguns are forbidden. Further south in Tanzania, fishermen use explosives despite the fact that this is illegal. A charge of dynamite will kill every fish in the area, many of which are too small to be edible. It also causes untold damage to the delicate corals, which may take generations to recover.

Other such marine national parks and reserves have also been established at Mombasa, while further south the Kisite Marine National Park is located in the Mpunguti Marine Reserve. This is one of the most spectacular places for diving and snorkelling in the Indian Ocean as the water is clear and the diversity and variety of fish and corals is astonishing.

WILD KINGDOM

The abundant wildlife is the predominant reason that Kenya welcomes so many tourists every year – the parks and reserves are accessible, the animals are easy to see and accustomed to being watched from vehicles. Times have changed since the sole reason for spotting animals was to hunt them – today the only shooting is done with a camera.

There are over 400 species of mammals in Kenya, 1 080 species of birds, and nearly 300 reptiles. Many of these are nocturnal, others are restricted in range and are seldom seen. With such varied habitat (highland and lowland forest; high moorland; grasslands and wooded grasslands; desert, semidesert and a variety of wetlands), it is therefore not surprising that the range of wildlife in Kenya is exceptional.

The big five

The collective name for elephant, rhino, buffalo, lion and leopard – the 'big five' – was coined by professional hunters and their clients in the days of the original hunting safari decades ago. These were the five animals most coveted as trophies, difficult to track and even dangerous to approach. Hunting these animals required skill and courage, and any one of them, if wounded, could reverse the odds and kill those who trailed them through the African bush.

Hunting in Kenya was banned in 1977. The East African white rhino is now considered extinct, but a number of these animals has been brought in from South Africa and they seem to be thriving in Kenya. The white rhino can be seen on some private ranches in the Laikipia area, and a few also live in the Lake Nakuru National Park and on a Maasai group ranch on the borders of the Masai Mara National Reserve.

To the keen photographer, the 'big five' remain the most sought-after animals. An African safari is somehow incomplete without having seen them.

Elephant The largest African animal is the elephant, which is also one of the most intelligent, and has a complex social structure. Elephant herds consist

More people are injured by buffalo than any of the other 'big five' species.

of related females and calves, led by the dominant matriarch. Males tend to leave the family group when they reach adulthood to form bachelor groups, only returning when a female is in oestrus. Elephant are known to communicate over long distances using low-frequency sound, with much of their knowledge and behaviour being passed down from generation to generation.

Elephant have been studied for many years throughout Africa, and particularly within Kenya's Amboseli National Park where some 700 animals remained protected and undisturbed during the horrendous poaching activity of the 1970s and 1980s. Today, numbers are recovering, but human population pressure is intensifying on all sides, and the natural range of the elephant is becoming increasingly restricted as the demand for land grows. Conflicts between man and elephant are frequent – farmers strive to grow crops for their families, which elephant trample and eat. Electric fences are being constructed all around the national parks to protect the elephant and people from one another. Ancient migratory paths thus cease to be accessible, threatening the ecological balance. Elephant have always been free to roam, thus allowing the vegetation time to recover in their absence. Now that they are restricted to small areas, the plants have no time to recover. Unfortunately, as a result of this, elephant are usually blamed for causing desertification.

When possible, elephant herds range over vast areas, from bushland to forest, wherever there is access to water. In times of severe drought, they will use their tusks to dig for water in dried-up riverbeds and waterholes, and at such times are followed by those weaker animals who cannot dig and might otherwise die of thirst.

Rhino There are two species of rhino in Kenya – the black rhino occurs naturally while the white has been translocated from southern states. Due to poaching, white rhino have become extinct in East Africa. Notwithstanding their names, the rhinos are not distinguished by their colour but by the shape of their mouths. 'White' is a corruption of the Dutch word for 'wide', which describes the white rhino's upper lip whereas the black rhino's lip is slightly prehensile, allowing it to get a grip on tasty shoots.

While white rhino are grazers, black rhino are browsers, and are found in forests and areas of grassland with trees. They are usually solitary, but a calf will stay with its mother until it is able to defend itself against danger. In Kenya the black rhino population was reduced to as few as 600 as a direct result of the intense poaching activity in the 1970s and 1980s. Rhino now enjoy complete protection, and the population is beginning to recover. Sanctuaries have been established within the Tsavo and Lake Nakuru national parks, and there are others on private ranches. A healthy population of rhino is to be found in the Nairobi National Park, which is situated just outside the city.

Buffalo Said to be Africa's most dangerous animal, the Cape buffalo deserves its place in the 'big five'. Weighing about 800 kilograms, Cape buffalo are formidable animals, and are often guilty of trampling crops. More people are killed or seriously injured by lone buffalo than by any other wild animal, although they are seldom dangerous when in herds. Buffalo are herbivores and can be found on open grassland plains as well as in forest. They frequently wallow in muddy pools, probably as a way of keeping their skin free from ticks.

Lion The lion is the largest of Africa's cats – a fully grown male weighs up to 200 kilograms. Widespread on the open plains, particularly within the Masai Mara National Reserve, lions can also be found in forests where there is adequate prey for their survival. But they are less common in areas of human settlement, where they are considered to be vermin and are destroyed if they become stock killers. Lions are social animals, associating in family groups, or prides. The dominant partner is the female, who does most of the hunting and cares for the young. Two or three males may stay with the pride to offer some protection, but other than exerting their authority at mealtimes, the males play the role of the 'spoiled king' to perfection.

Leopard The magnificent leopard is considerably more widespread than the lion, although, as it is mainly nocturnal, it is not nearly as regularly seen. Stealthy and secretive, leopards typically live close to human habitation, and have even been seen in built-up areas in the city of Nairobi. Residents in the suburbs of Langata and Karen have frequently lost their pet animals to leopards. These rosette-patterned cats are found in almost any area that has trees in which they can take cover during

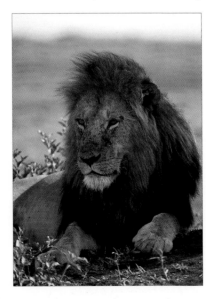

While male lions are the leaders of the pride, the lionesses do most of the hunting.

the day; they are quite easily seen lolling in the yellow-barked acacias during the heat of the day within Lake Nakuru National Park. Leopards are solitary animals, except when a female has young. They may have up to three cubs, although it is rare for these all to survive due to predation by lion and hyena.

Predators

The opportunistic predators of the plains are the hyena and the jackal, as well as the African wild dog whose numbers have fallen dramatically. Spotted hyena are the most common of the two species of hyena, and can be seen in open grasslands. Striped hyena are less widespread, being more dry-country animals. Neither species is particularly attractive, but hyena have their purpose and are extremely efficient hunters as well as scavengers. They are territorial, and have an advanced social system of clans dominated by the females.

Black-backed and side-striped jackals often live in the same area, although the black-backed is more widespread in the drier areas. Less common is the golden jackal which, like its relatives, is attracted to carrion but will also eat birds, frogs, rodents and other small mammals.

The least common of Africa's cats is the long-limbed cheetah. An animal of the open grasslands, the cheetah is now recognized as being endangered and at risk. This graceful and nonaggressive cat has become isolated in pockets across Africa, and the resultant inbreeding has caused the genetic diversity needed for its continued survival to be depleted. Cheetah are the fastest runners of all land animals, reaching a top speed of 113 kilometres an hour over short distances. But while this heightens the cheetah's ability to catch its prey, its slim build offers no defence against competition, and many of them lose their prey – and sometimes their cubs – to lion, hyena and jackal.

Other cats that can be found in Kenya are smaller and less common. Perhaps the most beautiful is the caracal, or African lynx, with its graceful tufted ears. Caracals are dry-country specialists, and hunt ground-dwelling birds and sometimes small antelope such as dik-dik.

These small cats are partially nocturnal, and can vary in colour from a warm brown to an almost silvery grey.

African wild cats are widespread, but in appearance are so like domestic cats that many people do not recognize them. They were probably the domestic cat's ancestor, and the two species are known to interbreed. Notoriously difficult to tame, African wild cats are ferocious little predators.

The serval has longer legs and larger ears than the wild cat. Its usual colouring is similar to that of a leopard – dark spots on a pale background – but black servals are not uncommon on the high moorlands of the Aberdare range. They are shy animals, and specialize in catching rodents, rabbits and even insects such as grasshoppers and locusts. Their normal hunting method is to stalk, listen, and then pounce.

Primates

There are several species of monkey in Kenya, perhaps the most striking being the magnificent black-and-white colobus monkey. Two species of colobus exist, one that lives in the high mountain forests, the other in what is left of the coastal forests. Exclusively treetop dwellers, colobus monkeys rarely come down to the ground, where they are vulnerable to predators. Their handsome coats make them particularly attractive to man, who used to make ceremonial robes from the skin. Now colobus monkeys are protected, and one of the forest sounds that visitors cannot forget is the throaty call that signals the presence of a troop long before it becomes visible. Less common is the red colobus, which can only be found within the Tana River Primate Reserve and on the island of Zanzibar off the coast of Tanzania.

Sykes' monkeys are fairly widespread guenons known for their gentle nature. They vary in colour depending on where they live, those in the western forests being mostly blue-black and those from the lowlands being more brown with a white collar. Their close relative, the vervet monkey, is equally widespread, and is a fearless little creature with a black face. Others in the same family include the magnificent red-tailed de

Brazza monkey that is found in western forests, and the dry-country patas monkey with its characteristic reddish head.

Another fascinating group of primates which are often heard but rarely seen because they are nocturnal are the galagos or bushbabies. The two common species to be found in Kenya are the greater and the lesser galago, both with enormous eyes that shine red in a spotlight. Extremely vocal at night, the volume of their calls seems out of all proportion to their diminutive size.

Related to the bushbabies is the slow-moving and equally nocturnal potto, which can only be found in forests in the extreme west of the country.

Herbivores

Giraffes are the tallest of all animals, and are browsers. There are three separate species to be found in Kenya. The most common is the Masai giraffe, widespread over the southern half of the country. These animals are marked with irregularly shaped brown blotches on a yellowish background. In the dry northern areas the handsome reticulated giraffe can be found; its darker brown markings are straight-edged on a white background. A hybrid of these two species is the Rothschild's giraffe, whose stronghold used to be west of the Rift Valley until numbers declined to such an extent

that the remaining animals were moved for their protection. They can now be seen in Lake Nakuru National Park, and at the Giraffe Centre in Langata, just outside Nairobi. These striking giraffes were quickly propelled to fame by the Lesley-Melvilles, who raised funds for their relocation and started the Giraffe Centre.

Two zebra species occur in Kenya, the common, or Burchell's, being the most widespread. They occur in large numbers on open grasslands, often in the company of other plains game such as wildebeest with whom the zebra migrate. The more delicately marked Grevy's zebra are dry-country animals, and can be seen in the northern areas.

Over 50 species of antelope occur in East Africa, ranging in size from the 700-kilogram eland to the diminutive 5-kilogram dik-dik. Eland are widespread in open grasslands and lightly wooded areas and are easily identified by their size and conspicuous dewlap. The rarely seen bongo is also of the spiral-horned group. Both greater and lesser kudu are dry-country animals, the greater kudu favouring hilly places. Much more common, particularly in forested and treed areas is the bushbuck, which is found at all altitudes. The unusual aquatic antelope, the sitatunga, favours swamps and wetlands. In Kenya sitatunga can only be found in the tiny Saiwa Swamp National

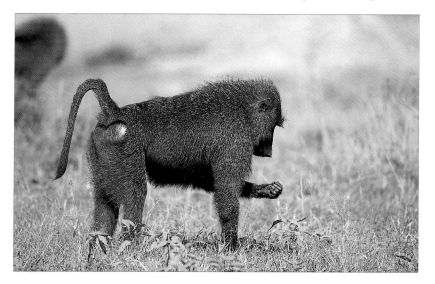

Baboons eat all sorts of fruit, and occasionally small mammals and birds. They are always careful to inspect the ground underneath acacia trees, hoping to find fallen seed pods.

Park where special platforms have been built to facilitate viewing this elusive animal. Sitatunga have distinctive splayed hooves which enable them to walk on floating vegetation. When alarmed they submerge themselves under the water with only their nostrils showing.

The smaller antelope are the most confusing to identify. Coastal and central forests are inhabited by the suni, a shy creature roughly the same size as the open grassland dweller, the steinbok. Another grassland species is the oribi, which is easily identified by the black gland below each ear. Klipspringer are found only on rocky mountain slopes. These delicate antelope bounce effortlessly along the cliffs on feet that are perfectly adapted to the terrain.

Two species of dik-dik occur in Kenya, both in dry areas. Guenther's dik-dik inhabit the north, and Kirk's dik-dik the south. These tiny animals live in pairs and mate for life. A traditional folk story tells of a dik-dik that was running away from a leopard when she tripped over a huge pile of rhino dung, thus enabling the leopard to kill her. The dik-dik's mate was so incensed by this that he asked the lion to call a meeting of all the animals. The committee discussed the matter, and it was decided that it was the rhino's fault that the dik-dik had fallen. Henceforth it was decreed that the rhino should scatter its dung rather than leave it in a pile, and the dik-dik would pile his little pellets into a heap so that the rhino might one day fall over it. The leopard was henceforth to change its hunting tactics, becoming more stealthy rather than openly running along forest trails.

The duiker is a bigger version of the dik-dik and can weigh between 10 and 20 kilograms. Grey duiker live in the open grasslands, but all other species of duiker inhabit forests, where they feed on fallen fruit and berries.

Antelope that live near wet areas of grassland include the waterbuck and the reedbuck. Two species of waterbuck occur, the common and the defassa. The defassa is a West African species, while common waterbuck occur mainly to the east of the Rift Valley and are easily identified by the white circle around their tail. These antelope species have

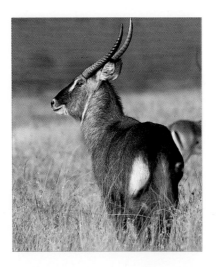

Defassa waterbuck, found mostly west of the Rift Valley, can be easily distinguished by their white rump.

been known to interbreed where their ranges overlap, and the hybrids of the two species do not feature the characteristic white ring. Both species are grey but only the males have horns.

Bohor reedbuck have forward pointing horns, and weigh about 40 kilograms whereas mountain reedbuck are smaller (30 kilograms) and the curve of their horns is not as pronounced. Mountain reedbuck prefer sloping hills, while the bohor is generally found near reedbeds.

The two most common gazelle species to be seen across the open plains are Thomson's and Grant's, the latter being significantly larger in size and slightly lighter in colour. Thomson's gazelle have a black side stripe, and their tail seems to be in perpetual motion.

The northern, long-necked gerenuk cannot be confused with other gazelles, as these are the only antelopes that stand on their hind legs in order to feed. Gerenuk are found in arid areas in the north and east of the country.

The 'clowns of the plains' are wildebeest or white-bearded gnu. They are also the most numerous of the plains animals. Nearly two million animals spend their lives migrating around the vast Serengeti-Mara ecosystem. January sees the wildebeest herds on the short-grass plains of the Serengeti preparing to drop their calves in February. The

young can run as fast as their mothers in a very short time, and they then spread in long lines to the Serengeti's northern and western areas, following the growth of the new grass. In July the wildebeest cross into Kenya, launching themselves into the Mara River. Many are drowned, injured or taken by crocodiles, but the fittest animals survive. The wildebeest herds stay in the Masai Mara until hunger and the dry weather drive them southwards again. Numerous zebra also travel with the wildebeest, and they, too, are followed by predators.

Related to the wildebeest is the hartebeest, the most common being Coke's. The Masai Mara also harbours substantial numbers of topi, a reddish-brown antelope characterized by darker patches on the face and thighs.

Two species of oryx occur in Kenya, the desert-dwelling northern beisa oryx and the fringe-eared oryx, an inhabitant of the wetter south and east. Sable antelope and roan antelope, with their scimitar-shaped horns, have never been widespread in Kenya, but they do occur in the Shimba Hills National Park situated south of Mombasa. Roan antelope can also be found in the Ruma National Park in western Kenya.

The beautiful impala might have been used by Disney as a model for Bambi. These russet-red animals have liquid brown eyes and elegant lyre-shaped horns. They are generally found where grasslands and woodlands meet. The dominant male will lead a harem of females, and never far away from this group is a bachelor group consisting of the remaining males.

Due to its size, the hippo should surely have been included in the 'big five'. These huge grazers can weigh as much as 3 000 kilograms. They spend their days partially submerged in water, and can be found in most major rivers that are not too fast flowing. Armed with large tusks, hippo can inflict a fatal wound, and rivalry between males often results in injury. Although hippo do not usually come into conflict with man, there are instances of people being attacked when collecting water or bathing. Hippo feed mostly at night, sometimes walking many kilometres from the river in search of grass.

BIRDLIFE

For both the serious ornithologist and twitcher, Kenya is akin to paradise. With its wide variety of habitats, it has the longest bird list of any African country other than Zaïre. A total of 1 080 bird species is known to occur within Kenya, many of them passage migrants whose seasonal routes take them along the length of the Red Sea and the Rift Valley. All but a small percentage had already been described before World War I, and most of those remaining before World War II. But the total list is constantly changing and in neighbouring Tanzania three species new to science have been discovered in the last four years. Kenya holds two world records, both attained during a marathon 'bird-watch' fundraising exercise in December 1986. The three-man team of Terry Stevenson, John Fanshawe and Andy Roberts holds the record for the highest number of species seen within a period of 24 hours – a staggering 341 species. Over a short period of 48 hours, Don Turner, Dave Pearson and Alan Root recorded 494. During the first fully international bird-watch organized in 1993 by BirdLife International, nearly 300 of Kenya's bird-watchers surpassed each of the other 80 countries by recording as many as 797 species over a single weekend.

A Kenyan safari is a good opportunity to start a lifelong passion for birds, for so many are brightly coloured and easy to identify. Of course, Kenya has its share of 'LBJs' (little brown jobs), but many of these can be identified by habitat preference or call.

The sound most evocative of Africa is the wild ringing call of the African Fish Eagle. These spectacular birds are common around the lakes and waterways throughout the country. Paradoxically, they do not always eat fish, and can occur in areas where there are none to be had. Flamingos, both Greater and Lesser, occur in vast numbers in all the alkaline lakes of the Rift Valley. They move from one lake to another, undertaking these journeys at night.

Ten species of kingfisher occur in Kenya, the largest being the magnificent Giant Kingfisher. The black-and-white

Second largest of the African vultures, Ruppell's Vultures nest in colonies on rocky cliffs. Few such colonies remain in Kenya, as some of the cliffs have been disturbed by rock climbers.

Pied Kingfisher can be seen hovering over freshwater lakes and along streams. The colourful Malachite and Pygmy kingfishers are also common near fresh water, while the Mangrove Kingfisher occurs only in the coastal lowlands and also along the Tana River. The Striped, Chestnut-bellied and Woodland kingfishers do not eat fish, and are common in open grassland where they eat insects.

Two species of pelican breed in Kenya, the Great White and the Pink-backed. The latter are the more widespread and occur in smaller groups nesting in trees. Great White Pelicans occur in greater flocks and nest on the ground. Of the herons, the most common and most widespread is the Black-headed Heron, which is often found a considerable distance from permanent water. Grey Herons prefer to be near water, as do Purple and Goliath herons. The locally distributed Black Heron is less common, but when found is well worth photographing. Black Herons have an ingenious way of fishing – they fan their wings forward to form an 'umbrella' and the shade created leads the fish to mistake it for shelter. The Buff-backed Heron, or Cattle Egret, is a common and widespread species in all but the very

dry areas, and associates with large animals. The birds can invariably be seen following in the footsteps of cattle or buffalo, picking up the insects disturbed by the animals' feet.

The Crowned Crane is one of Africa's most beautiful and elegant birds. It inhabits swamps and marshes, and has become increasingly threatened by human encroachment as the marshes are reclaimed for agriculture.

There are eight species of vulture in Kenya, each with its own peculiarity. All eat carrion, although the Palm Nut Vulture is more partial to the fruit of two species of palm. Palm Nut Vultures favour the coastal area, and up the Tana River to the Meru National Park. They can also be found in southern Tsavo. The Bearded Vulture, or Lammergeier, is an uncommon resident of high cliff faces in mountainous areas. The breeding population in the Hell's Gate National Park has not been evident for some years, their nests having been disturbed by rock-climbers. The Lappet-faced, White-headed, Ruppell's, White-backed, Hooded and Egyptian vultures are more widespread and are often seen together, tearing at the remains of a carcass or riding the thermals to gain height when

flying. The Egyptian and Ruppell's vultures nest on cliffs and rocky crags, while the Lappet-faced, the White-headed, the White-backed and the Hooded species prefer to nest in trees.

A conspicuous bird of prey in open country is the Martial Eagle, boasting the largest wingspan of all East Africa's eagles. The forest equivalent is the Crowned Eagle, capable of killing mammals as large as a Sykes' monkey. Easily identifiable in flight by its short tail, the red-faced Bateleur Eagle is incredibly agile in the air, performing intricate loops and swoops when displaying. The most successful raptor, which is particularly common around areas of human habitation, is the Black Kite, a tawny brown bird with a distinctly forked tail. The Tawny Eagle is also brown (in varying shades) but is a much bulkier bird and lacks the forked tail.

Some of the most colourful birds are those that are iridescent, such as the starlings and sunbirds, their glossy blues appearing almost metallic. The most colourful bird is probably the Superb Starling, a noisy, conspicuous bird, often found foraging around the lodge breakfast tables, cheekily begging for crumbs. With its glossy blue head and back, white necklace and chestnut-red chest, this bird is unmistakable. Sunbirds, Africa's equivalent to humming birds,

The Superb Starling is one of the most colourful representatives of its family.

are plentiful: 35 different species have been recorded in Kenya. The Variable Sunbird is the most wide-ranging, and has a glossy blue-green head, purple chest and yellow belly. There is a white-bellied species, and colours do vary in different areas, hence the name.

Two spectacular, colourful and wide-ranging families are the bee-eaters and the rollers. The most abundant bee-eater is the Little Bee-eater, similar in colour to the highland resident, the Cinnamon-chested Bee-eater, but much smaller. The striking blue and mauve Lilac-breasted Roller is both common and conspicuous in most open areas except the dry far north.

The Saddle-billed Stork is the most distinctive member of the stork family. It has a bold black stripe across its beak dividing the red tip from the colourful red and yellow face. The unattractive Marabou Stork sports an almost bald face and sagging crop and is commonly seen scavenging around waste dumps.

The most prolific of all the Kenyan birds, queleas can form flocks of many thousands, even millions. Considered to be pests because they quickly destroy grain and cereal crops, queleas appear to recover from even the most intensive control operations.

Most of the migrant birds come south, arriving from Eastern Europe and Central Asia, although there is also a number of species that are intra-African migrants hailing from other parts of Africa. Many of these are waders such as curlews, sandpipers, godwits, plovers and stints. From September to March large numbers of these migrant birds can be seen on coastal mudflats and around the lake shores. Other migrants include small passerine warblers, whose tiny wings carry them all the way across the Sahara Desert. There is a debate over their name – in Africa they are referred to as European Warblers whereas in Europe they are called African Warblers.

Bird-shooting is allowed in certain areas of Kenya in the nonbreeding season, with ducks being numerous, especially on highland lakes to the east of the Great Rift Valley. Game birds such as francolin, spurfowl as well as guineafowl are also present in sizable numbers.

FLORA

Most visitors to Kenya are struck by the colour and variety of the flowering plants, whose brightness and intensity is quite spectacular. Many flowering plants and trees are imported exotics, common in the tropics but not necessarily native to Kenya. These plants include the lilac-coloured jacaranda which lines many city streets, covering the pavements with a carpet of blossoms in October each year. Also common in residential areas is the Australian flame tree, which drops its leaves before flowering and then displays a mass of small scarlet blooms. The indigenous Nandi flame tree has larger bell-shaped flowers which are generally red although a yellow variety also exists. More delicately coloured, the Cape chestnut, also natural to Kenya, has flowers of a pinkish-white colour which are lightly scented.

Numerous colourful plants have been imported from South America, including the bougainvillea which occurs in many different colours and a profusion of flowers. The waxy-flowered frangipani displays white, cream, yellow, pink and peach flowers. Originally from Central America and the West Indies, in Kenya these plants flourish in hot, low-lying areas and are particularly successful along the Kenyan coast. Another tropical American import is the poinsettia, with vivid red bracts. There are yellow and pink varieties too, but the red one is known within the United States as the Christmas tree. Plants such as these are fairly small in Europe but in Kenya can reach heights of 10 metres or more.

Coconut palms have great commercial value and are a common sight along the coast, particularly in plantations at Tiwi. This plant would be an asset to anyone marooned on a desert island, as it provides all the basics necessary for human survival: food and drink from the nut, shelter from the leaves, and wood from the trunk. The dried shells make good charcoal for fuel and the fibrous husks can be made into rope or provide a perfect burning material for smoking fish. Coconut oil has many commercial uses, and a nutritious animal food can be made from the flesh and the copra. Date

Left: *Pajama lilies appear after rain. They are most common in the Masai Mara.*
Right: *The desert rose is a widespread succulent shrub, found in dry country.*

palms have not been exploited to the same extent as in northern Africa, but they grow well and could be very successfully cultivated in the drier northern areas. Doum palms, which are common along the northern Ewaso Ngiro River in the Samburu-Buffalo Springs national reserves, are majestic but do not have a significant commercial use. Their propagation is dependent on dispersal by elephants, as the seeds will not germinate unless they have been swallowed and digested by these animals.

The most widespread of all the indigenous trees on the African plains are the acacias, of which there are more than 40 species. The most characteristic is perhaps the flat-topped, yellow-barked variety commonly known as the 'fever tree'. When explorers were making their way around Africa, they often sheltered from the heat under these trees, and frequently became feverish with malaria as fever trees are most often found near water, where mosquitoes breed. It was some time before the mosquito, and not the tree, was blamed for causing malaria. Another common acacia is the whistling thorn, with strange spiked seed pods. Ants live in these pods. Although the ants will attack with little provocation, they tolerate giraffes, which feed on the leaves. The ants bore holes in the hard pod shell and when the wind blows through the perforated shell, a whistling sound occurs, hence the tree's name.

The baobab thrives in lowland Kenya, from Tsavo National Park down to the coast, offering shelter and sustenance to

a host of creatures. This extraordinary tree can attain an enormous size and some are known to be several hundred years old. Legend has it that the tree angered the gods, who uprooted it, flinging it upside down, and it landed with its roots in the air. Unlike most trees, baobabs have no age rings, and their huge fibrous trunks can hold substantial quantities of water. In times of severe drought both man and elephant have been saved by this surprising store of liquid.

Along the coast, mangroves are not uncommon although they have been overexploited for the making of poles. These strange plants with aerial roots thrive in brackish, tidal areas and play an important role in filtering the water, keeping nature's balance in check.

Two families of indigenous plants are protected in Kenya and it is prohibited to collect them. These include the many varieties of aloe that thrive in even the most dry conditions, and most species of orchid. Aloes have long been used in traditional medicine throughout Africa, and there are many varieties of this extremely useful plant.

The coastal leopard orchid (*Ansellia africana*) that grows on coconut palms is particularly sought after by collectors, and is often seen being sold illegally on many of the streets in Nairobi's Westlands suburb. *Ansellia africana* will not survive high altitudes, and is seriously endangered as a result of this unlawful collection. Other endangered plants are the many types of epiphytic orchids found in the highland forests.

CONSERVATION

Kenya has more than its fair share of conservation bodies – the United Nations Environment Programme has its headquarters in Nairobi. Regional offices for the Worldwide Fund for Nature, African Wildlife Foundation, Friends of Conservation, the International Wetlands Working Group, BirdLife International, Wildlife Conservation International, and the World Conservation Union, among others, are also to be found in the country. Not surprisingly, therefore, an army of conservation-minded people exists, working on a wide range of issues. Subjects covered are 'man versus wildlife' and all its ramifications, the protection of individual species, the care of areas of special importance, pollution monitoring, scientific studies and education.

Uppermost in the minds of numerous Kenyans is the politically sensitive 'man or wildlife' issue and which should be the more important. As the human population increases, so does the pressure on wildlife areas, particularly in the vicinity of national parks. The farmer, scratching a meagre crop from an area possibly unsuitable for agriculture and situated too close to the border of a wildlife park or reserve, cannot defend his field – or family – from marauding animals. The importance of the tourist dollar to the national economy is not relevant to him in his struggle to feed his dependants. While it can be said that man has lived alongside wildlife for thousands of years, never before has the pressure of human numbers been so great. Enormous conflict inevitably results, and this is a matter that must be addressed, and solved, by conservation bodies and government alike. From an economic point of view, wildlife cannot be allowed to vanish; aesthetics apart, it is certainly the greatest tourist drawcard and tourism generates income for the country.

Wildlife management in Kenya has always been the responsibility of the government, and this was only changed in 1989 with the formation of the Kenya Wildlife Service under the leadership of Dr Richard Leakey. Previously, the Wildlife Conservation and Management Department, a section of the Ministry of

Tourism and Wildlife, was heading in the direction of many other government departments. It faced problems of corruption, low morale, and lack of financial support. Poaching was rampant, rangers were poorly equipped, and funds were totally inadequate. On his appointment as director of the Kenya Wildlife Service, one of Dr Leakey's stipulations was that the organization should be allowed to retain all the revenue from the parks rather than hand them over to the central treasury. In this way, money earned by the parks could be channelled back into the wildlife service and used to repair vehicles, maintain roads, buy uniforms, train wardens and rangers, and set up a properly armed security force to deal with the problem of poaching.

In no time at all, the rangers had new uniforms and their quarters had been repaired and redecorated, vehicles were up and running with adequate supplies of petrol and spare parts, the roads and the airstrips were being regraded, and rangers were given modern weapons and sufficient ammunition to face the poachers' AK47s. Dedicated people of a high calibre were employed and paid realistic salaries. It was a massive task to turn the years of progressive mismanagement around into a positive, efficient, and self-sustaining organization responsible for the management of Kenya's greatest asset – its wildlife.

Dr Richard Leakey was the perfect choice to head the new Kenya Wildlife Service. Charismatic and brutally honest, straight-talking and hard working, he set about his new job with vigour. With his highly motivated team he mapped out a five-year plan, making the first step in the right direction. Despite losing both legs below the knee as a result of an accident caused by aircraft engine failure, he soldiered on with characteristic tenacity.

There were visible signs of the situation improving, demonstrating that the communities around the parks were benefiting from the income generated by the wildlife and tourism in the form of schools, water supplies and improved roads. Overseas donors had promised long-term financial backing worth over 300 million US dollars, confident that it would be well spent and properly accounted for. Richard Leakey intended that to happen. However, a bitter political campaign was launched against him, resulting in his resignation only three years after he was appointed.

Today Dr David Western, the former director of Wildlife Conservation International, is in charge of the Kenya Wildlife Service. Dr Western has perhaps a more relevant academic background in the field of conservation and, like Dr Leakey, was born and raised in East Africa. Western has integrity, international standing and wide support, but he is not accustomed to high-level political pressure. He is possibly more tactful, and in a quiet but effective manner is treading his way carefully.

The East African Wildlife Society has a worldwide membership of 13 000. The society continues to support conservation projects throughout East Africa, thus encouraging and funding many young and enthusiastic Kenyan biologists and botanists in their studies and research. The East Africa Natural History Society, based at the National Museum in Nairobi, has several subcommittees. These are all conservation societies in their own right, and include BirdLife Kenya, the Kenya Wetlands Working Group, and the Ornithological Sub-Committee that publishes the magazine *Scopus*. The Kenya Museum Society supports research into cultural as well as conservation topics, and arranges the 'Know Kenya Course' each year.

One network which promises much for the future of conservation in Kenya is The Wildlife Clubs of Kenya (WCK), of which there are 1 200 clubs countrywide with 140 000 members. Activities for school groups are coordinated by offices in the towns of Nairobi, Nakuru and Kisumu. Individual clubs are motivated by school teachers, who receive assistance and educational materials from various conservation bodies, especially the African Wildlife Foundation. Recently a book on the importance of indigenous trees was produced by KIFCON, a British aid project working to preserve Kenya's forests, for The Wildlife Clubs of Kenya. The idea behind the clubs (of which Dr David Western is chairman) is to educate and train the youth, who will then become the conservationists of tomorrow.

Situated in the Nairobi National Park, the elephant monument was erected to mark the spot where President Moi set alight hundreds of kilograms of poached ivory on 10 July 1989.

MOMBASA AND THE CORAL COAST

Above: *A young girl dressed for a religious festival in Lamu.*
Opposite: *A Hindu temple in Mombasa.*

Kenya's coast has a special, lazy charm, and the pace of life is noticeably slower than that of the highlands. Coastal history stretches back hundreds of years. Ancient ruined cities are still being unearthed by archaeologists who try to interpret the secrets buried in the coral blocks under centuries of thick undergrowth.

Today, hotel lawns and beaches are covered in sunbeds. Swimming pools and water-sports centres are crowded with people eager to soak up the sun and enjoy the comfortable warmth of the water. Away from the tourist hotels, the women farm their land, growing coconuts and cashews, mangoes and pawpaws. Their husbands fish the rich waters, many still using the traditional hand spear. In protected areas, such as marine national parks and reserves, this is the only method allowed.

Although many different religions are represented, most coastal people follow the Muslim religion, and the voice of the muezzin calling the faithful to prayer can be heard long before dawn. Women dressed from head to toe in long black robes known as *bui bui* modestly avoid the gaze of strangers. Only a pair of brown eyes is visible.

Far out to sea, deep-sea fishermen keep the Hemingway dream alive, strapped in their fighting chairs and armed with rod and line. Catches of sailfish, marlin, and sharks from these waters dot the record books. Smaller fish such as yellow-fin tuna, rock cod (*tewa*) and kingfish find their way through the fish markets to restaurants and hotel buffet tables. Crabs and prawns are now being farmed commercially, and trawling freezer ships have to stay far out to sea so as not to deplete the supply accessible to the local fishermen.

Because of the success of tourism along the Kenyan coast and the enormous number of beach hotels, there are fewer wild and undisturbed areas. Twenty years ago it was not unusual to see a leopard at night walking stealthily along a coral track, and there are substantiated reports of elephants on the beach near Lamu within the last 10 years. Now such sightings are very rare, and the only wildlife that visitors may see are baboons and monkeys, attracted to the easy pickings of food in the vicinity of the hotels.

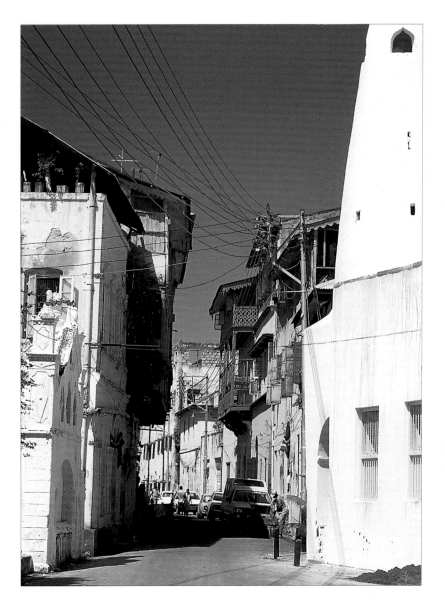

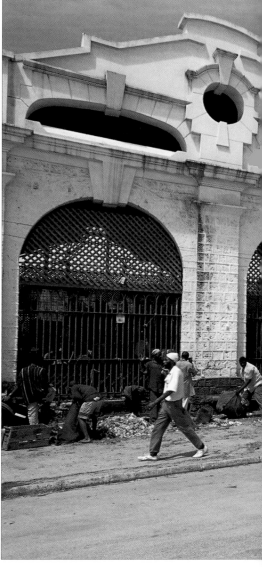

Above: *Many of the older buildings in Mombasa's Old Town still have wooden hanging balconies which jut out into the street below. The narrow pillar on the right is typical of the architecture, built as a lighthouse or landmark.*

Opposite top: *The market on Mombasa's Digo Road, backing onto the Old Town's streets, is an example of colonial architecture. The windows consist only of bars to maximize the flow of air through the building.*

Opposite bottom left: *The ubiquitous* mikokoteni *(handcart) is the standard form of delivery van. The two-wheeled vehicles are pulled (or pushed) by hand, and are used to carry anything from fruit and vegetables to motor vehicle spares.*

Opposite bottom right: *A variety of tropical fruits and vegetables are on sale at the market, while the aromas from a nearby spice shop waft through the open walls. Meat can also be bought here.*

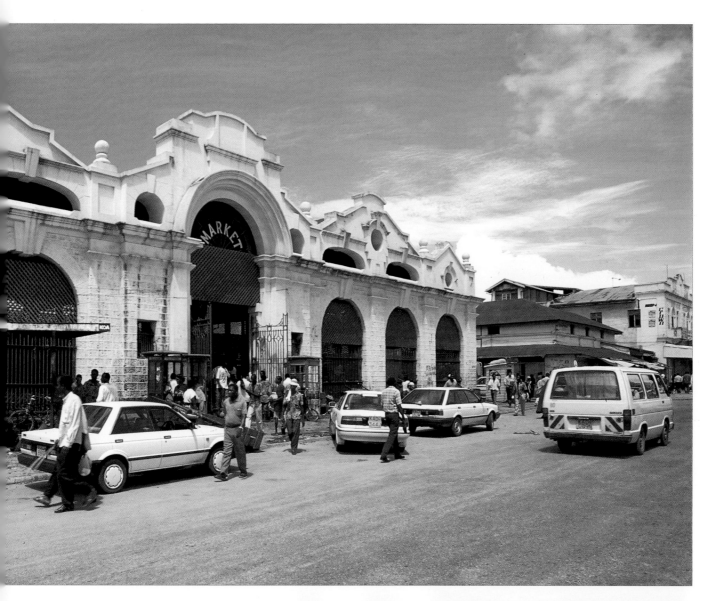

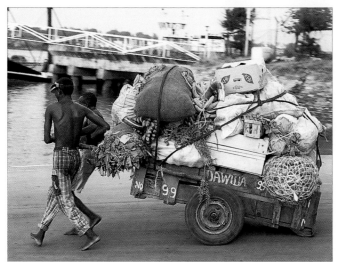

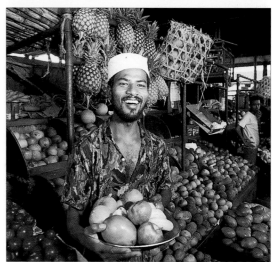

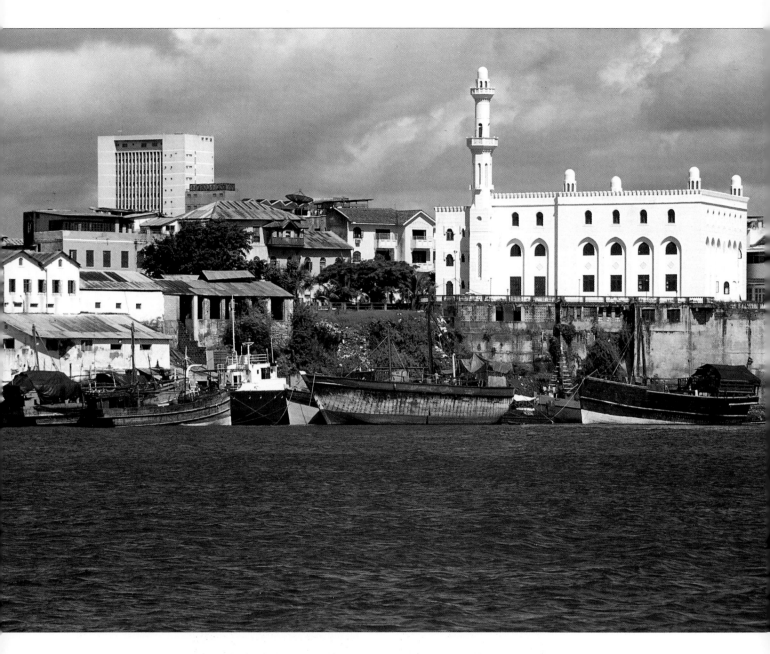

Above and opposite bottom right:
Mombasa Island is a mix of old and
new architecture. The air is heavy
with moisture from the humidity of a
breezeless narrow street or the drip
of an old rusting air conditioner.
Opposite top: The beautifully
tended gardens of the Serena
Beach Hotel in Mombasa are as
luxurious as the hotel itself. It has
been named one of the 'Leading
Hotels of the World', and is owned
by His Highness the Aga Khan.

Opposite centre: The Maulidi
festival at Lamu has taken place
every year since the late nineteenth
century. Muslim pilgrims come from
all over the Indian Ocean and East
Africa to feast, dance and celebrate.
Opposite bottom left: Fort Jesus,
built by the Portuguese, towers over
a fifteenth-century cannon. The fort
now serves as a museum, and
contains artefacts that are several
hundreds of years old, evidence of
its chequered and historic past.

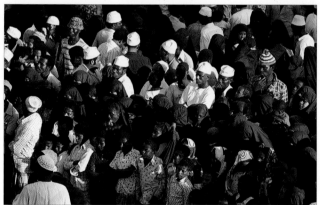

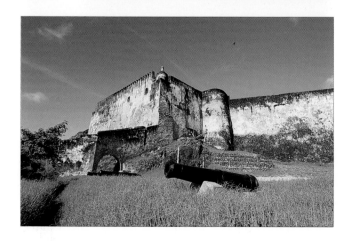

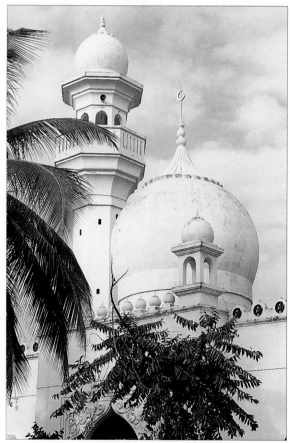

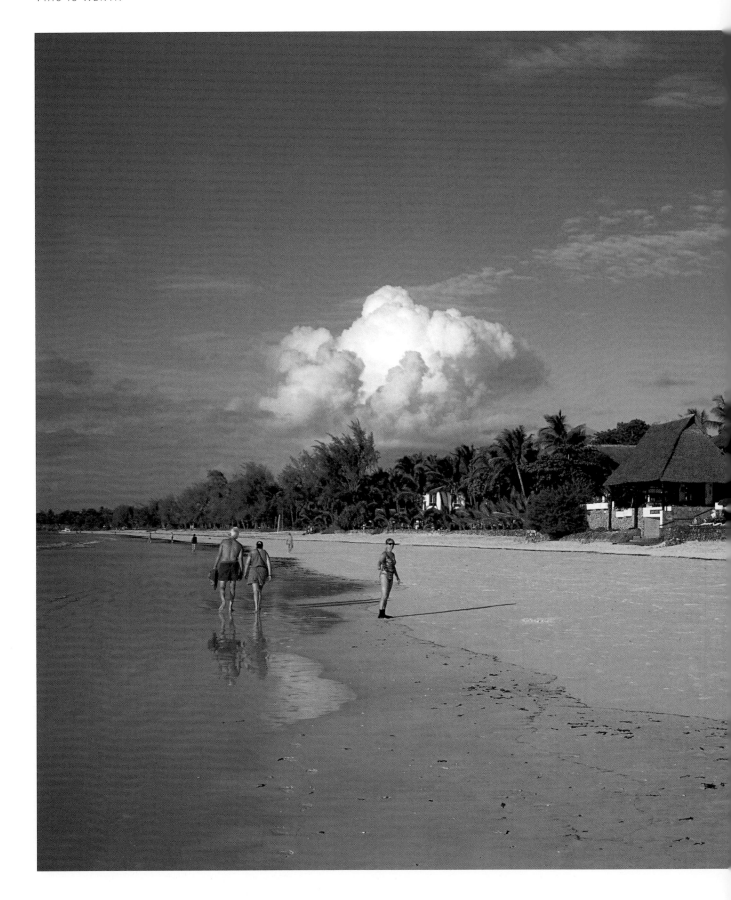

Above: *Kenya's traditional carvings are sought-after examples of local art, each one unique. Curio carvings of animals are mass produced in order to satisfy the insatiable tourist demand, although it is possible to find the work of a true artist if you have time to browse.*

Left: *Diani Beach is the longest and finest along the Kenyan coast, and boasts a beautiful shallow lagoon. It is possible to walk to the reef at low tide, exploring the rock pools and coral heads. At high tide, the sea can be rough, particularly in breaks in the reef, known as* mlango *(doors), where the water rushes through the gaps with surprising force.*

Above: Wood carvers display their wares on Diani Beach, as close to the hotels as they are allowed to get. Regulations require that they sell from official, registered kiosks rather than hawk their wares on the beach.

Above left: For those tourists who tire of the sun and the sea, a camel ride is a fun experience. Kenya is the venue of an annual Camel Derby, held each October in the northern district of Maralal.

Left: At any beach resort, there are always boutiques, either in the hotels or on the side of the road, offering beachware in local fabrics. Khangas were named from the Kiswahili word for 'guineafowl', as the original designs were spotted, resembling the feathers of this ground-dwelling bird.

Opposite: Tiwi, south of Mombasa, has one of the quieter beaches along the coast and the residents prefer its informal holiday cottages to the hotels of the more developed areas.

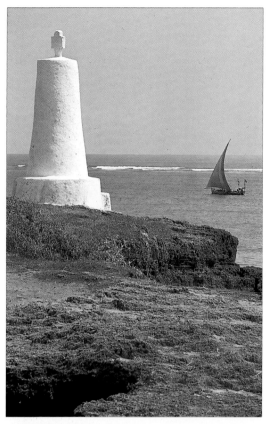

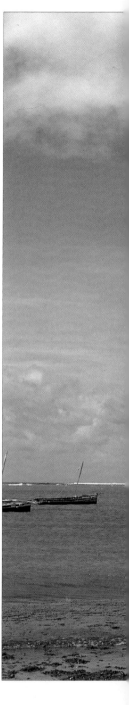

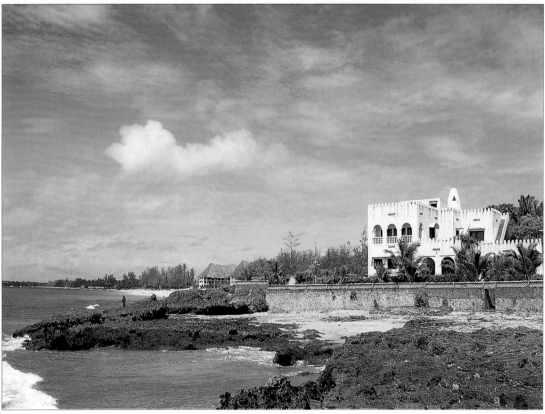

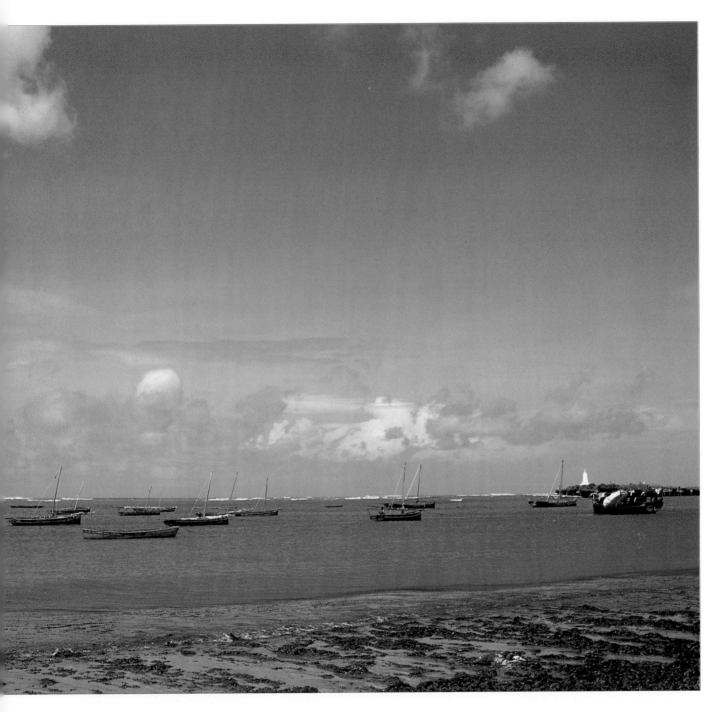

Opposite top left: *The Juma'a (Friday) mosque, in the old part of Malindi, marks the place where slaves used to be sold during the nineteenth century. The East African coast was notorious as a transit point for slaves. Two German missionaries, Johan Krapf and Johann Rebmann, worked hard to end the slave trade.*

Opposite top right: *The Portuguese explorer Vasco da Gama, who 'discovered' Malindi on his way to Goa, built a pillar as a landmark in 1499, using stone imported from Lisbon. Two hundred years later it was torn down during one of the area's many battles, and was restored by the Portuguese.*

Above: *A fleet of fishing boats moors in Malindi Bay, waiting for the next tide. Each day's catch is taken straight to the fish market.*
Opposite bottom: *Malindi's beach is famous for its surfing waves which, together with the deep-sea fishing opportunities, made this the starting point for the coastal tourist industry.*

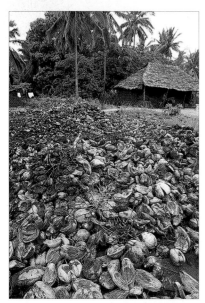

Above: *The ancient town of Jumba la Mtwana was mysteriously abandoned, as was the lost city of Gedi further north. Several mosques and houses have been uncovered, revealing evidence of an advanced civilization about which little is known.*

Left and right: *Every possible use is made of coconuts in Kenya and there are many palm plantations along the coast. Coconut flesh is used extensively in coastal cooking. The 'milk' called for in recipe books is made by first grating the flesh on a grater known as an* mbuzi, *then soaking the flesh in hot water. After standing, the liquid is strained off and the flesh put into a strainer made from palm leaves called a* kifumbu, *dipped in water and squeezed. Green coconuts are sliced open with a sharp knife, providing a thirst-quenching drink known locally as* madafu. *The milk from mature nuts ferments to produce a potent type of palm wine.*

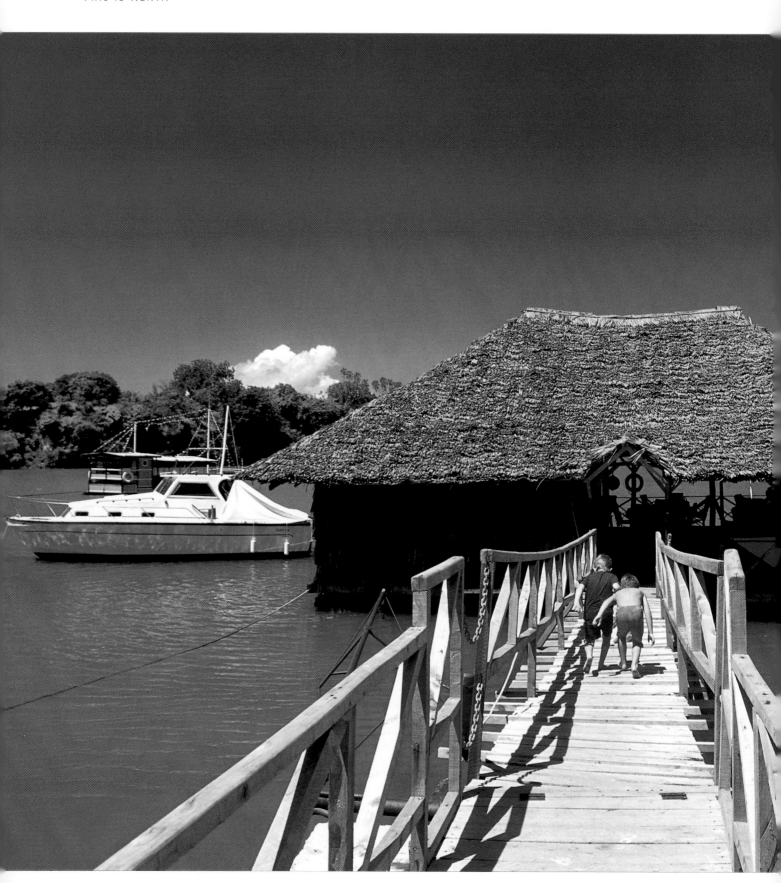

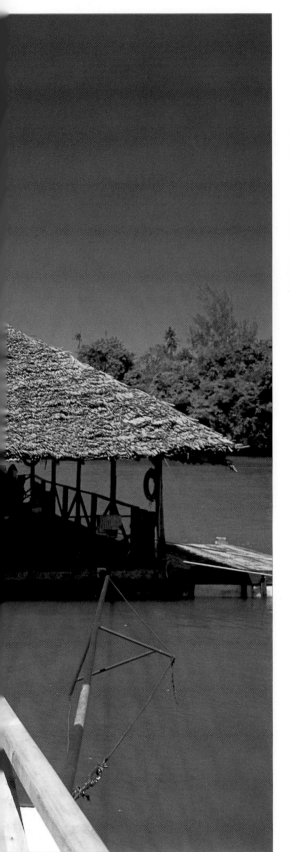

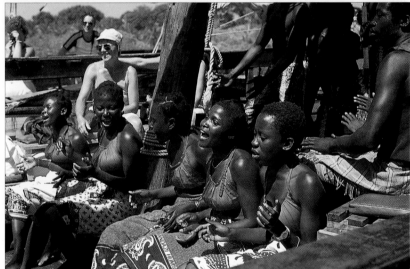

Above: Porini Village, not far from Mtwapa Creek, is a cultural centre where traditional crafts are made and sold. Visitors to the village are given the opportunity to sample the local food and drink, and are entertained by singers and dancers in traditional costume.

Left: Boats moored in the sheltered waters of Mtwapa Creek lie waiting for the deep-sea fisherman to try his luck. Fishing competitions are held regularly in this area, some of them in the creek itself.

Top: Breakers pound the reef beyond the entrance to Mtwapa Creek. A new bridge over the creek has replaced the pontoon structure that was built after World War II. Travellers before that time were transported on the 'singing ferry', which was hand-pulled across the waters.

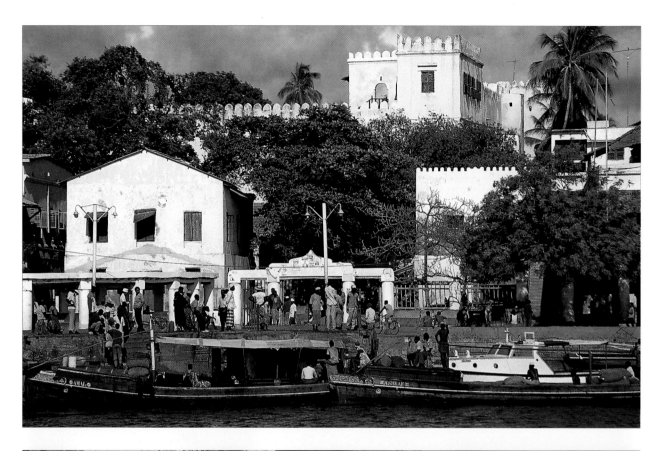

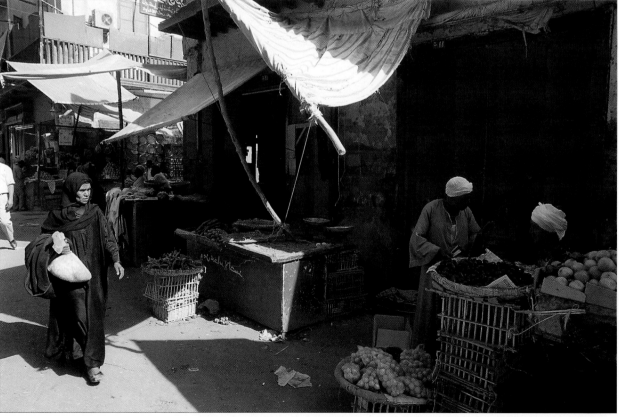

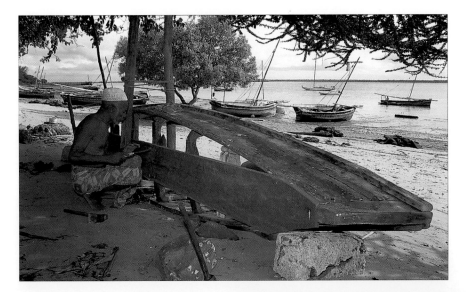

Above: The art of ship building has been perpetuated in Lamu, where dhows spend three to four months each year. When the monsoon wind turns in late March, the dhows head seawards once again to trade in the Arabian Gulf.

Right: Designed to take advantage of variable winds, the traditional lateen sail allows boats to speed across the water. The maritime art of sail-making is alive and well along the Kenyan coast, particularly at Lamu where ocean-going dhows are still made.

Opposite top: Lamu has for centuries been used as a port, the many islets in the archipelago providing shelter from the winds and waves of the open ocean. A natural break in the reef offers safe passage for ships, similar to that off the island of Mombasa, another natural port.

Opposite bottom: Baskets for fruit and vegetables are made from the locally abundant supplies of palm leaves. Fish and rice are the staple foods, generally enriched with spices, herbs and vegetables and invariably cooked with coconut.

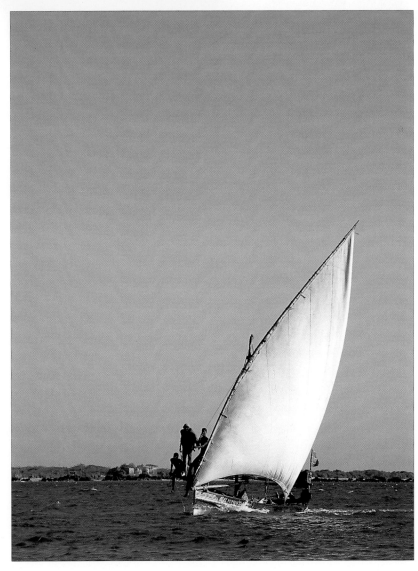

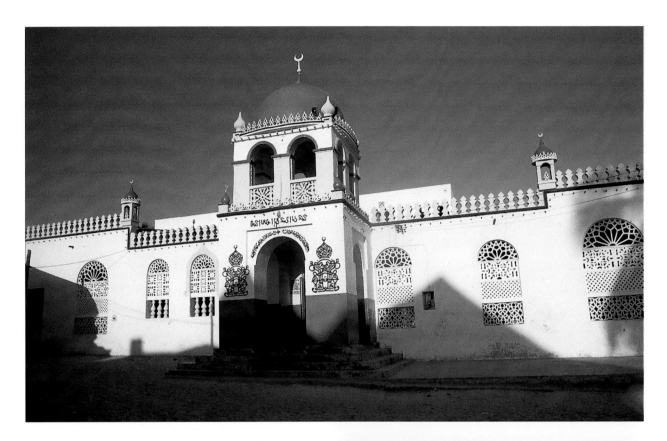

Above: The town of Lamu has more than 40 mosques, the largest of which is the Riyadha Mosque.
Right: Lamu architecture is intriguing. Thick coral stone walls ensure that the houses remain cool inside, and allow breezes to pass through. Many of the older buildings have inner courtyards that are open to the sky. Narrow streets minimize the heat of the sun's rays.
Opposite: The Lamu market in front of the old Sultan's Fort is open every morning for fruit, spices, vegetables, and local specialities such as halwa and mandazi. On this side of Lamu, away from the beaches and hotels, it is said that time stands still.

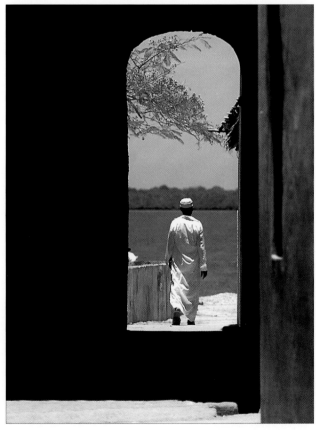

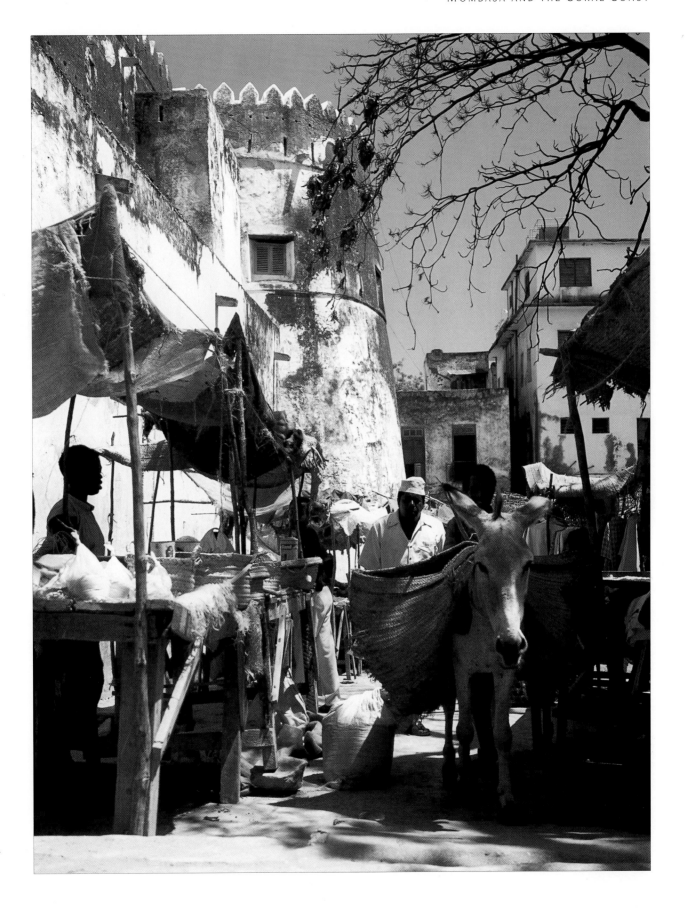

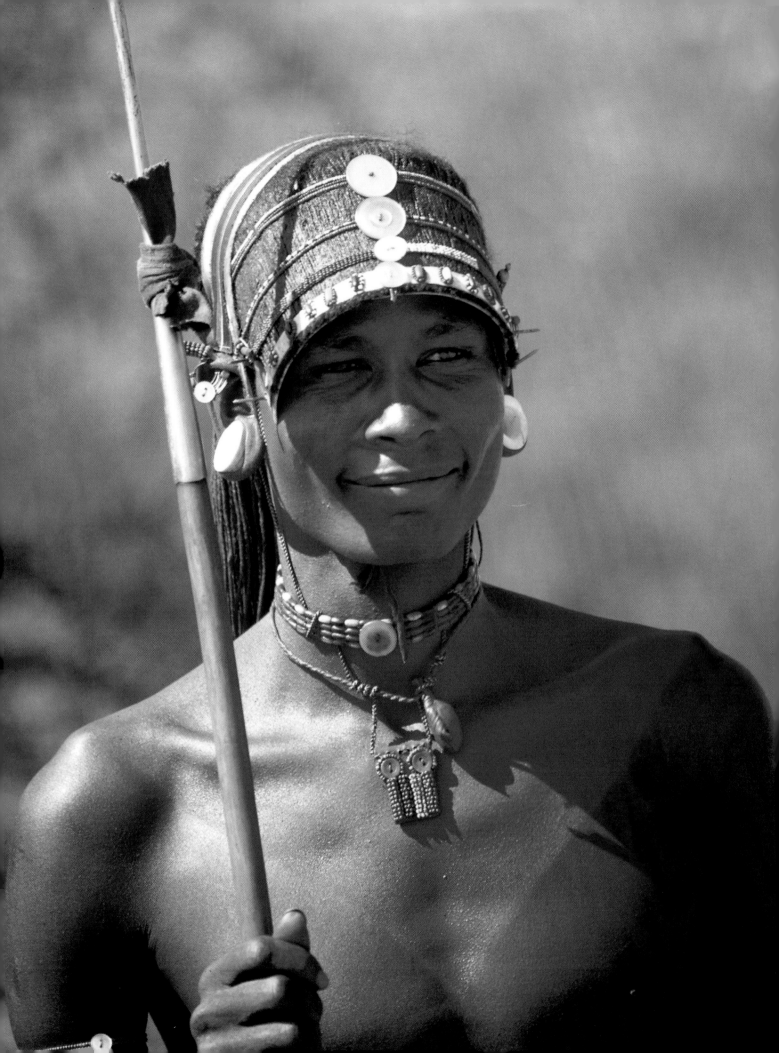

SAMBURU AND BUFFALO SPRINGS

Above: *The striped ground squirrel.*
Opposite: *A Samburu warrior in traditional dress.*

To the north of Mount Kenya and west of the great north road to Ethiopia are Kenya's most popular northern game reserves, Samburu and Buffalo Springs, adjacent to each other and divided only by the northern Ewaso Ngiro River. This low-lying country is at the southern tip of the sparsely populated and almost arid desert that forms the NFD, or Northern Frontier District. Much of the reserve is covered in thorny scrub, acacia trees and dry grasslands, while along the banks of the river doum palm trees grow.

This area is the best for seeing Grevy's zebra, reticulated giraffe, beisa oryx and gerenuk, all dry country animals that are not found further south. Grevy's zebra are easily distinguished from the common or Burchell's zebra by their much narrower stripes and large ears. The reticulated giraffe is the most handsome of Kenya's three varieties, with straight-edged dark brown patches. The gerenuk, when standing on all four feet, seems just like another antelope, with a disproportionate long neck. But its peculiarity is browsing on leaves that other antelopes cannot reach, and to do this it stands on its hind legs to reach them, at heights of up to seven feet. It has been called the 'giraffe antelope'. Gerenuk do not need to drink, as they obtain all the moisture they need from the leaves that they eat. Elephant are also found along the river, and in times of drought they can be seen digging for water in the dry sandy *luggas* or river beds.

Birdlife in this northern area is spectacular, and boasts specialities such as the Orange-bellied Parrot, the Red-billed Buffalo Weaver, the Bearded Vulture and the Pygmy Falcon. On the other side of the main north road, and also sharing the same river, is a small, newly established reserve known as Shaba, after the mountain of that name. A colony of Ruppell's Vultures nests high on the rocky ledges of Shaba Mountain.

The Samburu people of this northern area are closely related to the Maasai, and speak the same language, Maa. They too are cattle-owning pastoralists, and are nomadic. Though not naturally aggressive, the Samburu are fearless fighters and many of them enlisted with the British forces during World War II.

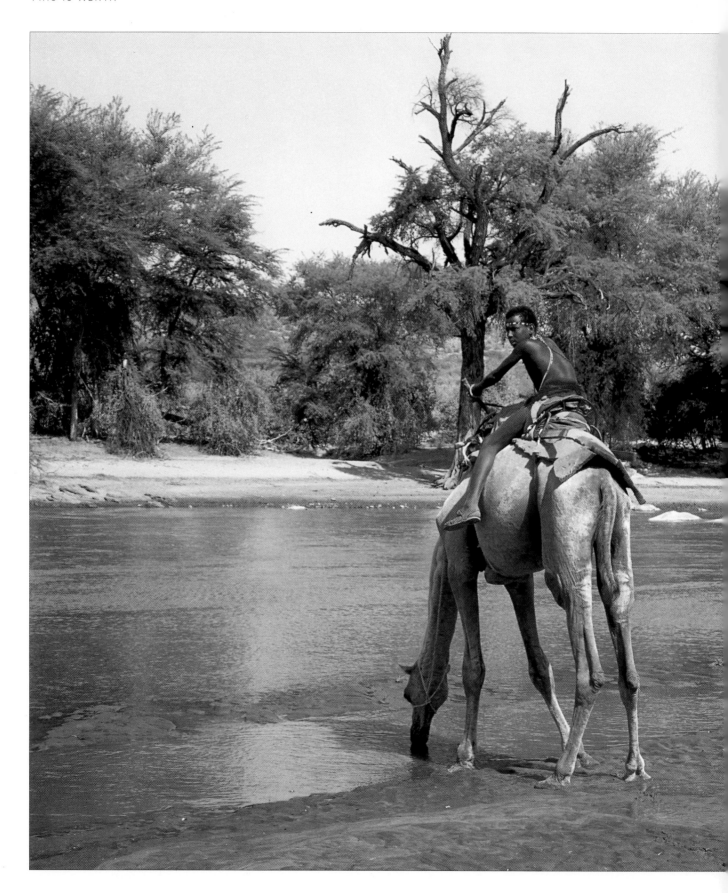

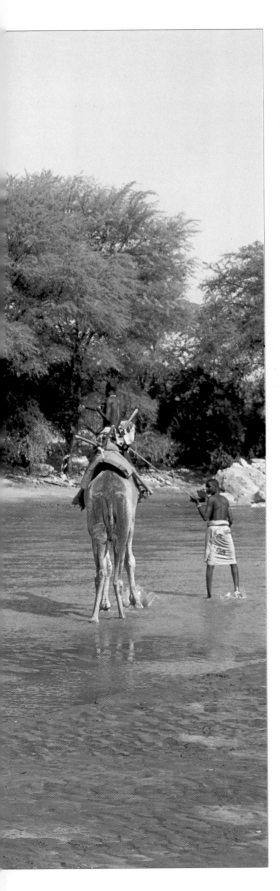

Left: *The Ewaso Ngiro River is the only available source of water for animals in the Samburu, Buffalo Springs and Shaba national reserves. Camels are prized by nomadic peoples as they can survive for long periods without water.*

Below: *When nomadic people, especially the Gabbra or Rendille, move house, they load all their belongings onto their camels. The bow-shaped frames of their houses form a half crescent, and all smaller goods are loaded inside the curve.*

Bottom: *The tourist camps in the Samburu National Reserve are constructed economically using local materials, such as the doum palm. Palm leaves are used for thatch and plaited or woven to make furniture such as beds and chairs.*

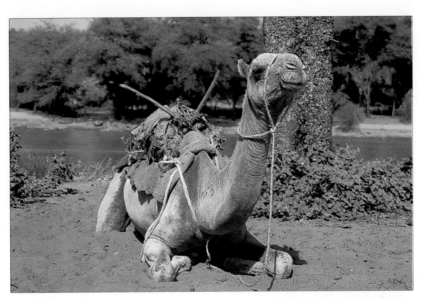

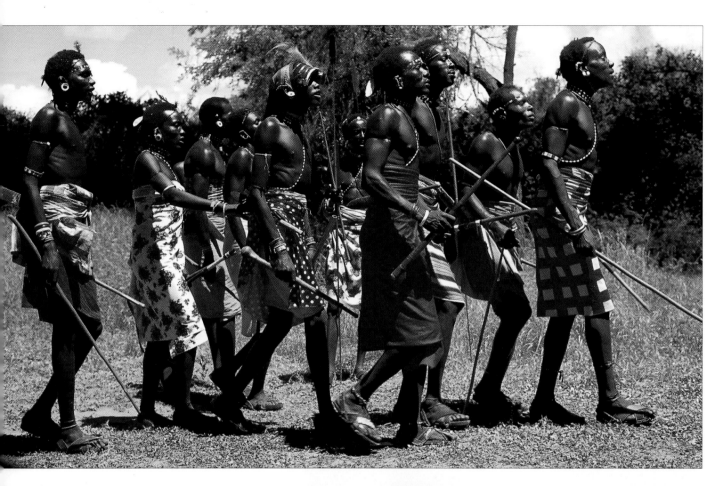

Above: *The Samburu people hold initiation ceremonies for their young* moran *every few years, after which the boys are divided into 'age sets', each group being given a name and consisting of boys of a similar age.*

Right: *Like their Maasai cousins, the Samburu men love to dance. Young girls are always impressed by the* moran *who can jump the highest.*

Opposite: *Young Samburu girls are allowed to take lovers among the* moran, *and to accept gifts such as necklaces or beads. However, rules are strict and if a girl becomes pregnant, the pair is disgraced and the two are forbidden ever to marry.*

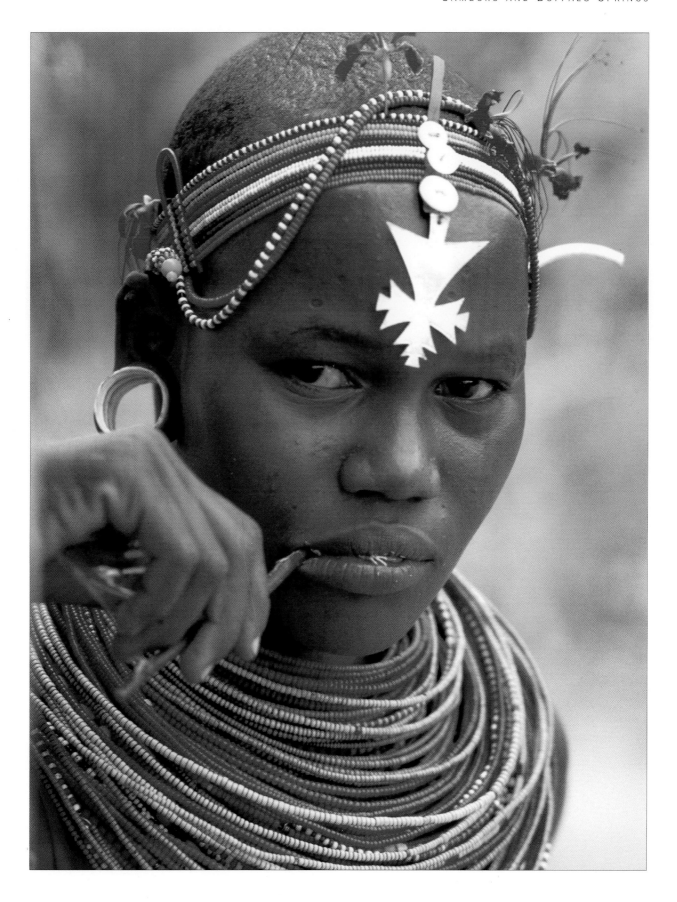

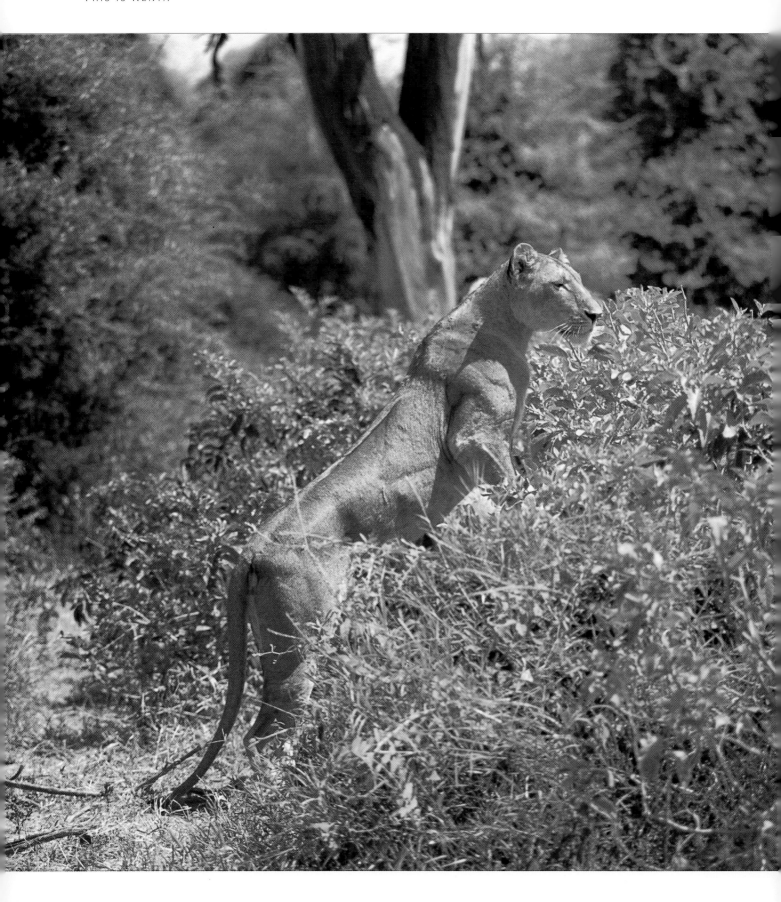

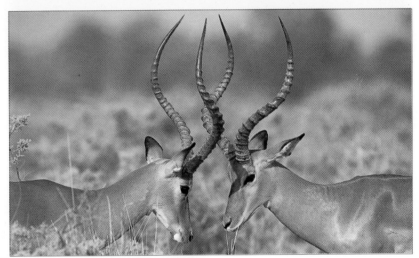

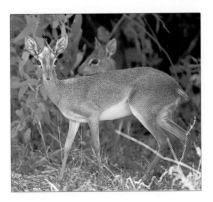

Left: Lionesses form the basis of a pride and do most of the hunting, usually working as a team. Their favoured prey is wildebeest, hartebeest, zebra and gazelles.

Above: The territorial impala ram, when confronted by another male, will adopt an erect posture and present its forehead for 'inspection'. The rival will either drop its head submissively, or respond in kind, indicating that it is challenging the dominant ram's superiority.
Left: Dik-diks mate for life, and are most often found in pairs, seeking cover under small bushes and browsing for green shoots.
Top: Larsen's Camp, a Block Hotels establishment, lies in tranquil surroundings under acacia trees on the banks of the northern Ewaso Ngiro River in Samburu.

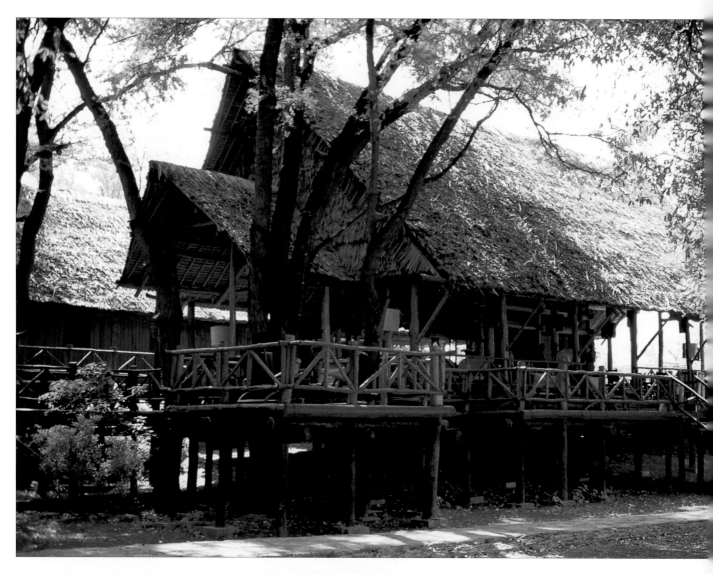

Above and left: *Samburu Intrepids Club, discreetly hidden among the riverine trees, offers both space and comfort to its guests. Tented camps can be every bit as luxurious as lodges, and offer the ambience of the safari of years gone by. The private tented safari is based on the old hunting-camp routine. Guests camp under the stars without the discomforts or the dangers that usually accompany 'roughing it'.*

Above: Vervet monkeys eat the petals of flowering shrubs as well as succulent leaves, seed pods and any available fruit. These little monkeys are fearless and cheeky, and their characteristic black faces bear intelligent expressions.

Left: The Orange-bellied Parrot is conspicuous both by its colouring and its screeching call, and is common in dry areas, especially where there are baobab trees.

Above: The beisa oryx is a northern, dry-country resident. Further south it is replaced by the fringe-eared oryx, and both are related to the southern African gemsbok.

Left: A rarely seen resident of this area, the cheetah faces stiff competition from lion, leopard and hyena. Cheetah have relinquished strength and power in favour of speed, and have little chance of defending their prey from a more powerful predator. A cheetah may take a while to recover from its chase, during which time it is vulnerable to thieving competitors.

Opposite: Giraffe have long prehensile tongues which enable them to strip leaves and shoots from acacia branches without being injured by thorns. As they are residents of the dry country, reticulated giraffe are only found in the north of Kenya.

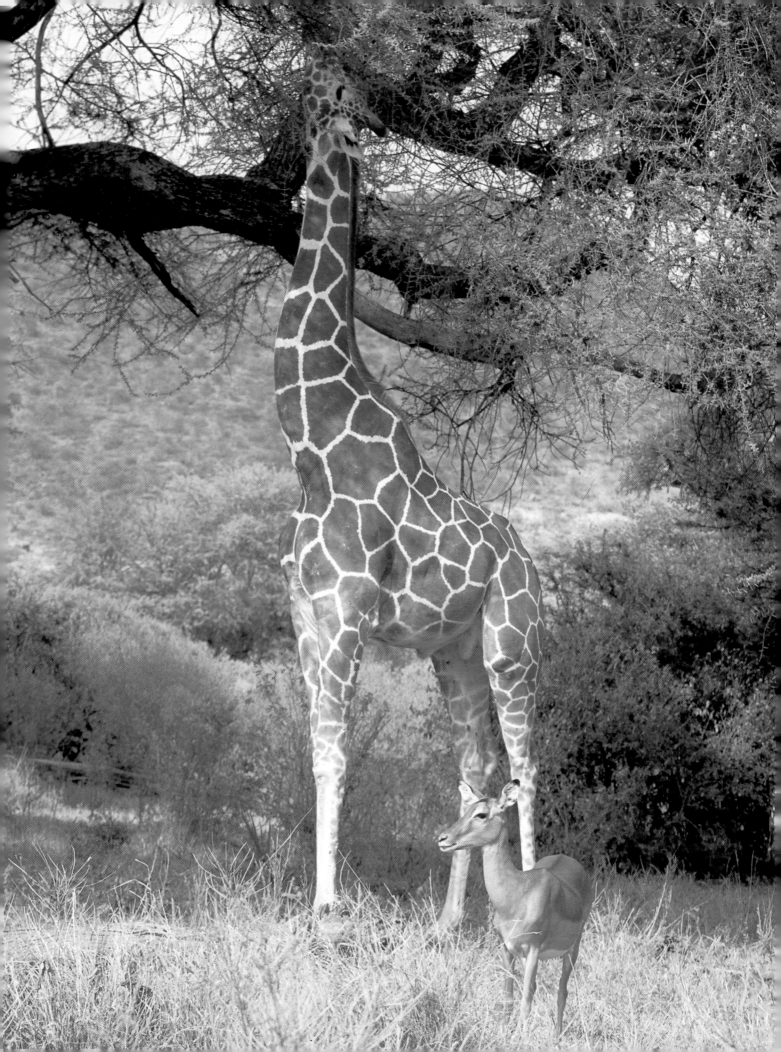

Above: Tourist minibuses circle round some lions resting on the edge of a dried-up river bed. Visitors are requested not to get too close, nor to harass animals trying to stalk or hunt prey. While animals in all the parks and reserves are accustomed to vehicles, they should be spared the pressure of being crowded in.

Right: The elegant gerenuk stands on its hind legs to reach succulent acacia leaves that are too high for other antelope. It has a feeding level of its own, with only giraffe reaching still higher for food.

Opposite: Elephants in this area forage near the river. They eat prodigious quantities of vegetation, and need to drink every day. Herds generally comprise groups of females and young, led by the dominant matriarch. Males form bachelor herds, or wander alone.

Right: The graceful impala is one of the most beautiful of the antelopes with its graceful lyre-shaped horns. The dominant male will oversee a harem of females, keeping watch and defending them against rival males. The other males will form their own bachelor herd, never grazing far away.

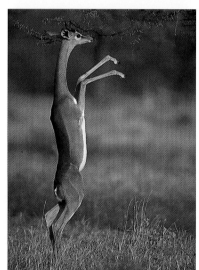

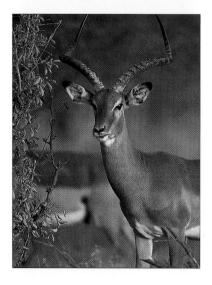

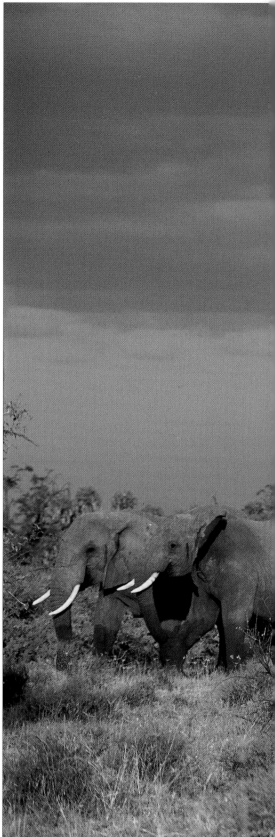

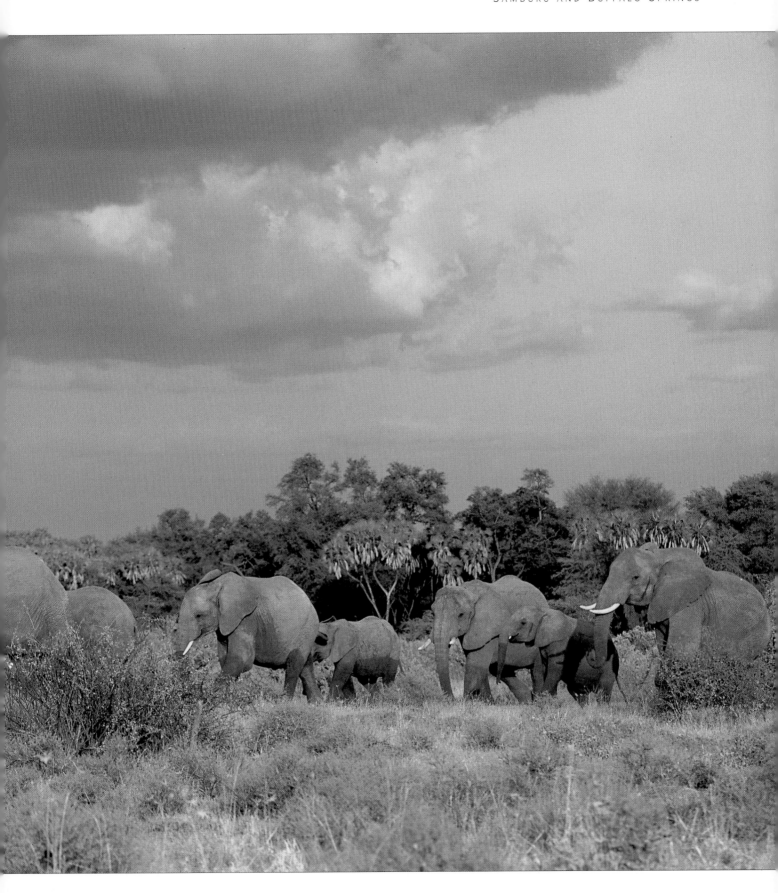

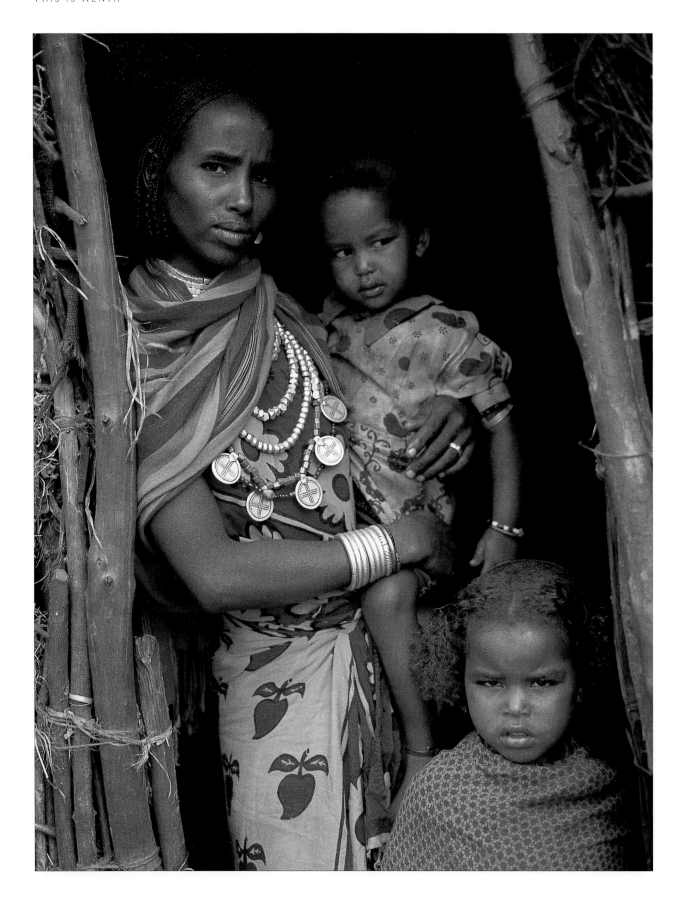

Left: Rendille water buckets were traditionally made from giraffe hide, but today are often made from camel skin. Other containers are very often handwoven from plant fibres.

Opposite: A Boran mother and child. The Boran people keep cattle and goats, and will wander in search of pasture when there has been rain. During dry periods they will stay close to known sources of water.

Below left: The candelabra tree is a succulent euphorbia that grows in arid country. The euphorbia forest at Lake Nakuru National Park is one of the largest in Africa.

Below right: The Lilac-breasted Roller is one of the most eye-catching of the rollers, so named because of the spectacular aerial twists and turns they perform during their courtship displays.

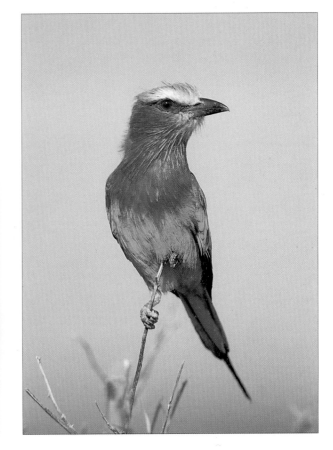

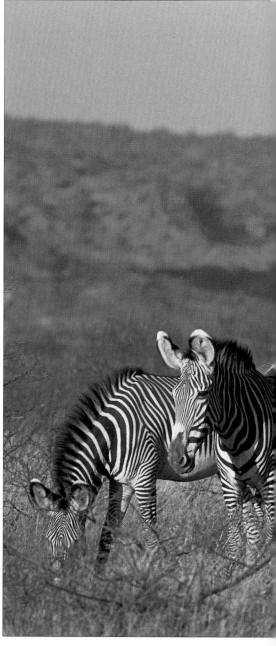

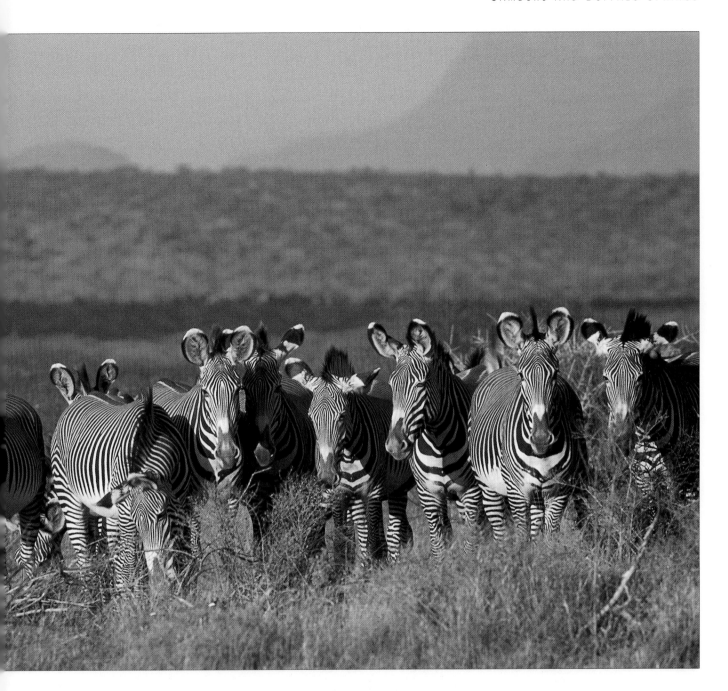

Opposite top: The Tana River forms the southern boundary of Meru National Park. Adamson's Falls were named after George Adamson, who spent many years across the river in the Kora National Reserve.

Opposite bottom: Dramatic rocky outcrops are common in the Shaba National Reserve, the largest of which is Mount Shaba. The reserve is less crowded than others.

Above: Grevy's zebra, with their large ears and narrow stripes, are characteristic of these northern areas, and are found in Samburu, Marsabit and Meru National Park. They do not occur naturally south of the Tana River. Their range goes north into Ethiopia, and the Kenyan zebra population can all but disappear at certain times of the year during seasonal migrations.

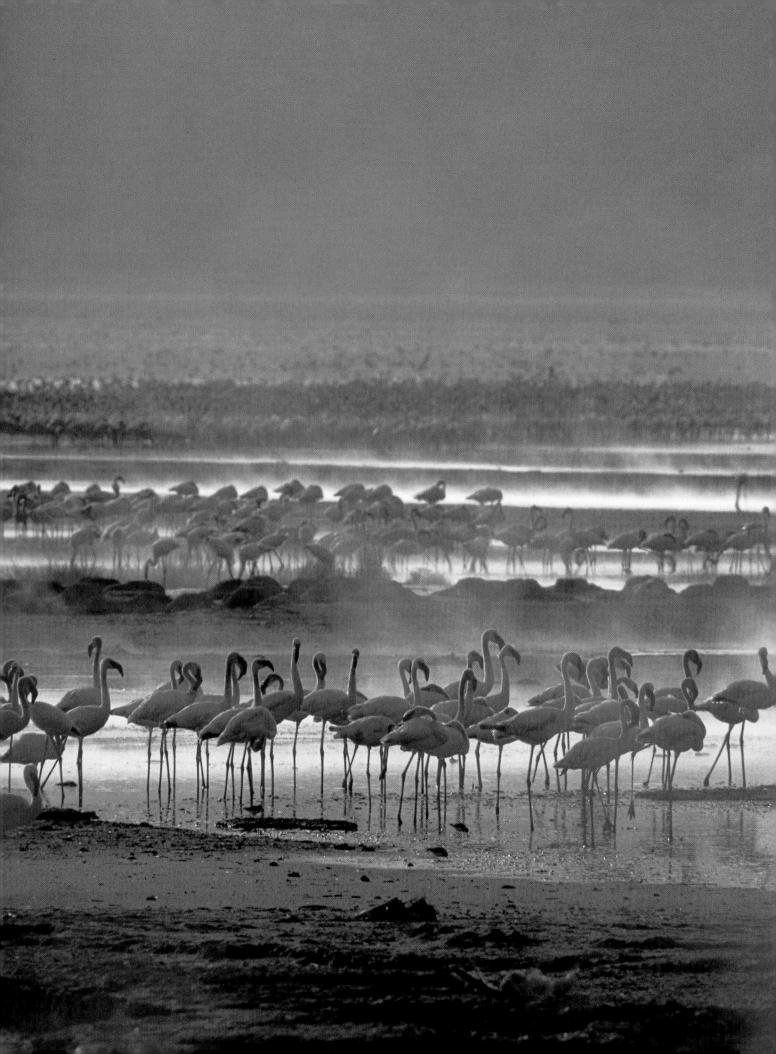

GREAT RIFT VALLEY AND LAKE VICTORIA

Above: *A hot-water geyser at Lake Bogoria.*
Opposite: *Flamingos congregate at Lake Bogoria.*

The dramatic scar down the eastern side of Africa known as the Great Rift Valley, is a microcosm of the whole African continent. Down the length of the Red Sea, through the Horn and the highlands of East Africa it stretches like a river bed, flowing through deserts and mountains, gorges and forests.

Once there were large lakes all over the valley floor – not many remain and only a few are completely fresh. These shallow lakes were formed in depressions on the valley floor. Their salinity varies, the most caustic being Lake Magadi, on the Tanzanian border. The levels of the lakes have varied too and there is evidence to suggest that they are becoming shallower over time. In some cases this is due to an increase in both agricultural and human water use, or the creation of dams for hydroelectric purposes. The largest, Lake Turkana, used to cover a much bigger area, and early man camped around its shores at Koobi Fora. The lake at Olorgesailie has long since dried up, leaving a ring of ancient hominid tools, another rich archaeological site, around its former edge. Rocky outcrops and volcanic cones lie scattered on the floor of the valley.

The eastern and western edges of the Kenyan part of the Rift Valley vary in their steepness. At times the drop is daunting, a sheer vertical descent of two or three thousand feet. In other places it is more gentle as a result of subsequent faulting followed by centuries of erosion by wind and weather, giving a gradual rounded descent to the floor below.

Cooler temperatures at the top of the high escarpments contrast dramatically with those on the dusty floor of the valley. The heat is particularly intense in the lowest areas where the water of the lakes is so caustic that it causes damage to the skin. In such places, even a gentle breeze feels like the opening of an oven door, and the human body feels parched and yearns for humidity. Dust devils gather speed, caught by winds that dance and spin across the plains. The freshwater lakes bring relief – Victoria, to the west of the Kenyan rift, Baringo and Naivasha with their prolific birdlife. The Rift Valley is a magical place, full of contrasts and scenic grandeur.

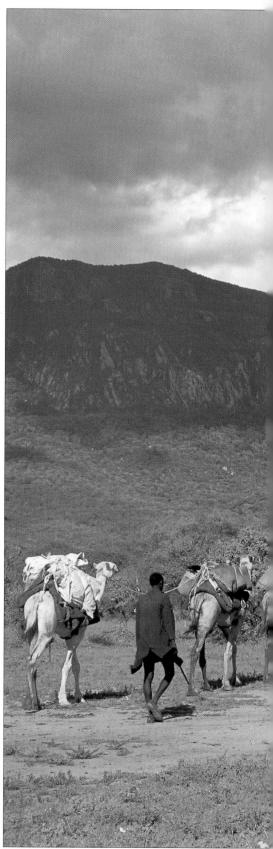

Above: The prehistoric site at Olorgesailie is managed by the National Museums of Kenya. Although it was once a lake, the site is now hot and dry, and the stone tools (particularly Aechulian hand axes) excavated by the Leakeys are on display, some in a small museum and others in situ.

Top: The road winding down the escarpment into the Rift Valley was built by Italian prisoners of war during their imprisonment in World War II.

Right: A safari of camels skirts the base of Namanga Mountain on the border between Kenya and Tanzania. Camel safaris are increasing in popularity with those who wish to experience the African outdoors first-hand. Safari-goers ride or walk beside trained camels carrying light equipment and food supplies.

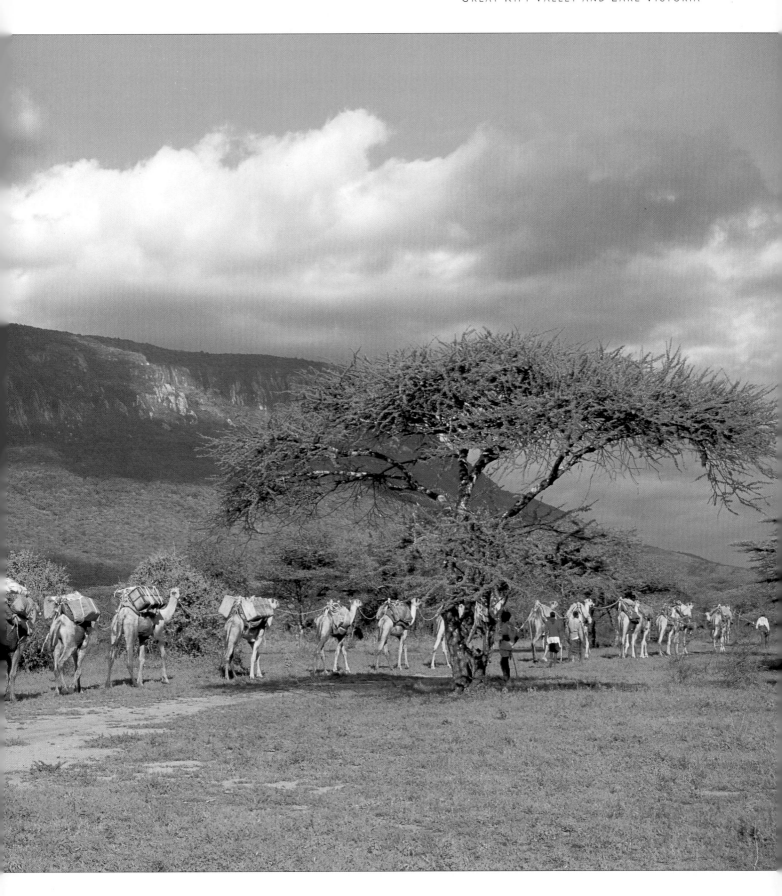

Above: *Salt crystals, blown by wind into jagged peaks, give the waters of Lake Magadi a sinister appearance. Yet there are freshwater streams entering the lake, and it is a place particularly rich in birdlife. One species of fish, of the cichlid family, survives in the hot water springs on the eastern shore of the lake.*
Left: *The pinkish soda crystals, or trona, on the surface of Lake Magadi regenerate quickly, and have been commercially harvested by the Magadi Soda Company for decades.*

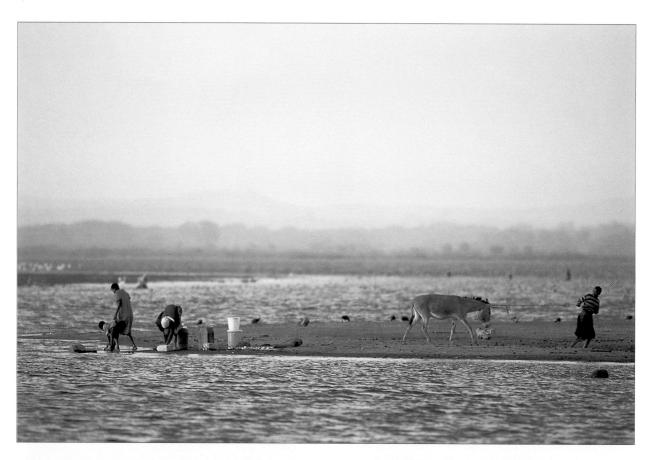

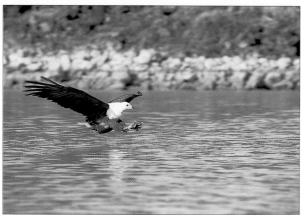

Above: *The African Fish Eagle, with its haunting and far carrying cry, catches fish while still flying and carries them to a perch to eat them.*
Top: *The sanctuary of Crescent Island, situated in the middle of Lake Naivasha, is a haven for birds and animals, including hippo who spend much of their time in the shallow crater lake.*

Above right: *The expansive and shady lawns of the Lake Naivasha Club, a Block Hotels property, reach down to the lake shore with its private jetty. More than 400 species of birds have been recorded here, and many of them have become extremely tame, especially on a Sunday when guests have their buffet-style luncheon in the garden.*

Opposite: *The soaring cliffs of the Ol Jorowa Gorge, in Hell's Gate National Park, were once the nesting site of the Lammergeier, or Bearded Vulture. Disturbance by rock climbers caused the birds to leave the area, and they are now increasingly rare. These magnificent vultures can also be found in the highland areas around Mount Elgon and Mount Kenya.*

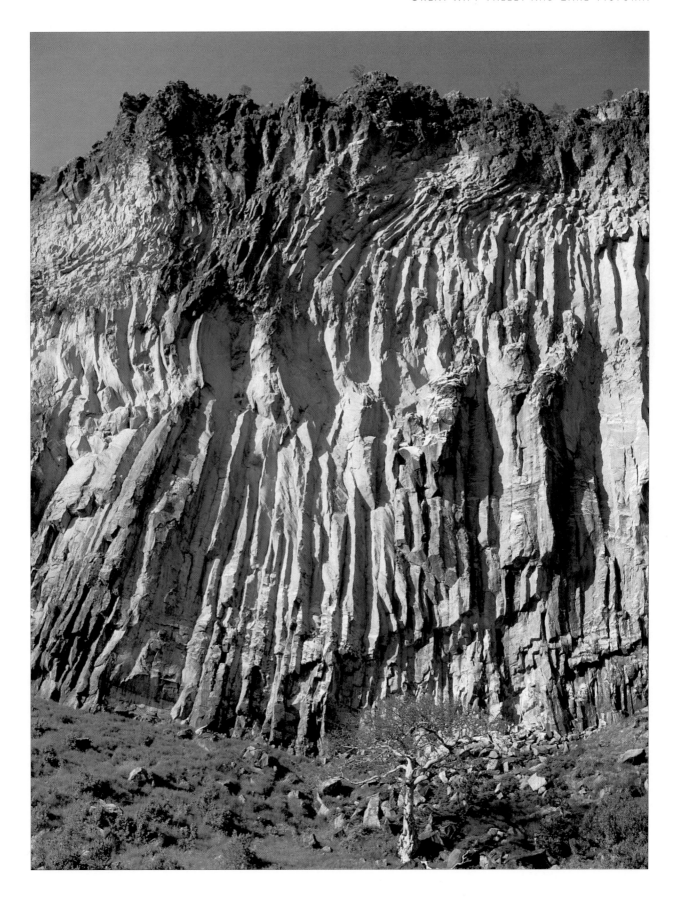

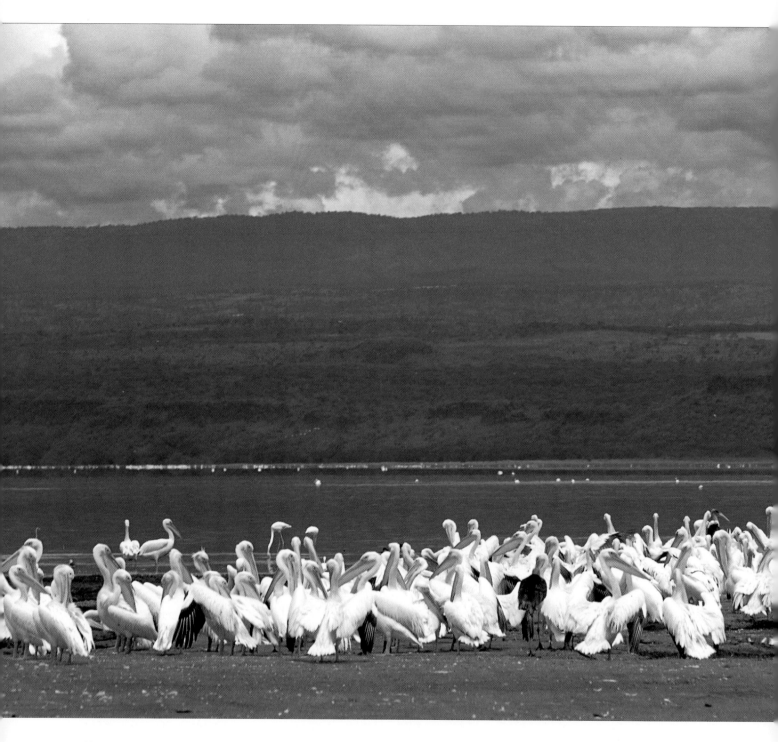

Above: The sight of large flocks of White Pelicans settled on the shore of Lake Nakuru are almost as impressive as the sight of a million flamingos. The pelicans find ample supplies of fish in the lake, and occasionally fall prey to leopard.

Opposite top: Jackals are fearless and opportunistic, and will challenge young waterbuck despite the large difference in size between the two.
Opposite centre: Rothschild's giraffe occur naturally only in the Lake Nakuru National Park.

Opposite bottom: Waterbuck are so numerous in the Lake Nakuru National Park that lions were introduced as a means of controlling their numbers, without much success. It has become necessary to control the population by shooting the buck.

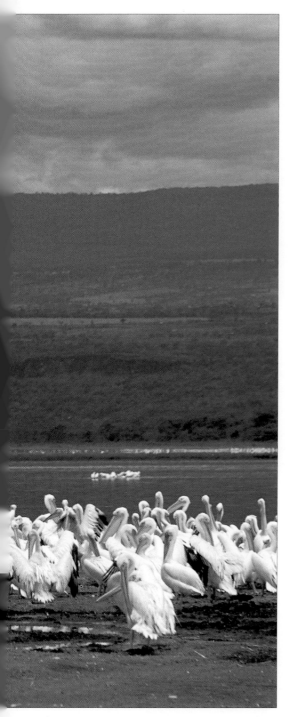

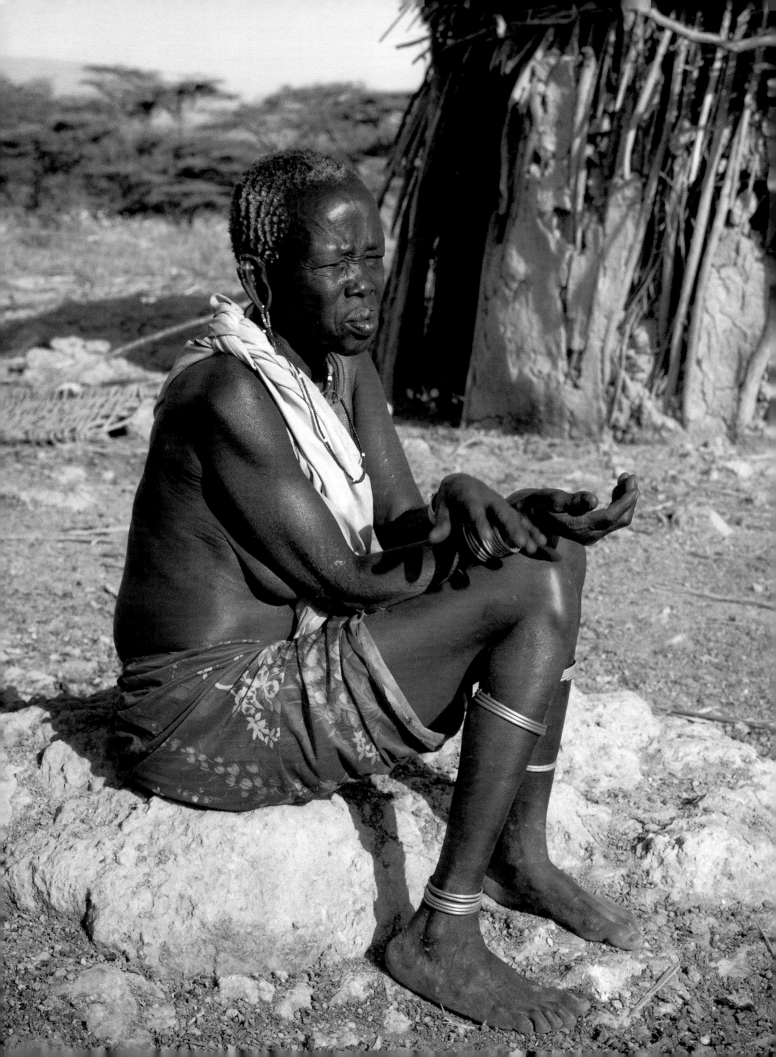

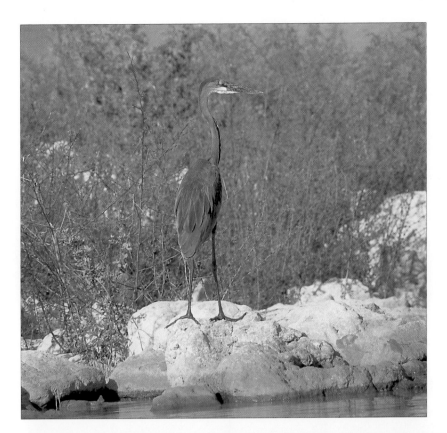

Opposite: The Njemps or Ilchamus live on the shores of Lake Baringo. This small group of people, previously pastoralists but now fishermen and agriculturalists, are related to the Maasai and the Samburu and speak the same language.

Left: The largest of the African herons, the Goliath Heron, is common around Lake Baringo, and from a boat a nesting colony can be seen on the cliffs of Gibraltar Island at the southern end of the lake.

Below: Although dangerous to humans in other parts of the country, the crocodiles at Lake Baringo have a reputation for being placid and harmless, stoically putting up with water-skiers and fishermen.

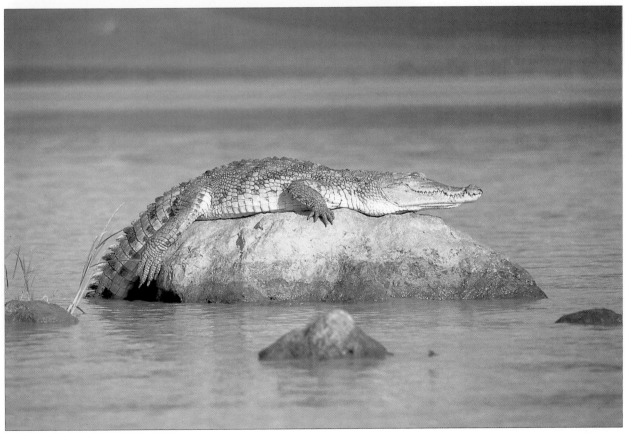

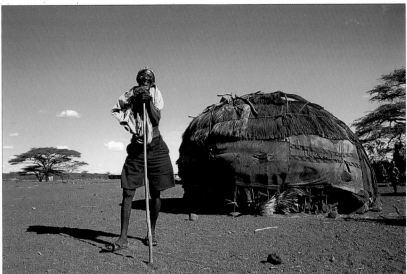

Above: *Catholic missionaries in remote places have become more than 'rescuers of lost souls', and will quite likely keep a supply of motor and aviation fuel, and fresh water for the few travellers who pass their way. They also grow fruit and vegetables.*

Left: *Lake Turkana was formerly called Lake Rudolf, and is universally known as the 'Jade Sea'. The waters of this vast lake seem to change colour as the light and winds change.*

Top: *The Gabbra graze their camels, cattle, goats and sheep over a wide area, as far east as Marsabit and north to the Ethiopian border. Like the Rendille, their houses are made of fibre mats and skins laid over a basic framework of thin sticks.*

Right: *Close to their Ugandan roots, the Pokot people live in villages on the slopes of the fertile Cherangani Hills. The Pokot are a Kalenjin people, but are influenced by the Turkana.*

Opposite top: *A forest trail through the shrinking Kakamega Forest is often followed by local residents and visiting bird-watchers alike. Both agriculture and human settlement are encroaching on the boundaries of this forest reserve.*

Opposite centre: *The busy market town of Tambach, not far from Kabarnet and the Kerio Valley, has little claim to national fame, but is an important checkpoint along the route of the Safari Motor Rally.*

Opposite bottom: *The game of bao, which is played on a wooden or stone board, is similar to backgammon, and demands considerable skill. The aim is to 'take' your opponent's counters, usually small stones or beans.*

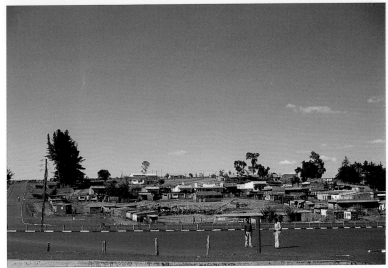

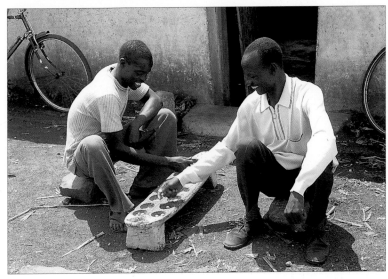

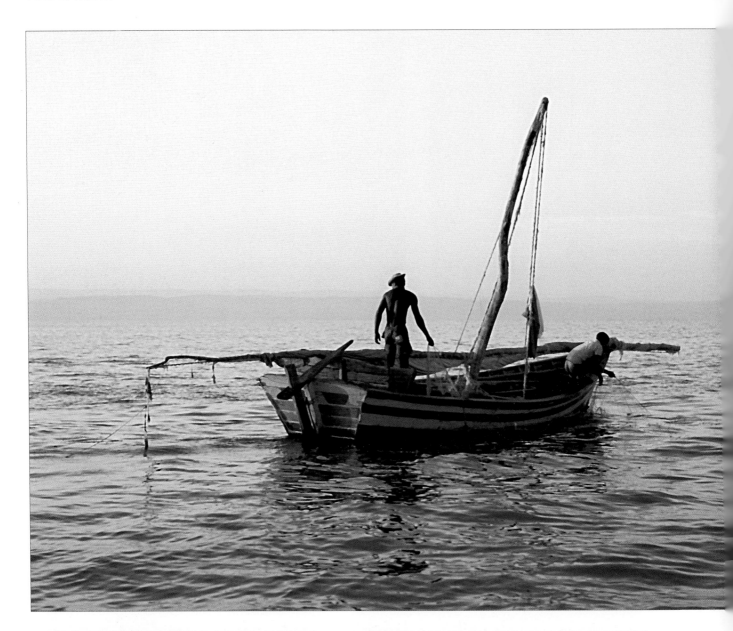

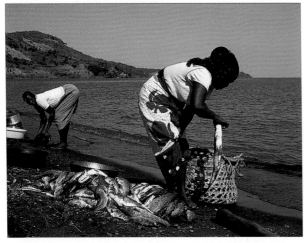

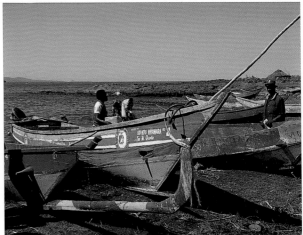

Left: *Luo fishermen on Lake Victoria keep some fish for local consumption, or sell their catch to commercial packing companies who freeze it for sale all over the country.*

Opposite bottom left: *Luo women remain on shore to inspect the catch, and prepare and clean it. The catch usually consists of Nile perch or tilapia, but the local preference and speciality is a small sardine-like fish called* omena, *which is dried in the sun and serves as an important source of protein.*

Opposite bottom right: *Luo fishing boats are always colourful, and many of them have an eye painted on the prow, to ward off evil spirits and bring good luck to the fishermen.*

Below and bottom: *The luxury island resort of Mfangano Island Camp was established as a fishing camp. Visitors are flown in light aircraft from the Masai Mara National Reserve, either for the day or for an overnight stay. Boats take them out fishing for Nile Perch, which can weigh up to 200 kilograms.*

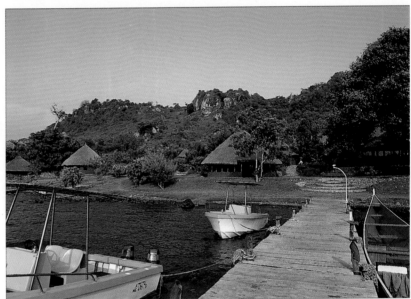

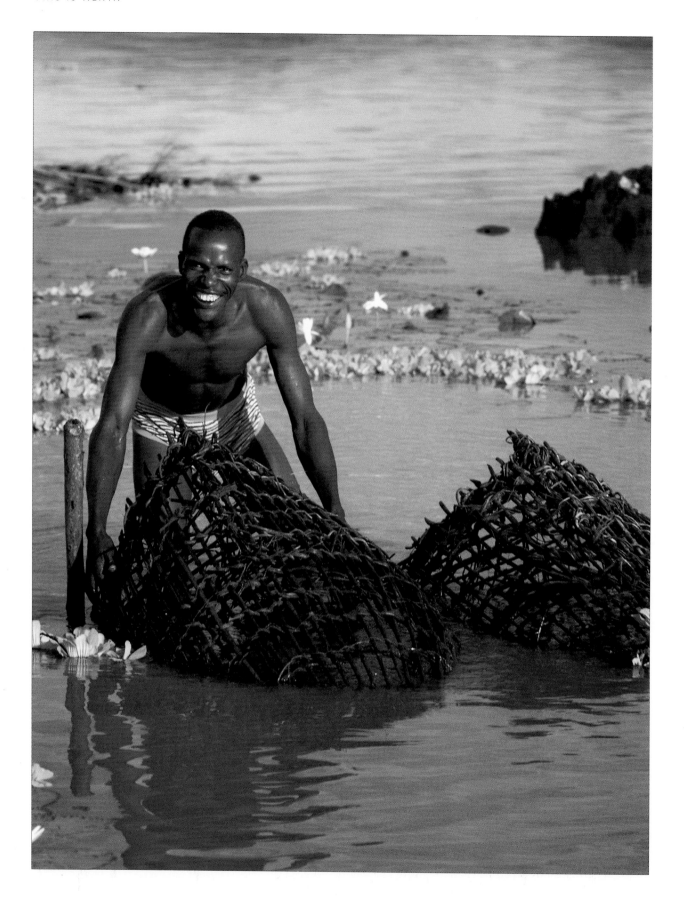

Above: The International Centre for Insect Physiology and Ecology has established a research centre at Mbita Point on the shores of Lake Victoria. This well-established facility is staffed by both Kenyan and international scientists.

Right: Homa Bay, on a particularly scenic part of the shore of Lake Victoria, was a popular port in the days when a luxury steamer cruised around the lake. It is an administrative centre and fishing town, noted for its crocodiles.

Opposite: Handwoven basket traps, often laid at the mouth of a stream entering the lake, are one of the principal forms of fishing by the Luo. The traps are laid to form a maze, often in conjunction with a fence made from papyrus stems.

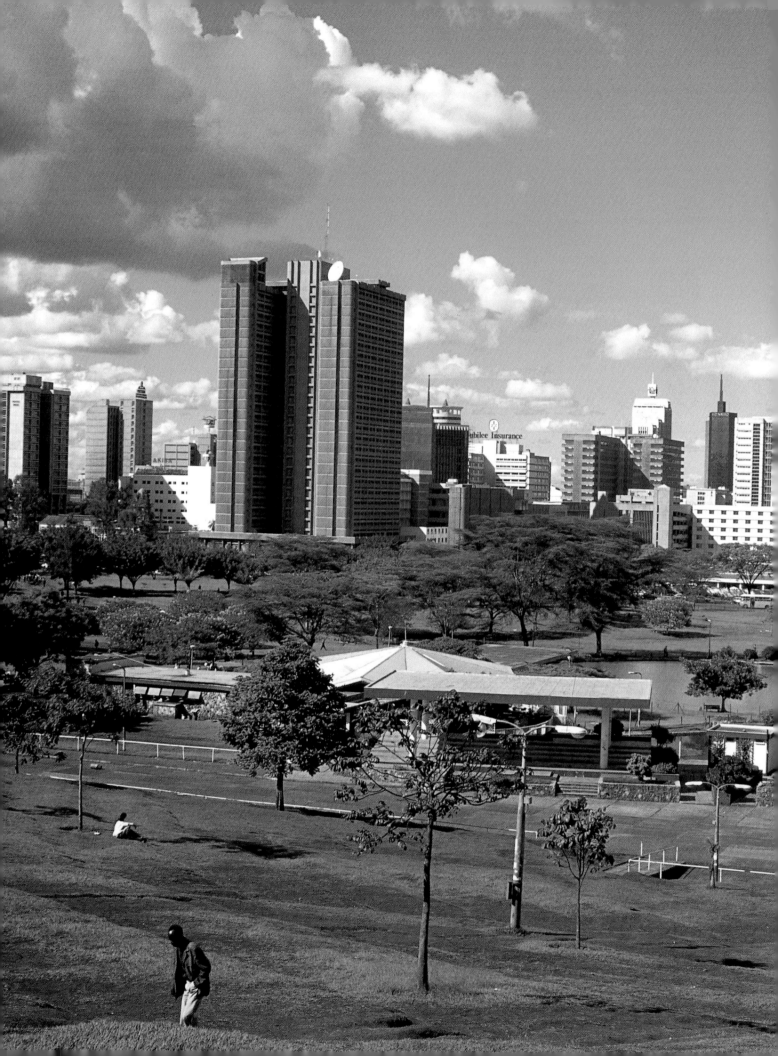

NAIROBI AND CENTRAL UPLANDS

Above: *The head doorman at the Norfolk Hotel.*
Opposite: *The Nairobi city skyline.*

The capital city of Nairobi grew from a sprawling compound of railway workers who were delayed waiting for supplies to arrive from the coast. Being swampland, the site was not the most suitable. Many of today's modern builders have had problems sealing off underground car parks, but the city has nevertheless expanded to reach a population of nearly two million people. Nairobi is found approximately halfway along both road and railway between the coast and Lake Victoria, and so is an important communications centre. The Jomo Kenyatta International Airport, situated 24 kilometres to the east of the city, links travellers with destinations all over the continent.

Nairobi is a garden city, and its original planners took great care to make the thoroughfares and parks attractive. Bougainvillea in all its riotous colours is planted along the main Uhuru Highway, interspersed with colourful flowering trees and many palm trees. Traffic roundabouts are planted with giant succulents and many varieties of aloe, often in rockeries to discourage unwanted vehicles. The main street, Kenyatta Avenue, was named after the country's first president and is lined with jacaranda trees.

The residential suburbs sprawl around the north and west of the city, while the southeast is mostly taken up by the large, untidy, noisy, fume-filled industrial area. Within the city boundaries too is the Nairobi National Park, about 20 minutes' drive from the city centre. Only 30 kilometres from one end to the other, the park is fenced around the western, northern and eastern edges, but the southern boundary is open to allow a corridor for the passage of migratory animals. There are more than 50 black rhinos in this park.

Nairobi's altitude of approximately 1 800 metres gives it an equitable climate for most of the year. Further west, towards the old 'white highlands', the country is higher, and cooler, rising to nearly 2 500 metres before plunging precipitously down the escarpment which is the eastern wall of the Rift Valley. To the south and east, the Athi and Kitengela plains stretch far into northern Tanzania. Northwards, the ground rises towards the fertile foothills of Kenya's highest mountain, Mount Kenya.

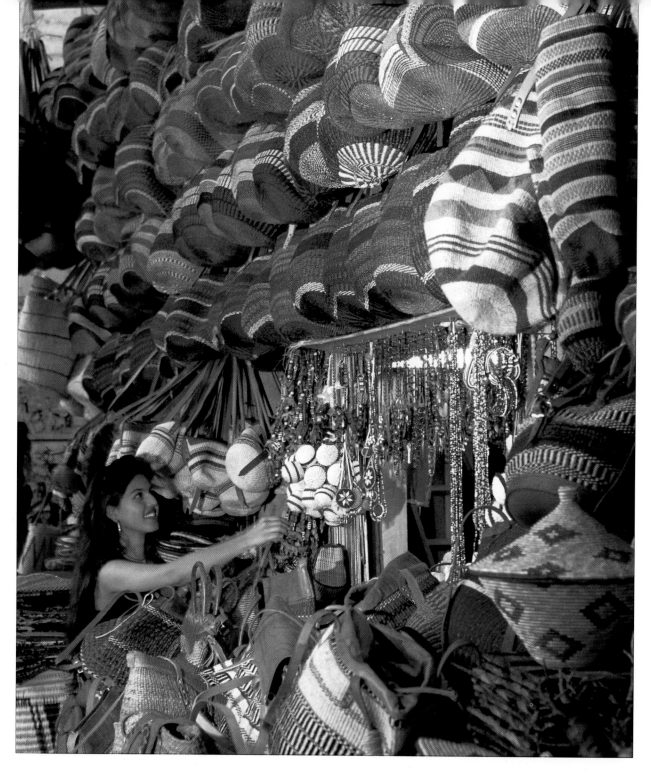

Above, opposite centre and opposite bottom: The high ceiling of the Nairobi city market covers a wide assortment of tropical fruits and vegetables, as well as carvings and curios. Vendors will go to great lengths to attract customers to their loaded stalls, shouting and whistling to gain attention. One section of the market sells cut flowers, delivered daily. Prices are incredibly cheap, but the sellers will still accept a little friendly bargaining.

Opposite top right: Horse-racing at the Ngong Road Racecourse, only minutes from the city centre, is a curious relic of British colonialism. Yet Kenyans crowd the railings every Sunday. Race days such as the Kenya Derby or the Kenya Oaks are also an opportunity for the fashion-conscious to show off their finest clothes.

Opposite top left: The Uhuru monument in the Uhuru Gardens commemorates Kenya's independence from colonial administration, attained on 12 December 1963.

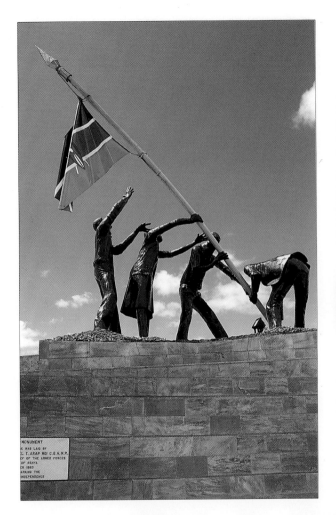

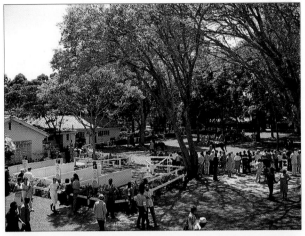

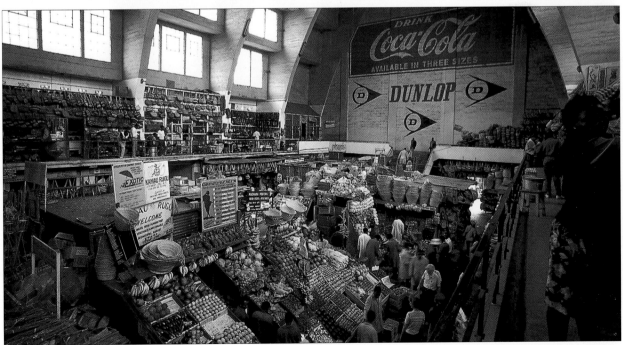

Above: The Thorn Tree Café is part of the New Stanley Hotel and is one of the most famous meeting places in the world. It is said that if you sit at this pavement café long enough, you will be sure to meet a friend from some other part of the world. A noticeboard built around the tree itself is full of messages.

Above left: Kenyans love well-cooked meat, which is known as nyama choma (literally translated as 'burnt meat'), and will consume vast quantities whenever possible. The most successful and popular restaurant in Nairobi is the Carnivore, part of the Tamarind Group. Not only will the diner be able to order beef, chicken, mutton, and pork, but may also sample giraffe, gazelle, crocodile, hartebeest and zebra. This game meat is farmed commercially.

Opposite: At the 'Bomas of Kenya' village just outside Nairobi, dancers and singers live in the authentic surroundings of their culture. This is designed as a demonstration cultural centre, so that people can take photographs of traditional life, and be entertained at the same time.

Above: Kenyans, particularly the Kamba people, are expert wood carvers and the city's markets have a vast range of their products. The Gusii people have cornered the market for soapstone carvings, and much talent goes into the making of each piece. Here traditional masks are displayed, and it is possible to have them shipped rather than carrying them as hand baggage.

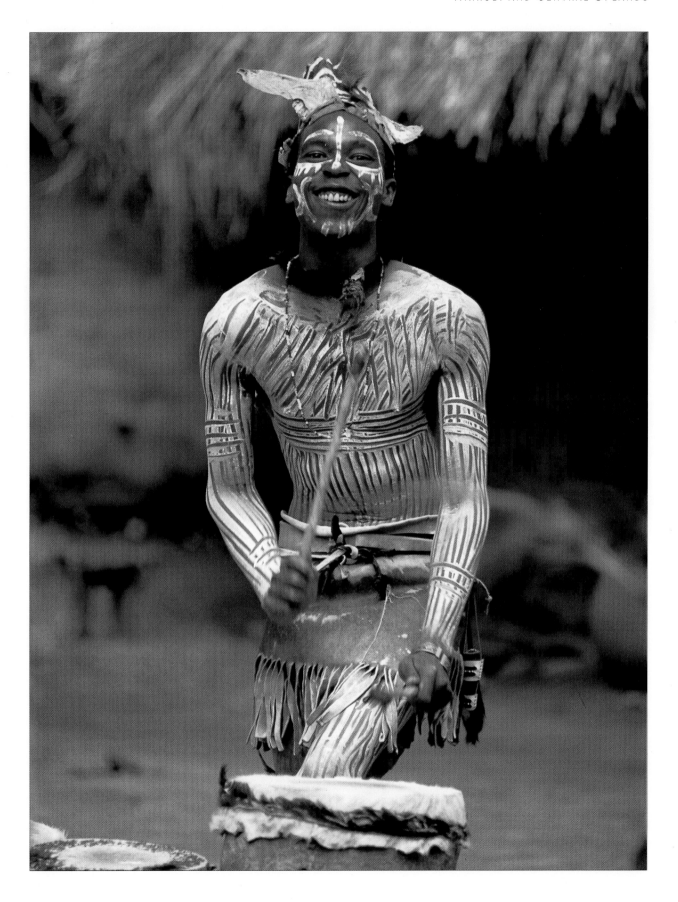

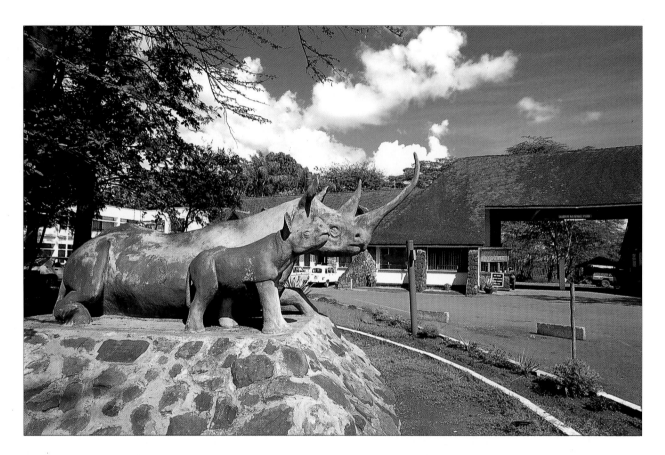

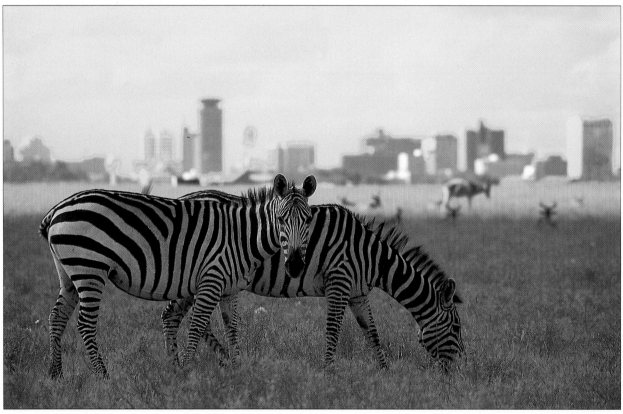

Opposite top: *The headquarters of the Kenya Wildlife Service (KWS) are located at the main entrance to the Nairobi National Park, along the Langata Road. The rhino, sculpted by Terry Matthews, marks the entrance of the KWS Education Department.*

Opposite bottom: *The city skyline, including the circular tower of the Kenyatta International Conference Centre, makes a unique backdrop for photographs of animals taken in the Nairobi National Park.*

Right: *Cape buffalo in herds are not normally aggressive, although they should still be treated with respect. It is the lone male buffalo that can be exceedingly dangerous.*

Below: *An orphaned elephant calf at Daphne Sheldrick's orphanage in the Nairobi National Park. Rangers keep the orphans company 24 hours a day, and the daily mud wallow is followed by playtime, with an assortment of toys.*

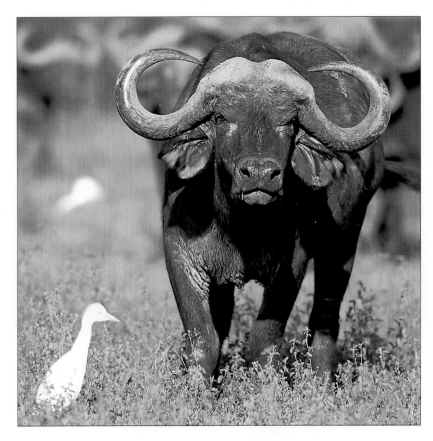

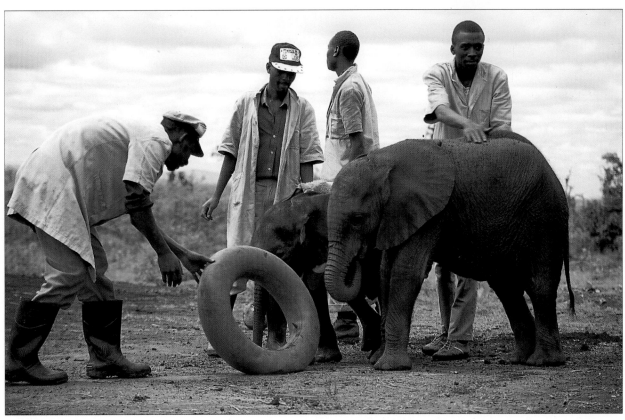

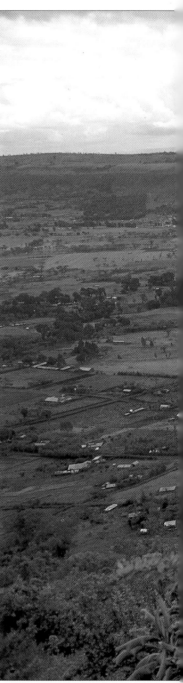

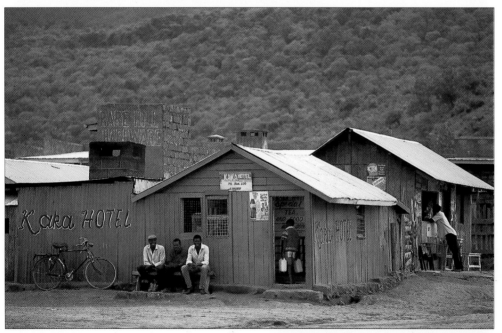

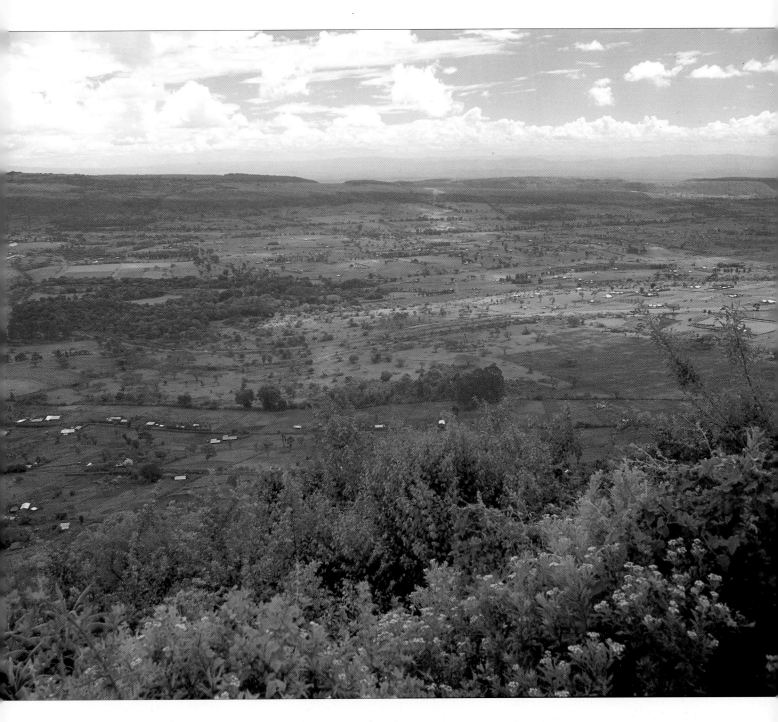

Opposite top: *A speciality of the Kikuyu people, these chairs are made from slim green branches. When the branches dry out, the chairs retain their shape and with the addition of a few cushions can be surprisingly comfortable.*

Opposite centre and bottom: *Buildings made of corrugated iron sheets are common in villages and small towns such as Limuru. Kiosks of this sort sell food and drinks to passers-by, but despite the name do not offer accommodation.*

Above: *The highlands to the west of Nairobi are extremely fertile and smallholdings spread for miles, with individual homesteads growing subsistence crops. The major portion of the country's export crops are produced by smallholders.*

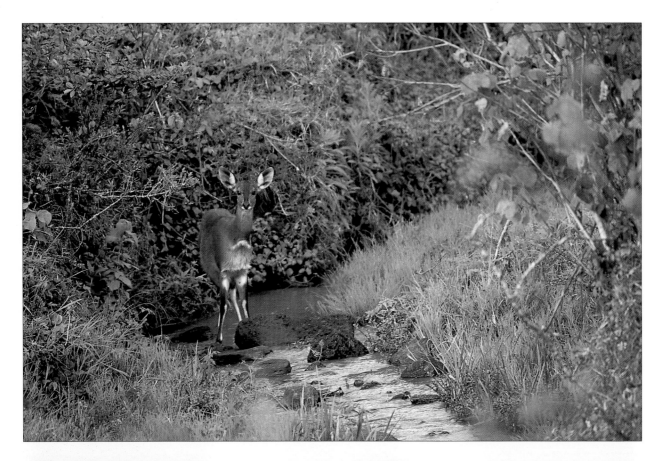

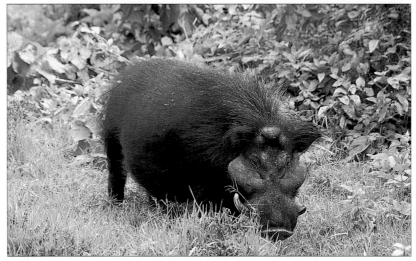

Above: The delicate blooms of the indigenous deciduous Cape chestnut appear in forested areas twice a year, from February to April and again from late August to November. The tree is also cultivated in gardens.

Above: Weighing as much as 135 kilograms, the giant forest hog is the largest of the swines. It feeds from dusk to midnight. The hog's social unit consists of a sow, a boar, and three successive litters.

Top: One of the most graceful of the spiral-horned antelope, the shy bushbuck lives in woodland, near water. The males are darker in colour than the females, but both sexes bear the thin white body stripes.

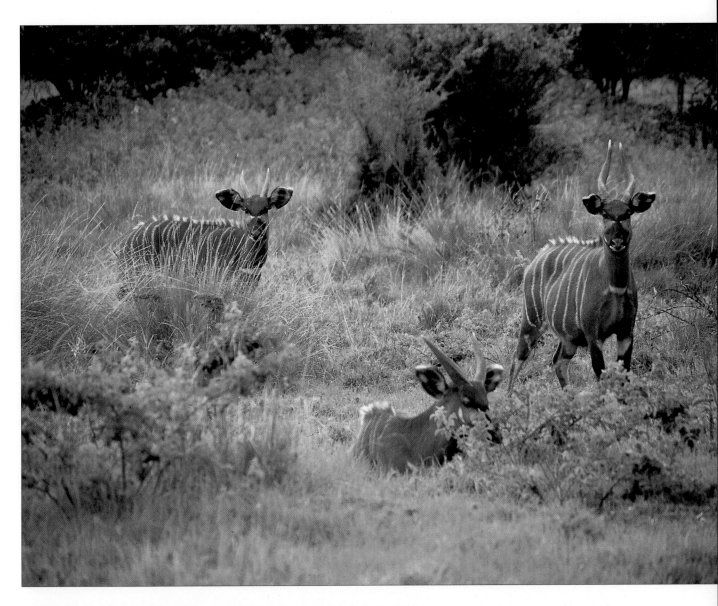

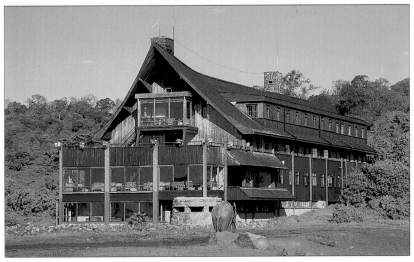

Above: Bongo are only occasionally seen as they are nocturnal and favour the dense thickets and forests of Mount Kenya and the Aberdares. However, they can be spotted when they visit the salt licks and waterholes near the lodges at night.

Left: Built to resemble a 'ship of the forest', The Ark lodge offers luxury night-time game-viewing. An underground viewing room resembling a wartime pillbox enables visitors to watch the activity on the edge of the waterhole at ground level.

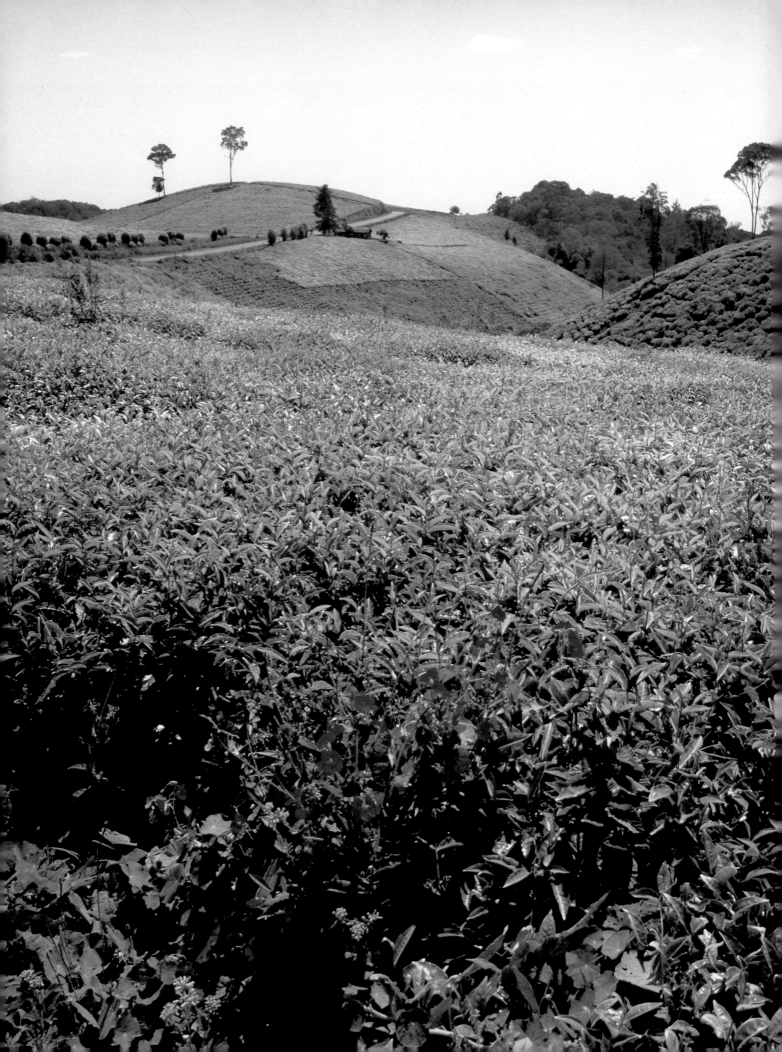

Opposite: *The bright green 'table' of a Limuru tea plantation stretches as far as the eye can see. Tea bushes are always kept pruned to table height, so that the pluckers can easily harvest the leaves. Tea bushes can grow to a height of 30 feet.*

Right: *A coffee picker plucks the ripe red berries which weigh down the branches. The height of the picking season is January/February, following the October/November rain which washes the white flowers away.*

Bottom: *Ripe coffee beans must be dried and roasted to extract the best flavour. Kenyan coffee is a world favourite, and grows best in the Kiambu/Nyeri area and on the southern slopes of Mount Kenya. It likes rich red soil, and good rainfall, and is not successful at altitudes below 1 500 metres.*

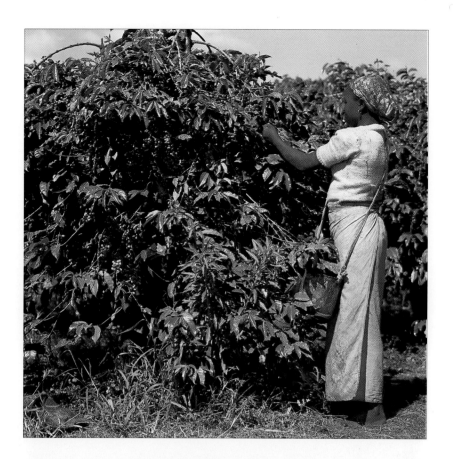

Above: *A fly fisherman tries his luck in one of the fast-flowing streams of the Aberdare mountains. Both brown and rainbow trout were introduced early in the century, by Colonel Ewart Grogan, and there are now commercial trout farms to meet the needs of the country's restaurants.*

Left: *Centuries of wind have carved the volcanic rocks of the Aberdare mountain range into strange shapes such as the outcrops known as the 'dragon's teeth'.*

Right: *When the Athi River is in flood, it pours over the Fourteen Falls at Thika, a growing industrial town.*

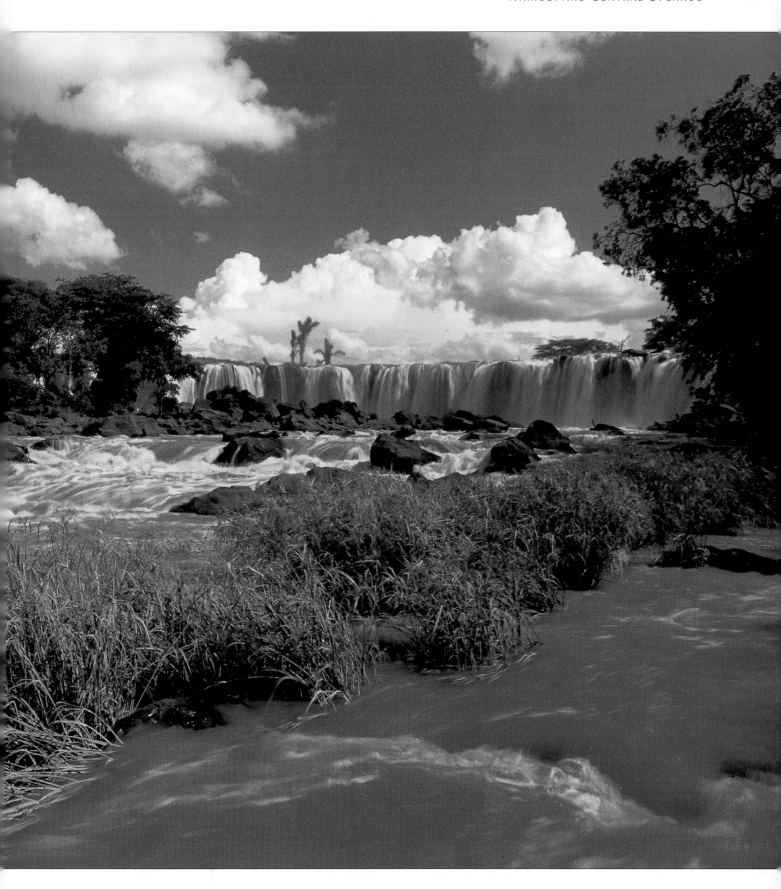

Right: *The giant groundsel (Senecio) is an alpine plant endemic to the high mountains of East Africa. These spectacular high-altitude plants may reach six metres in height, and have a built-in frost-proofing system that serves to protect them from the freezing night-time temperatures.*

Centre: *Climbers enjoy a modest meal at Mackinders Camp the night before they ascend Mount Kenya. The cabin was built by the Mountain Club of Kenya, which also organizes any mountain rescues in conjunction with the national park rangers.*

Bottom: *The luxurious Mount Kenya Safari Club was built by actor William Holden and originally called Mawingo (meaning 'clouds'). Landscaped gardens with sweeping lawns include a miniature golf course, bowling green, and heated swimming pool.*

Opposite: *For the more hardy travellers, camping at the top of the Teleki Valley on the way up the mountain is a unique adventure. Temperatures drop well below zero at night, tent zippers often freeze, and there are frequent snow storms.*

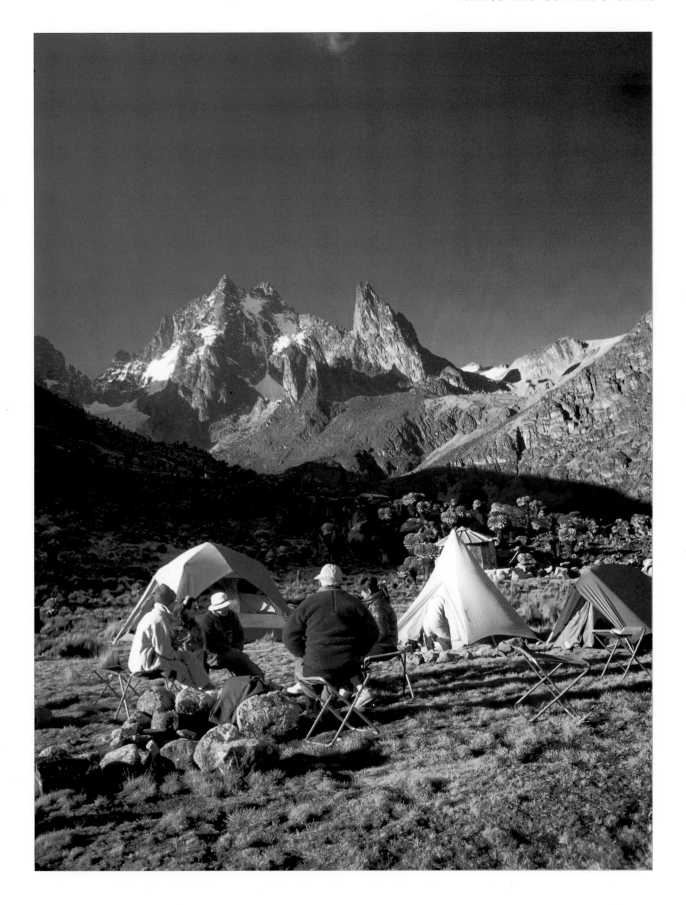

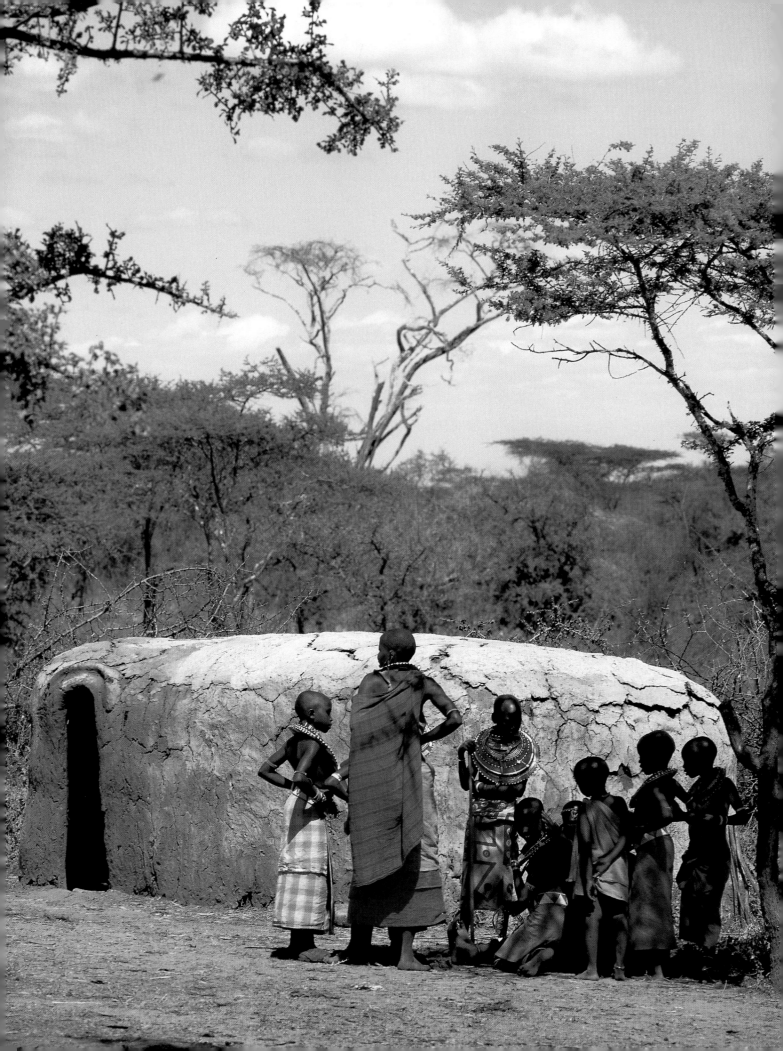

MAASAILAND

Above: *A Maasai moran.*
Opposite: *A Maasai woman and children.*

Maasailand is an area with no real boundaries, named after the proud, semi-nomadic cattle herders who stride across the plains. The Maasai people have captured the imagination of the visitor as they epitomize the 'real' Africa. Faced with the tall Maasai with their spears in their hands and red *shukas* wrapped round them to ward off the morning chill, it is easy to forget that this is the twentieth century.

Maasailand is a swathe of open grasslands, from the foothills of Mount Kilimanjaro around Amboseli all along the country's southern border to the western edge of the Masai Mara National Reserve, spilling over into neighbouring Tanzania. As the Maasai believe that Ngai (God) gave them all the cattle in the world, so they believe that this land is also theirs. The international boundary is of no consequence to them.

The Masai Mara National Reserve welcomes more visitors than any other park or reserve, and has by far the widest variety of wildlife. As the northern tip of the vast ecosystem known as the Serengeti, the Mara plays host to one of the world's greatest wildlife spectacles – the annual migration of wildebeest and other animals. The predators – jackal, hyena and lion – follow in the wake of the migrating herbivores. Every visitor wants to see a kill, and because of this pressure from tourists, many animals (particularly lion and leopard) have modified their behaviour and now hunt at night. Too often their stalk has been interrupted during the day by minibuses, too often their view of their prey has been blocked by four-wheel-drive safari cars. It is worth sparing time to look for the smaller game too, such as a bat-eared fox, an aardwolf, a pack of mongooses, and hundreds of species of birds.

The Mara River, passing through the reserve on its way to the Serengeti and Lake Victoria, is home to large numbers of crocodile and hippo. Even in times of drought, these animals will remain in the river, for there is no viable alternative nearby. However, both crocodile and hippo are capable of walking long distances overland if necessary.

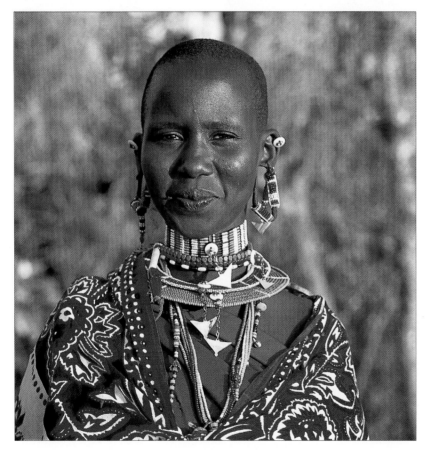

Above: In typical Maasai country, rolling grassy plains offer good grazing for the cattle. A group of Maasai huts encircled by thorny branches, to protect both livestock and people from wild animals, is correctly known as an enkang, although many people refer to such a settlement as a manyatta.

Left: Exquisite beadwork is characteristic of Maasai women, who spend long hours threading necklaces, earrings and armbands as well as decorating such items as gourds and sheaths.

Opposite: The Maasai people venerate their cattle, which are a measure of wealth and status. If there is no rain for some time, the cattle are taken further afield to feed, and eventually the whole settlement may move to better pastures.

Left: *Vultures squabble noisily with each other when crowding around a kill. They have incredible vision, and can see a carcass on the ground from enormous heights. Early each day they can be seen circling the thermals, rising high in the air.*

Opposite top: *The large, imposing and unmistakable Saddle-billed Stork is never found far from water and feeds on aquatic snails and frogs. Commonly found in the Masai Mara, the Saddle-billed Stork is also prolific in Buffalo Springs and Amboseli.*

Opposite centre: *White-bellied Bustards are found in small numbers in dry country such as that of the Masai Mara and Tsavo. Their preferred habitat is open savannah, thornbush and grasslands and less commonly, open woodlands.*

Above: *Male cheetahs and other cats mark their territory by 'sprainting'. Young males will leave their mother when she mates again, and bachelor groups may stay together until they in turn find mates. Females take the responsibility for the raising of young.*

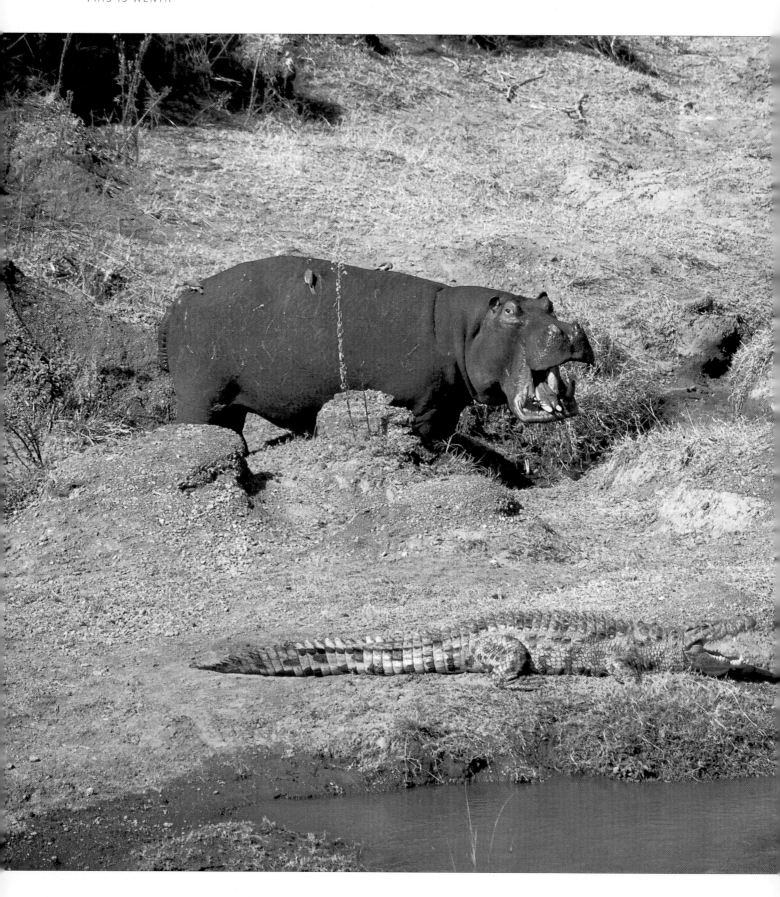

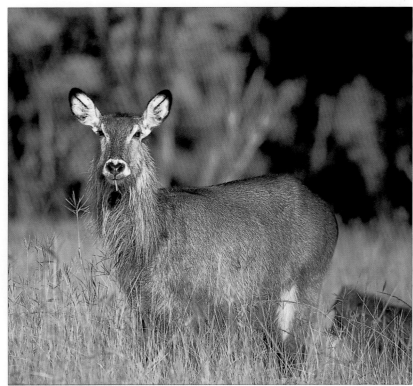

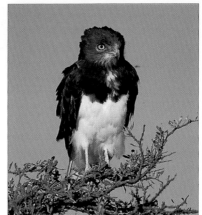

Above: *Female defassa waterbuck have no horns. Their coats are almost waterproof as the hairs are hollow and coated with an oily secretion coming from glands in the skin.*
Left: *Black-chested Harriers can be seen soaring over the savannah plains in search of rodents, small birds and reptiles on which they prey.*
Opposite: *Hippos generally spend the day in the water, only coming onto land at night to feed. They may graze many miles away from the water. They will submerge to escape the attentions of tick birds. Crocodiles bask on the river banks during the morning and late afternoon, returning to the water at midday to escape the heat of the noon sun,*

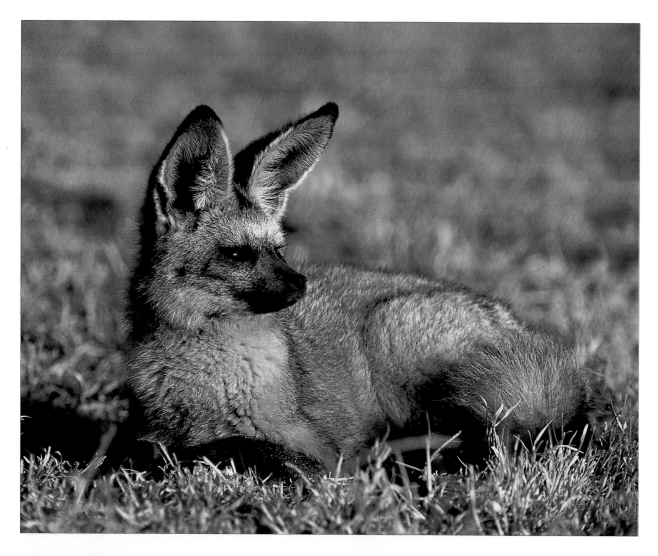

Above: Bat-eared foxes live in small family groups in dry, open areas. They use their oversized ears to detect prey such as insects and small mammals.

Left: Siana Springs Camp (previously Cottar's Camp) is located just outside the Masai Mara National Reserve. It was built on the favourite campsite of a legendary game warden, Lyn Temple Boreham.

Left: *The Mara Serena Lodge was designed to blend in with the surrounding terrain, and each room is in the shape of a Maasai hut.*
Below: *Banded mongoose live in large colonies, nesting in old termite hills. They are intelligent animals and have an advanced social structure in which the whole pack helps in the raising of young produced by the dominant breeding pair. Duties such as baby-sitting are shared among the females, while the males take turns to keep watch.*

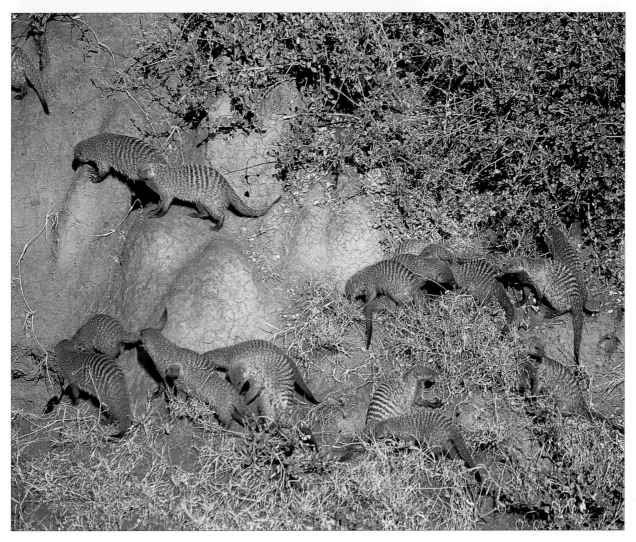

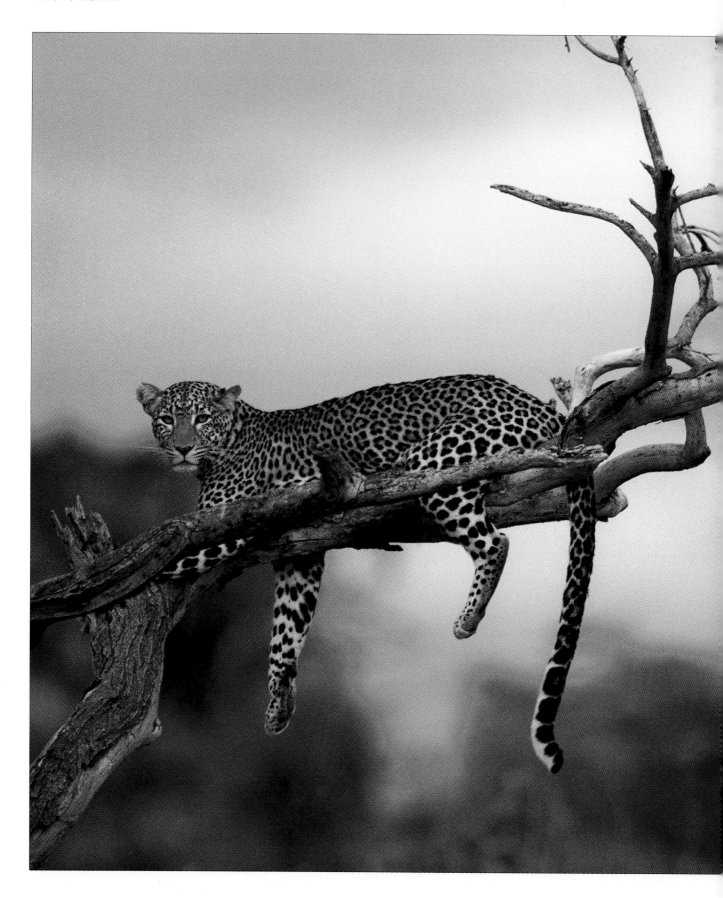

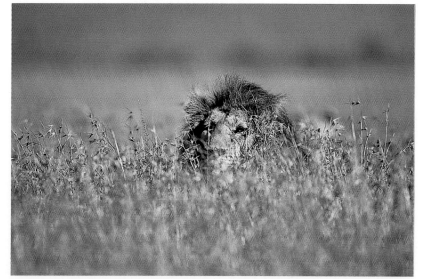

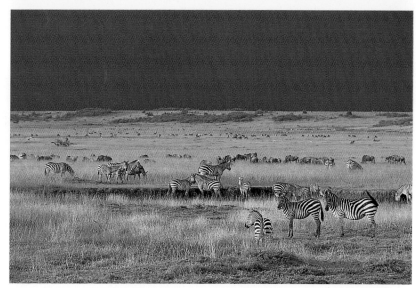

Above: *Plains game such as zebra have to share the same waterholes with predators, and are at their most vulnerable when drinking. They take turns to drink, while some of the males keep watch for danger.*

Left: *Leopards are solitary animals. They spend much of the day in hiding, and are largely nocturnal. They often lie in the branches of a tree during the day, and usually drag their kill into the fork of a tree safely away from other predators.*

Top: *Male lions also rest during the heat of the day. Lone males are not uncommon, although survival is not easy, as they stand little chance of getting enough to eat unless they steal it from other predators.*

Opposite: *Giraffe flee from an approaching balloon. The noise of the burners alarms the animals, and the shadow passing over the land can panic a herd.*

Left: *A champagne breakfast with all the trimmings is laid out on the plains to mark the successful end of the day's hot-air balloon flight.*

Below left: *The burners roar in the pre-dawn stillness, preparing the balloons to take off at first light.*

Below: *A bird's-eye view from the basket of a hot-air balloon offers the visitor an entirely different perspective of the animals below. The Masai Mara National Reserve is one of the best places in the world to fly.*

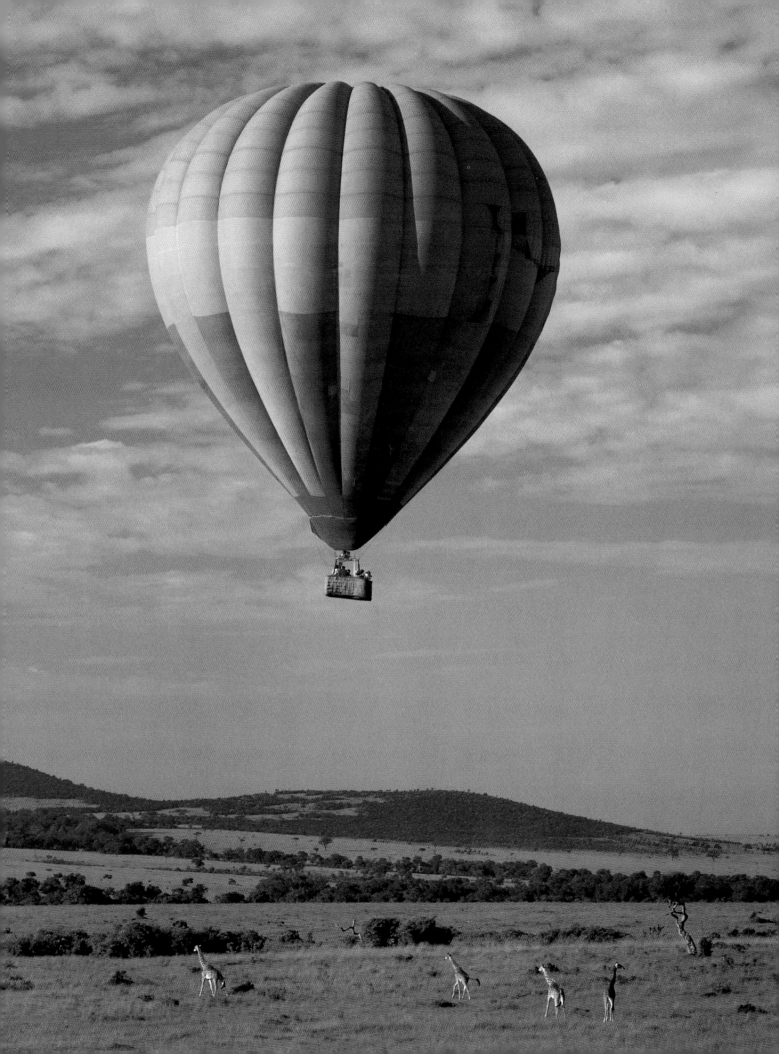

Above: *The topi, with its purplish flanks, is a relative of the hartebeest and is characteristic of the Masai Mara. Typically they stand on termite mounds or little hillocks to get a good view of the surrounding area and spot any approaching predators.*

Left: *In the Masai Mara National Reserve, elephants, such as this small herd of female and young, have not yet been seriously threatened. However, if they stray from the reserve and cause damage to farmers' crops there will be conflict.*

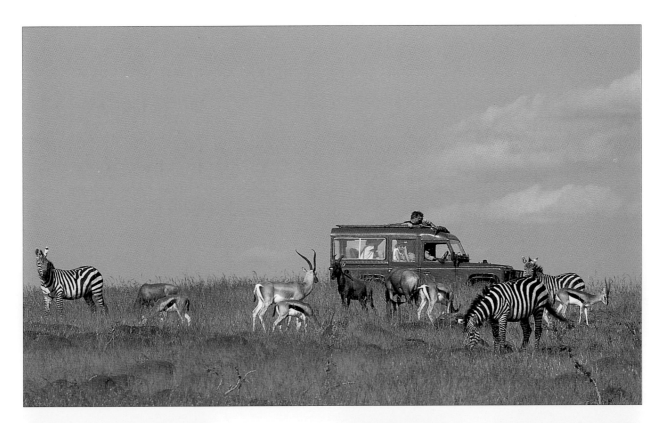

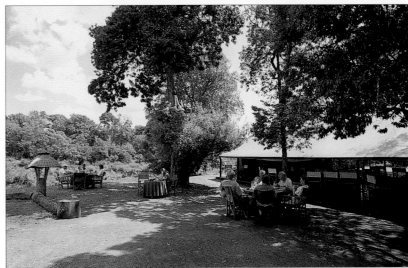

Above: Wattled Plovers favour flat open areas, and are commonly seen on the airstrips of the Masai Mara. Only the male birds have wattles.
Top: Governors' Camp, like most camps in the Mara, offers morning and evening game drives. Roof hatches and large windows ensure good visibility for the photographer.

Above: Comfortable insect-proof tents are spread out along the river at Little Governors' Camp, across the river from the main Governors' Camp.
Opposite: Baboons are probably Africa's most successful primate (apart from man), and are both wide ranging and adaptable. They can be found in open plains or woodlands.

Overleaf: The Masai Mara is home to more lions than any other park, and it is difficult not to see them. Natural disasters, such as an outbreak of canine distemper virus from the neighbouring Serengeti, account for a small percentage of deaths, but generally they are resilient and successful predators.

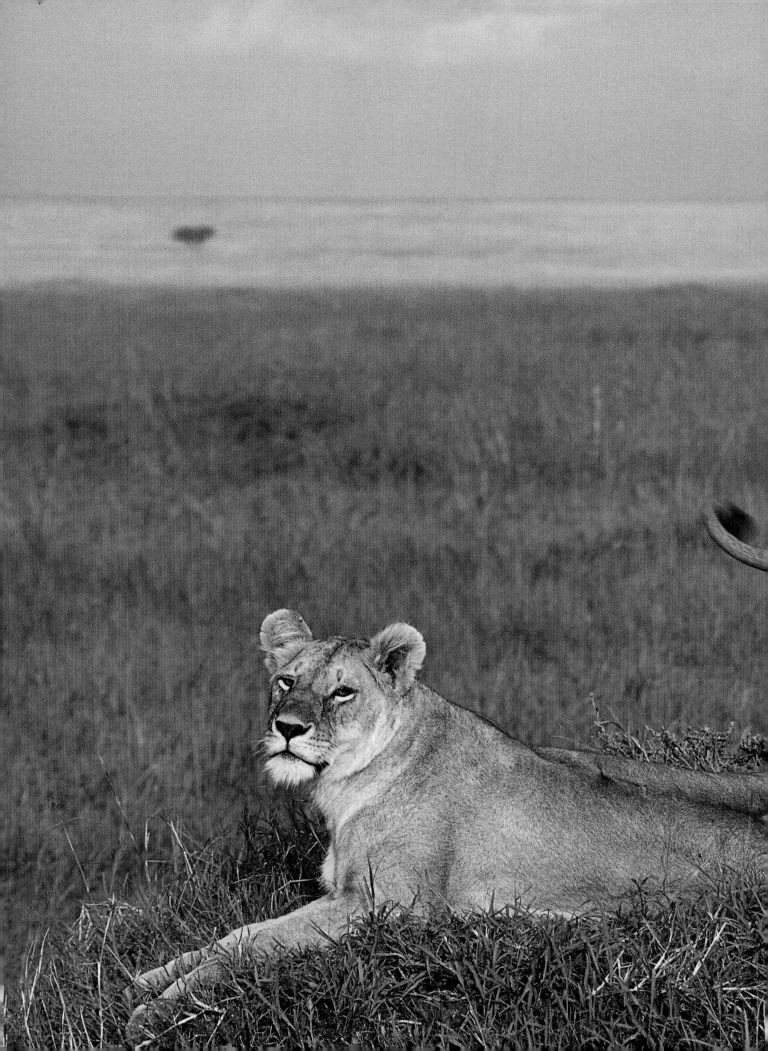

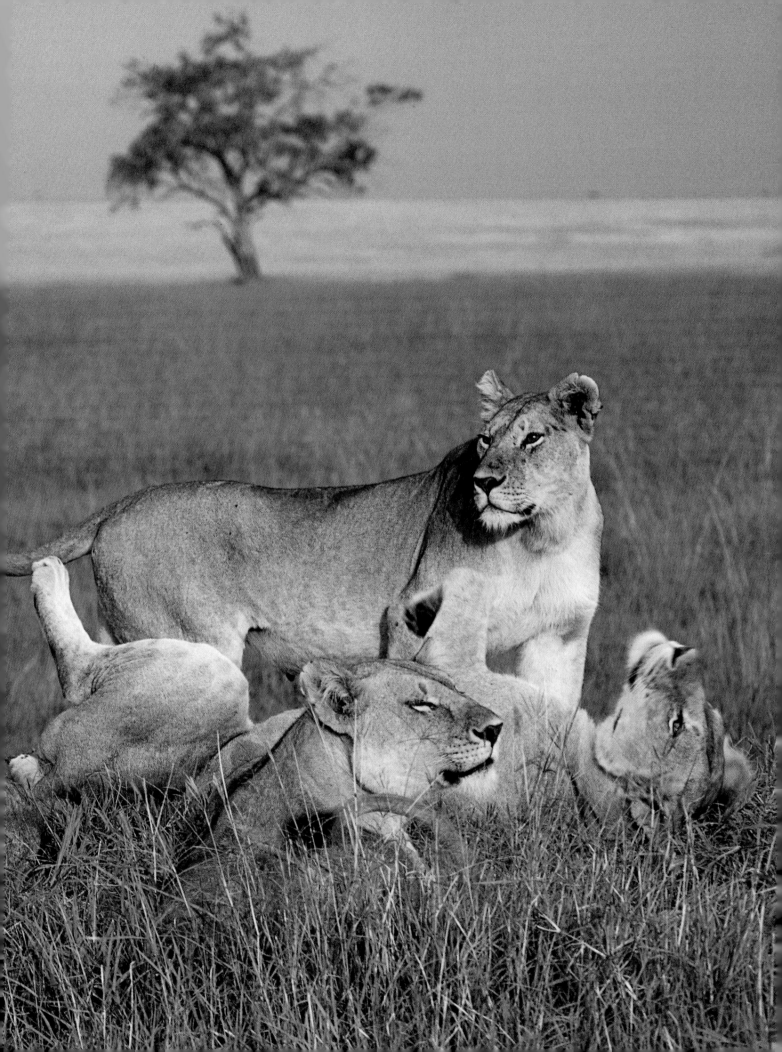

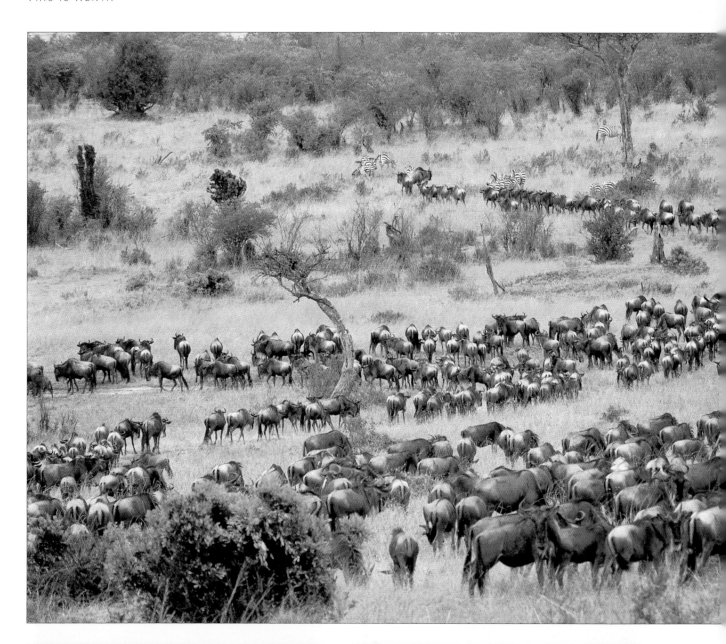

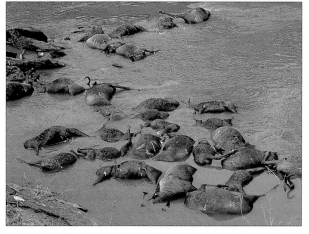

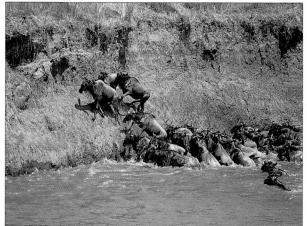

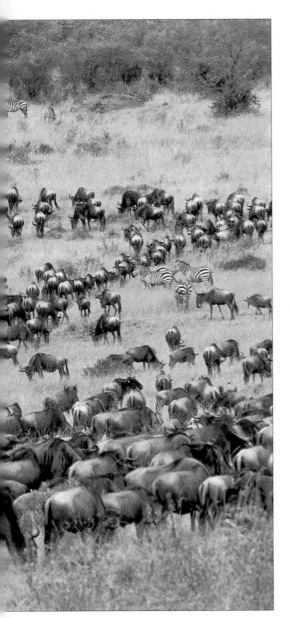

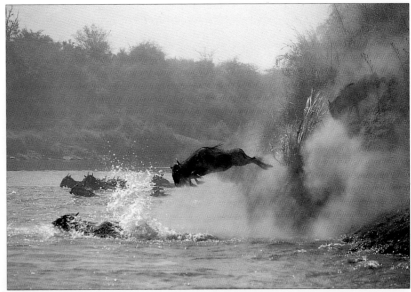

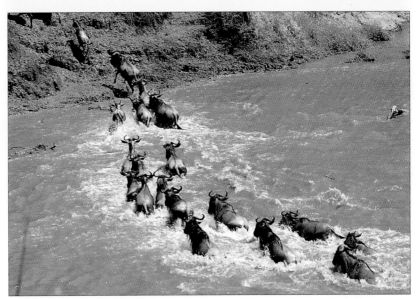

Above: *During their ceaseless migration, the wildebeest, followed by other plains animals such as zebra and gazelle, spread over the plains for as far as the eye can see. The months of July through October guarantee plentiful prey for the Mara's predators.*

Opposite bottom right: *The wildebeest have to cross the Mara River, often when it is in flood, to reach the grass on the other side. The journey is fraught with danger.*

Opposite bottom left: *Not all of the wildebeest make it safely across the river. Many animals break their legs while jumping into the unknown waters from the river bank, others drown, and yet more are taken by the numerous crocodiles who lie in wait at this time of year.*

Top: *The wildebeest often enter the river in unsuitable spots, launching themselves into the waters from a high cliff when a shallower, safer entry point may be just metres away.*

Above: *The wildebeest migration originates in Tanzania's Serengeti and may consist of two million animals. The journey is perilous, especially when crossing rivers, as fast-moving currents or floating trees may sweep a full-grown animal away, or rocks can fracture a limb.*

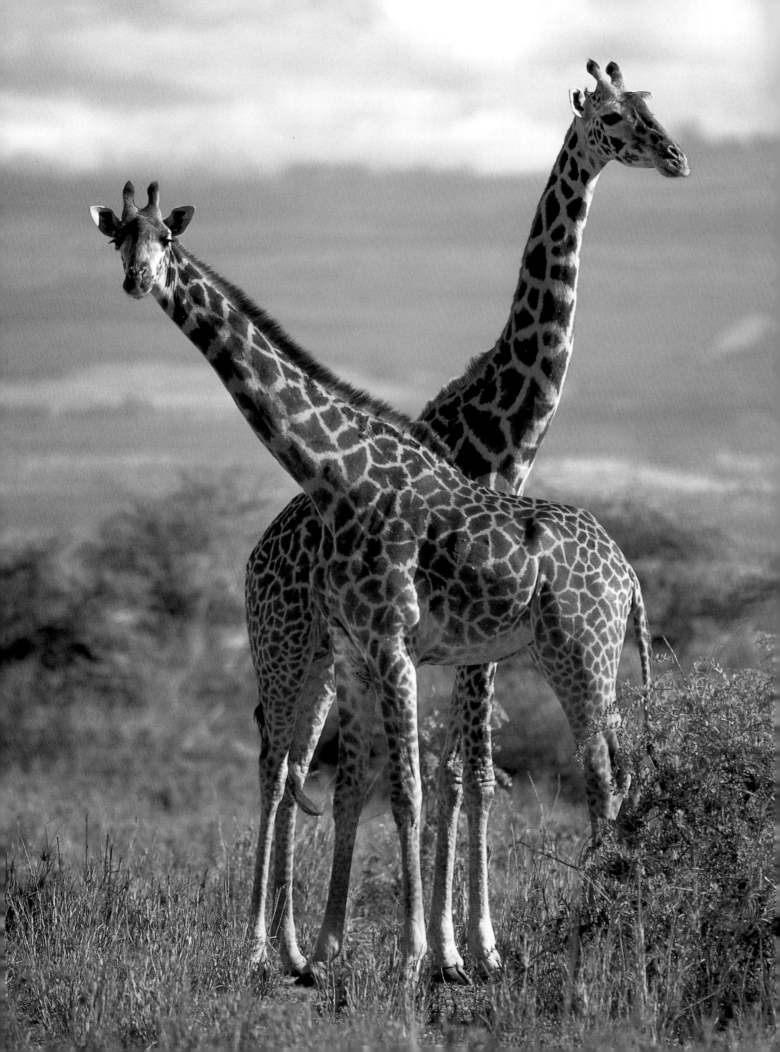

AMBOSELI NATIONAL PARK

Above: *Acacia trees.*
Opposite: *Masai giraffes.*

Amboseli's fame is probably due to one man, the writer Ernest Hemingway, whose first hunting safari in 1933 led him to write one of his best stories, *The Snows of Kilimanjaro*. He was smitten by the eerie magic of the place, and by the majesty of the snow-capped mountain. The images that he captured on paper made many of his readers want to visit Kenya and see the mountain. The film, which came out in the early 1950s, made all who saw it yearn for the great African safari experience. In those days, the place was rarely visited, except by hunting safaris and the occasional photographer. Those were the early days of wildlife film making, and the legendary Belgian film maker Armand Denis and his wife Michaela spent many successful months working in Amboseli.

Amboseli was designated as a national reserve in 1948, and the self-help *bandas* at Ol Tukai were built immediately. The early wardens had many problems to solve, including the provision of water for Maasai cattle and the building of a causeway over the Simek River. Rider Haggard's epic story *King Solomon's Mines* was partly filmed here, and was the forerunner of a series of African films in the 1950s. The Ol Tukai *bandas* were used by the film company, who installed electricity as payment for the facilities.

Amboseli's easy accessibility by road or air from Nairobi, and by air from the coastal hotels, means that it is one of the most popular parks. Too much so, in many people's view. Enormous numbers of people fill dozens of minibuses every morning and drive off in a swirl of dust, eager to be the first in line. Those at the rear soon become coated with the fine white volcanic dust that is characteristic of this area. Nevertheless, the tourists keep on coming. No other park has such a dramatic mountain backdrop, the perfect setting for almost any wildlife photograph. The park also suffers extremes of climate – it may not receive significant rain for many months and then suddenly, almost overnight, it can experience serious floods. The vegetation has to be hardy to survive this, and many of the acacia trees for which the park was famous are now lifeless skeletal stumps. However, new growth appears after each rain, and the park survives, unique in its charm.

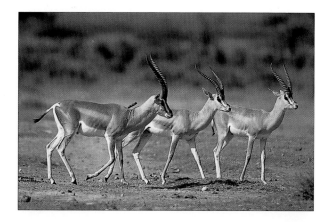

Above: The oldest safari company, Ker & Downey, has all its vehicles painted in the same distinctive dark green. The company was formed by Donald Ker and Syd Downey, both of whom were born in 1905, and boasts a most impressive client list of royalty, Hollywood stars and authors.

Top: Grant's gazelle are much larger and lighter in colour than Thomson's gazelle, and lack the black stripe along the body.

Right: Cattle and wildlife share the same territory, and use the same paths to reach water. It is generally agreed that the wildlife causes significantly less damage to the grass than domestic stock.

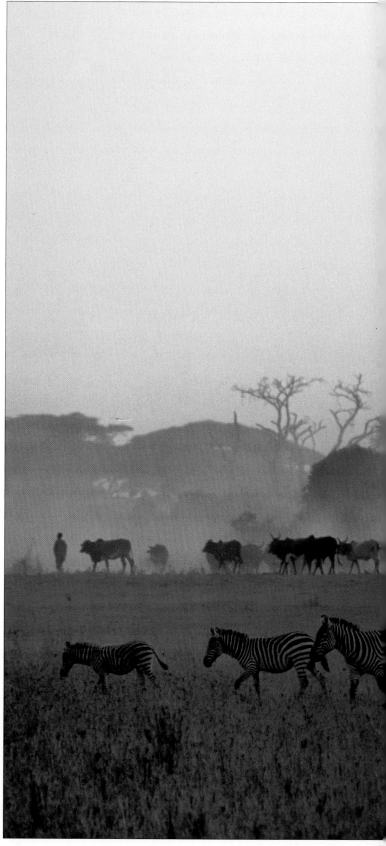

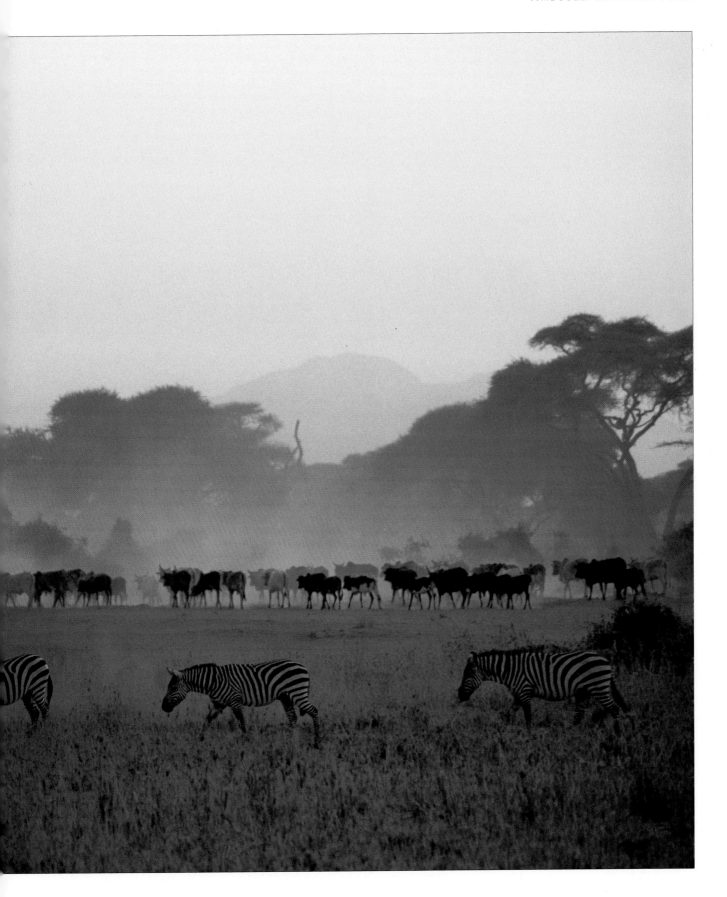

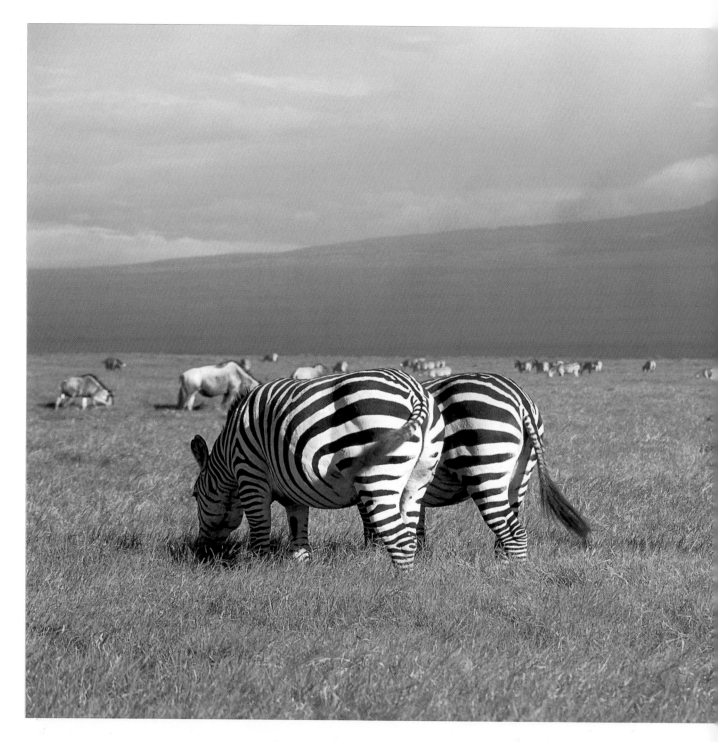

Above: *The Amboseli National Park supports large numbers of Burchell's zebra, and it is very unusual to see one that is out of condition. Even during the driest periods the zebra invariably look fat and well fed, and have sleek coats.*

Opposite top: *Grey Crowned Cranes thrive in the wetlands of Amboseli, and perform their energetic courtship dances on the edge of the swamp, where they also nest and raise their young. They are widely distributed and are also found in grasslands.*

Opposite bottom: *Giraffe cover long distances in search of their favourite food, acacia trees. Trees in Amboseli are being replaced in a well-publicized tree-planting exercise. Many trees have died due to the minerals in the soil being too concentrated.*

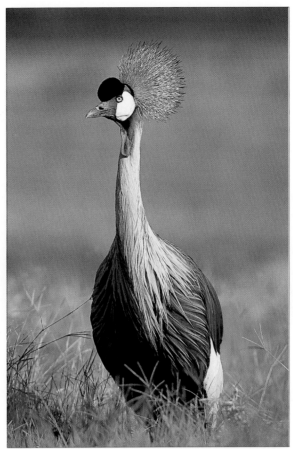

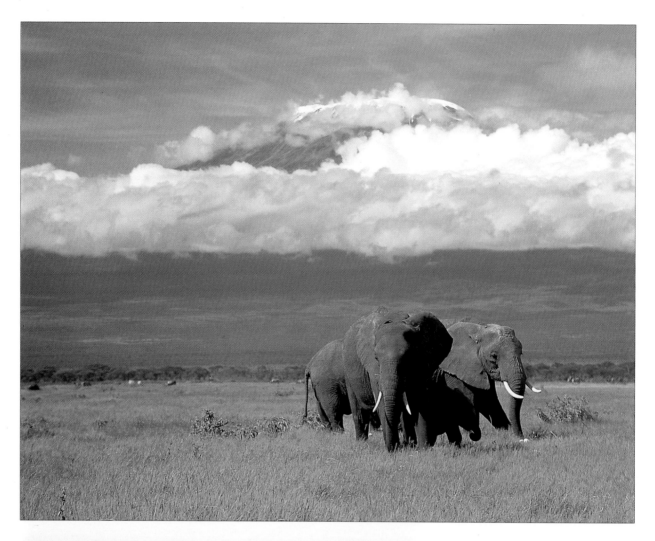

Above: Each of the 700 or more elephants in Amboseli is known individually by the researchers who work on the African Wildlife Foundation elephant research project. When there is sufficient water in the swamp, elephants love to play and bathe.

Left: The short-legged Squacco Heron is an Amboseli National Park resident, living in swampy and marshy areas, usually where there are aquatic plants in which to hide. The similar Madagascar Squacco Heron is a seasonal visitor, and can be distinguished by its heavier bill.

Left: *Amboseli's swamp is home to many waterbirds, including the Goliath Heron which, at a height of 1.5 metres, is the largest of the herons. This bird is never far from water and is also commonly found at Lake Naivasha.*

Below: *The female buffalo lacks the heavy boss of the male, although the horns may spread almost as wide. A male's horns may spread more than one metre from tip to tip, measured along the outside curve.*

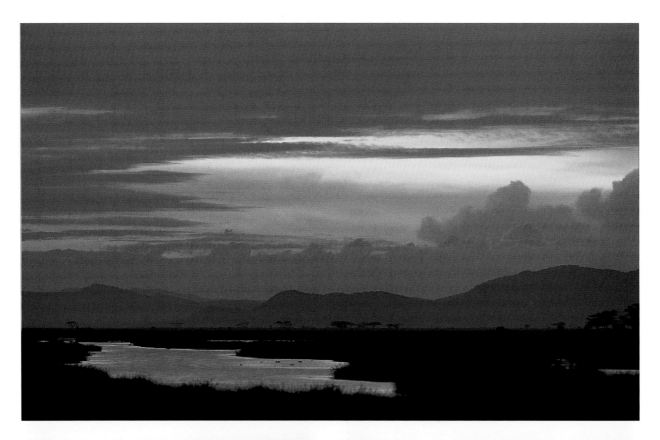

Above: *Amboseli Lodge, in the centre of the park near Ol Tukai, offers views of two of Mount Kilimanjaro's peaks. The gardens abound with colourful shrubs that are alive with birds.*
Top: *The last rays of the setting sun reflect on Lake Amboseli, a seasonal waterbody. In January 1993 the park was closed following heavy rains, and many visitors were unable to leave their hotels for several days.*

Above right: *Joe Cheffings, long-time naturalist, photographer and director of the exclusive Bateleur Safaris, entertains clients with sundowners around the campfire in Amboseli.*
Opposite: *Lake Amboseli, situated in the extreme west of the park, is often completely dry. The name is thus quite appropriate as it is a corruption of the Maasai word* embosel *or* empusel, *meaning 'salty dust'.*

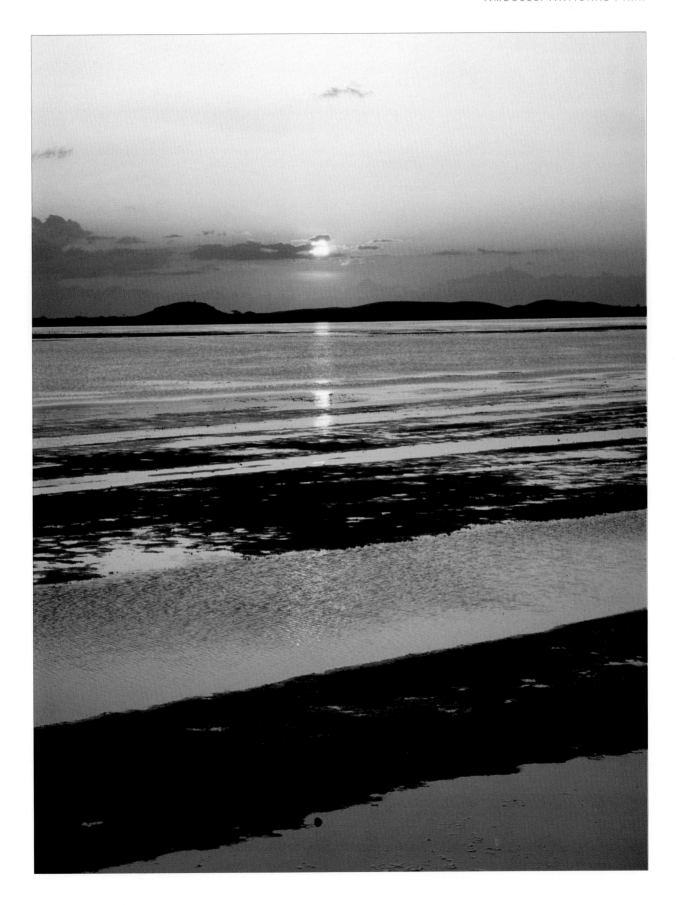

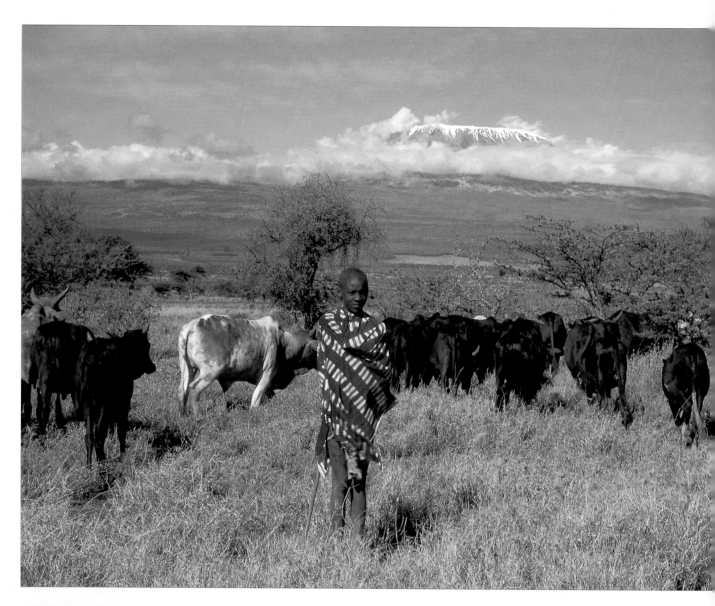

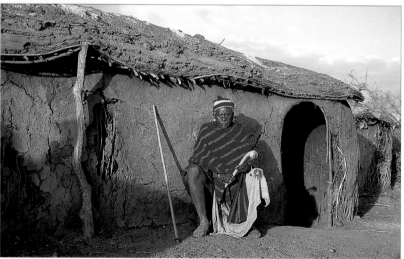

Above: Owned by the local Maasai, the Selengei Group Ranch is situated in the reserve area outside the national park. Cattle and wildlife compete for scarce resources, particularly grazing and water, and the park authorities have provided water troughs for cattle in order to keep them out of the wildlife area.

Left: In Maasai society men undergo a series of rituals to become senior elders and therefore respected leaders. Elders are responsible for justice and order in the community, and make the major decisions.

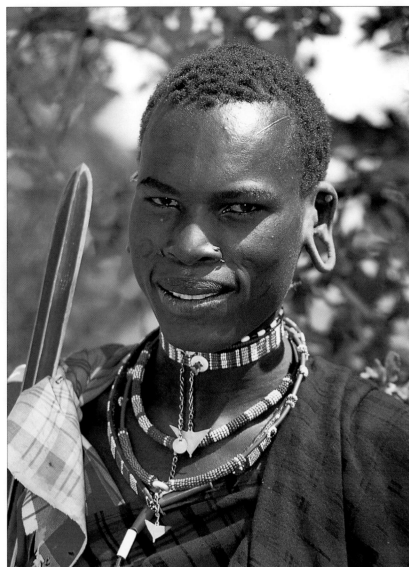

Above right: After being circumcised, young Maasai boys spend some time as 'warrior recruits' before becoming moran, or 'warriors', and setting up their own manyatta. For the next few years they are relatively free of responsibility until they become junior elders in a ceremony known as the eunoto, or 'coming-of-age'.

Right: Knobkerries being carried by a Maasai child. Traditional knobkerries are always carried by Maasai men, and are often fashioned from carefully chosen naturally knotted branches. They may also be handcarved.

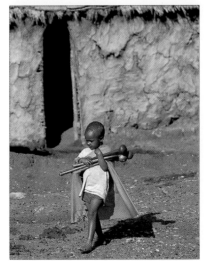

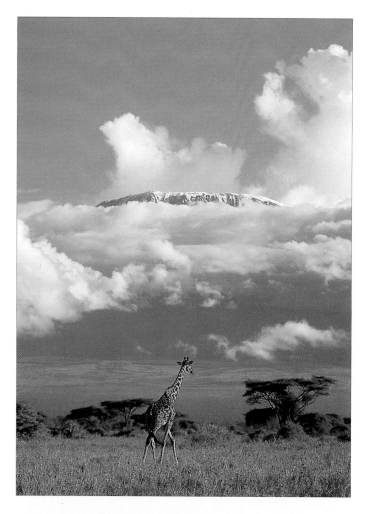

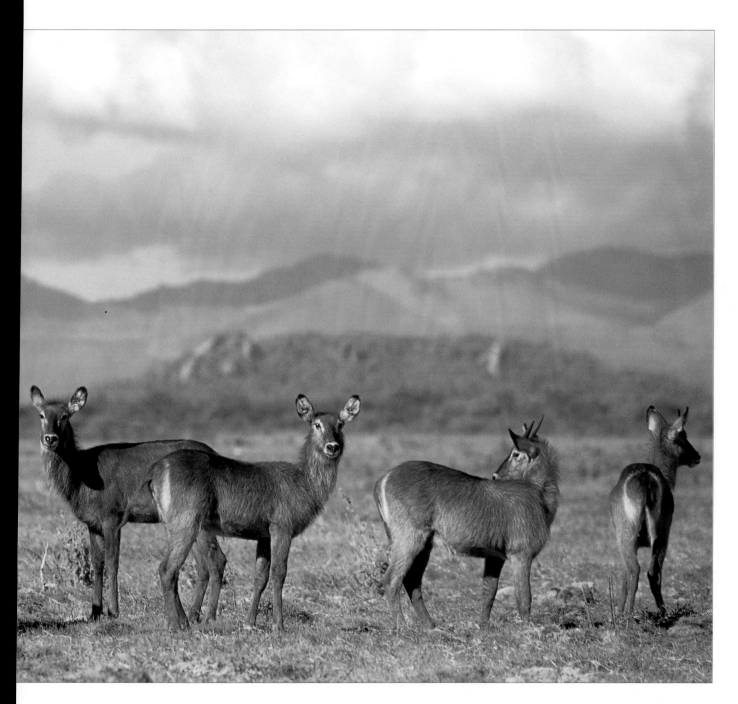

Opposite top: *A cloud-covered Mount Kilimanjaro is the landmark by which Amboseli National Park is recognized. The peaks are covered in snow for most of the year, and in some years the snowline is so low that it covers the saddle.*

Opposite bottom: *Kimana Lodge, situated outside the boundaries of the Amboseli National Park, is located on what is known as 'the pipeline road' from Oloitokitok to Sultan Hamud. In good weather this serves as an alternative access road.*

Above: *Waterbuck are common in the wet, marshy and swampy areas of Amboseli and also occur in Tsavo National Park and Nairobi National Park. They take cover in the reedbeds but may wander away from the water to feed.*

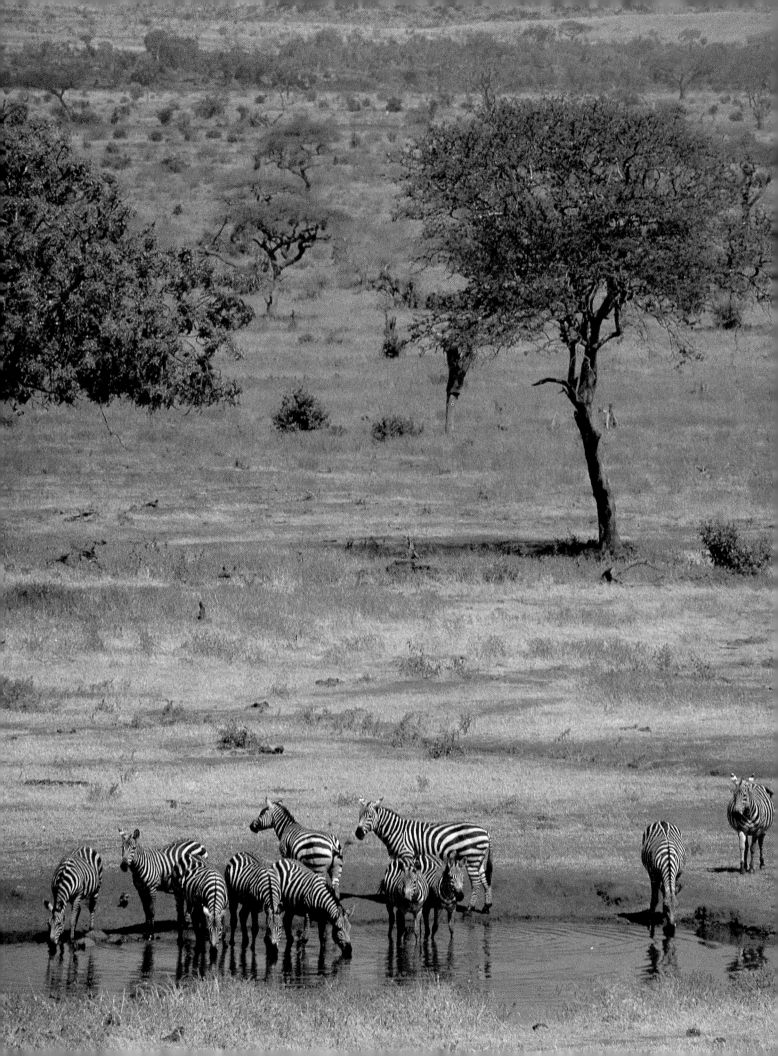

TSAVO AND SHIMBA HILLS

Above: *Voi Safari Lodge.*
Opposite: *Zebras at Kilaguni waterhole.*

Tsavo is the largest of Kenya's national parks, a vast area of over 20 000 square kilometres. It is divided by the main Mombasa to Nairobi road which runs between Tsavo East and West. The once thickly treed Tsavo West has become an area of open bushland, while in Tsavo East the bush is more sparse and verges on the semi-arid. Thirty years ago Tsavo was famed for its large numbers of elephant, and it was rare to drive along the road to the coast without seeing big herds from the car window on both sides of the road. In those days there were about 60 000 elephants, one of the greatest populations in Africa. There were also substantial numbers of black rhino, maybe as many as 7 000. Then came the poaching boom. Situated between Kamba country to the west, and Somali country to the east, Tsavo was the prime target for illegal hunting, sandwiched between two groups of people known for their prowess as hunters. Inevitably, technology changed their approach – the hunter was no longer a lone poacher with bow and poisoned arrow. The poachers ganged together, using increasingly sophisticated weapons obtained from across the country's borders. The rangers were powerless to stop them, armed as they were with ancient single-bolt-action rifles and insufficient stocks of ammunition.

After the formation of the Kenya Wildlife Service in 1989 under the leadership of Dr Richard Leakey, the war against poachers was finally won. Leakey's first move was to bring in a crack military man to take charge of security, and to provide his rangers with sensible weaponry to defend both the wildlife and themselves against the AK47s of the poachers. A 'shoot to kill' policy was instigated, and soon the poaching menace was all but wiped out. Today, the elephant herds in Tsavo are building up again, although the older animals are still wary of people. A fenced rhino sanctuary in the Tsavo West National Park is in place, and numbers of rhino are also increasing.

Shimba Hills is one of Kenya's smallest reserves, and yet is one of the most idyllic. Set in forest several hundred feet above sea level, yet within sight of the Indian Ocean, Shimba Game Lodge has a romantic atmosphere that is unique.

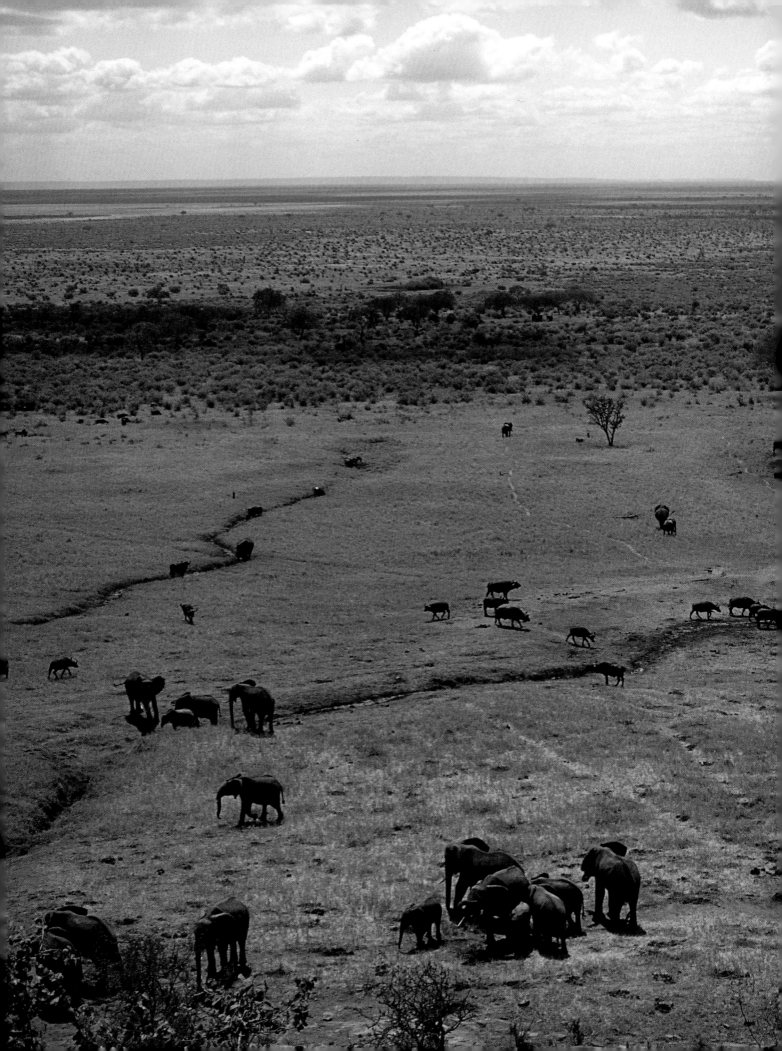

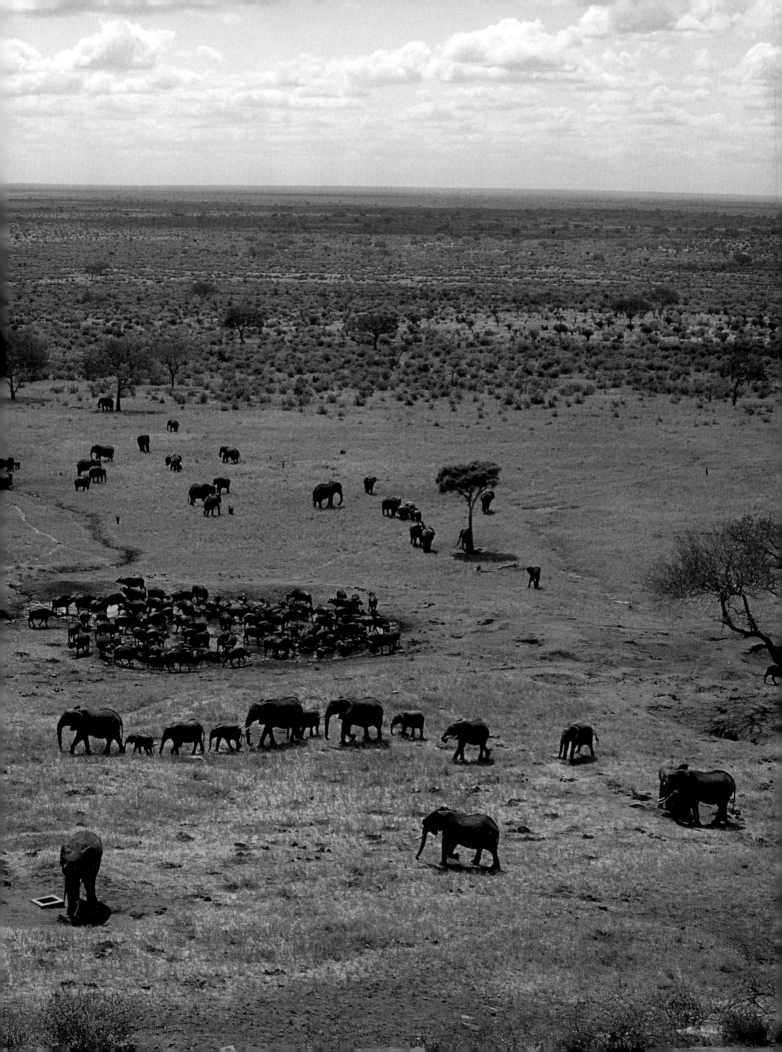

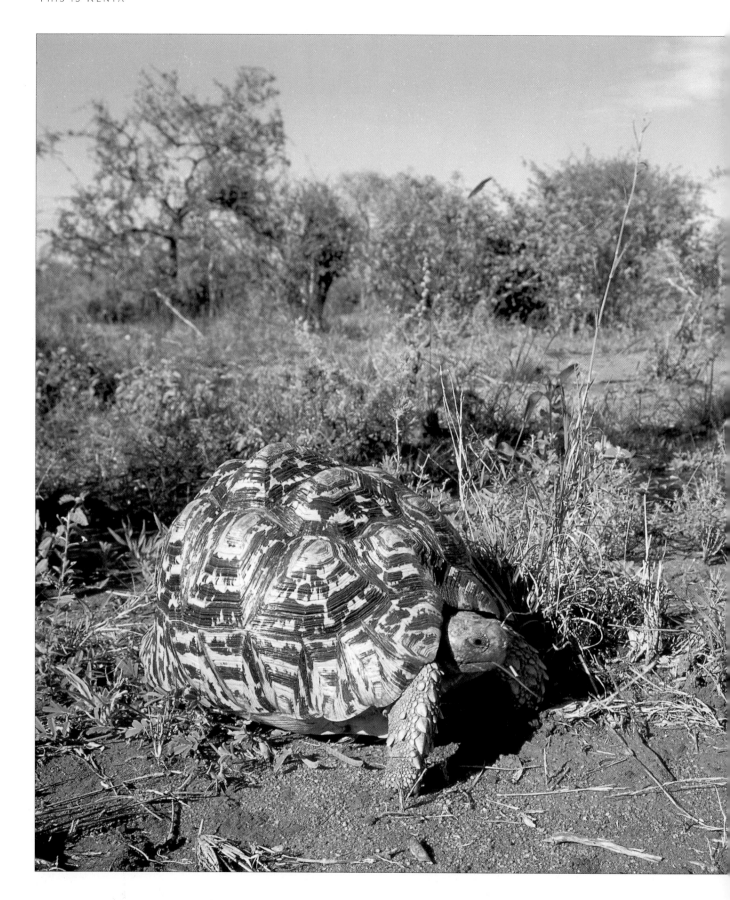

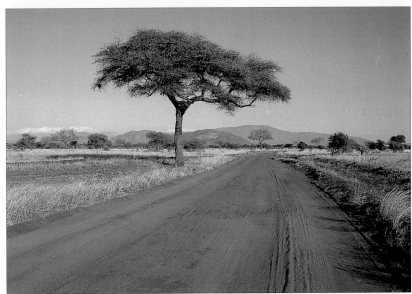

Left: Leopard tortoises are not uncommon in dry grassland areas, and are known to live to a great age. They feed on plants, obtaining most of the moisture they need from the early morning dew.

Top: Vulturine Guineafowl, the most decorative of the guineafowls, inhabit low, dry areas and can be found in both Tsavo West and East national parks. They usually occur in flocks, and feed on seeds and roots.

Above: The rich red colour of the soil is characteristic of Tsavo. After mud wallows and dust baths elephants acquire this colour, which makes them look totally different from the elephants in other areas, such as in Amboseli where they are light grey.

Previous spread: The open space on all sides of a Tsavo waterhole stretches out below the Voi Safari Lodge, near the park headquarters of Tsavo East National Park.

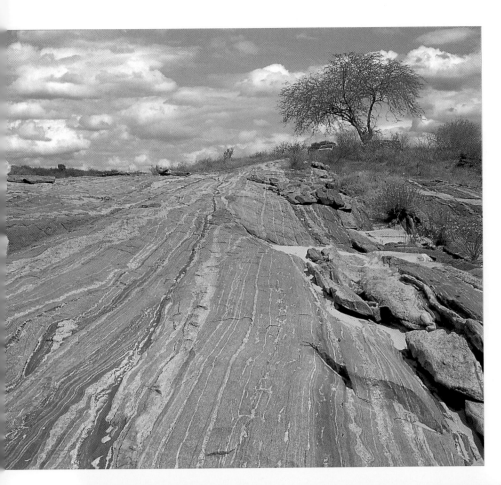

Opposite top: *The diminutive rock hyrax has to spend time soaking up the early morning sun to build up its energy. It is related to the tree hyrax, which occurs in higher areas.*

Left and opposite bottom: *Weathered rocks are evidence of the force of water that plunges over Lugard's Falls in times of flood. At this point, the river is called the Galana, but the name changes to the Sabaki River before it reaches the Kenyan coast.*

Below: *Graceful and shy, female greater kudu seek shade during the heat of the day. Both greater and lesser kudu are found in Tsavo, although the greater kudu is less common. Greater kudu prefer rocky, hilly terrain, while the lesser species is happy in low flat country.*

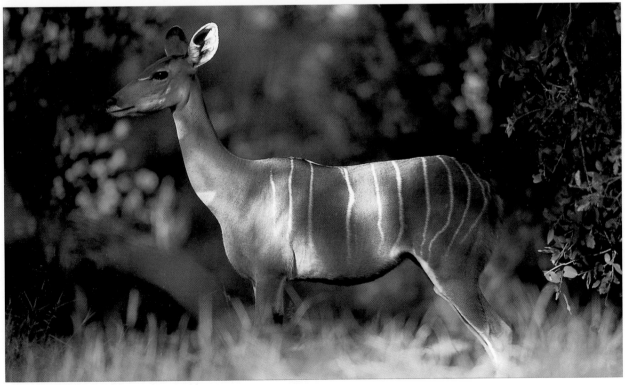

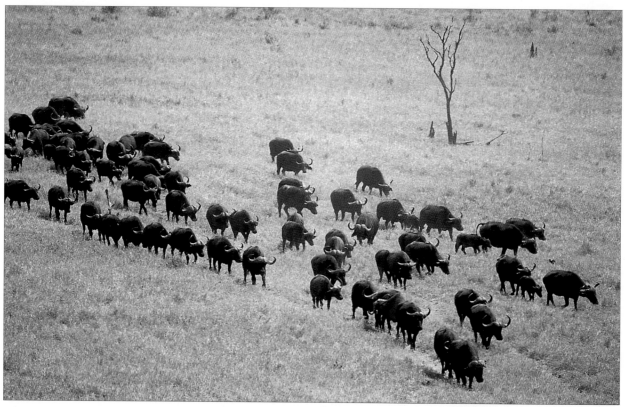

Opposite top: *The view of Tsavo from the top of the Yatta Plateau. The Tsavo Tsafari Camp on the banks of the Athi River arranges daily 'sundowners' at this fine vantage point. On a clear day, Mount Kilimanjaro can be seen on the southern horizon.*

Opposite bottom: *Large herds of Cape buffalo are common in Tsavo, particularly around waterholes. In addition to drinking water, they need mud wallows to keep their skin free from parasites such as ticks.*

Left: *Giraffe are numerous in both Tsavo East and Tsavo West national parks, occurring in herds of up to 35 animals. They have excellent hearing and sight, and spend most of the day feeding.*

Below: *Young baboons play around a termite hill, while an adult female keeps watch on top, acting as nursemaid for the troop. The troops can consist of as many as 80 animals and baboon society is built on strict rules of hierarchy.*

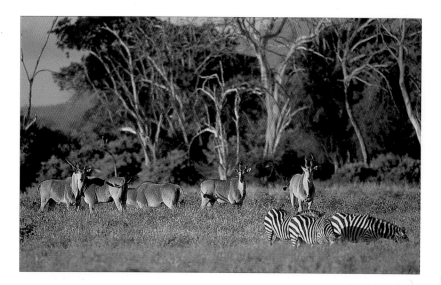

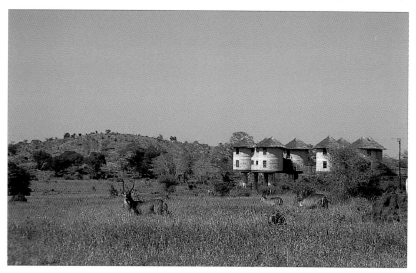

Above: Salt Lick Lodge, built on stilts, is part of the Hilton chain, as is the nearby Taita Hills Lodge. Hilton Hotels have a full-time ecologist to run their private wildlife sanctuaries (Salt Lick and Taita Hills), where visitors often see more animals than in the nearby Tsavo National Park.

Top: Largest of the African antelopes, eland are capable of jumping great heights from a standing start, despite their weight of up to 900 kilograms. Though browsers, they will also dig for bulbs and roots. To loosen twigs, they position them between their horn pedicles and twist their heads.

Opposite: The Chyulu Hills, lying parallel to the Nairobi to Mombasa road in the west of Tsavo West, are evidence of fairly recent volcanic activity – small conical craters can be seen from the air. A lava flow crosses the road and is named Shetani (meaning 'devil' or 'evil one').

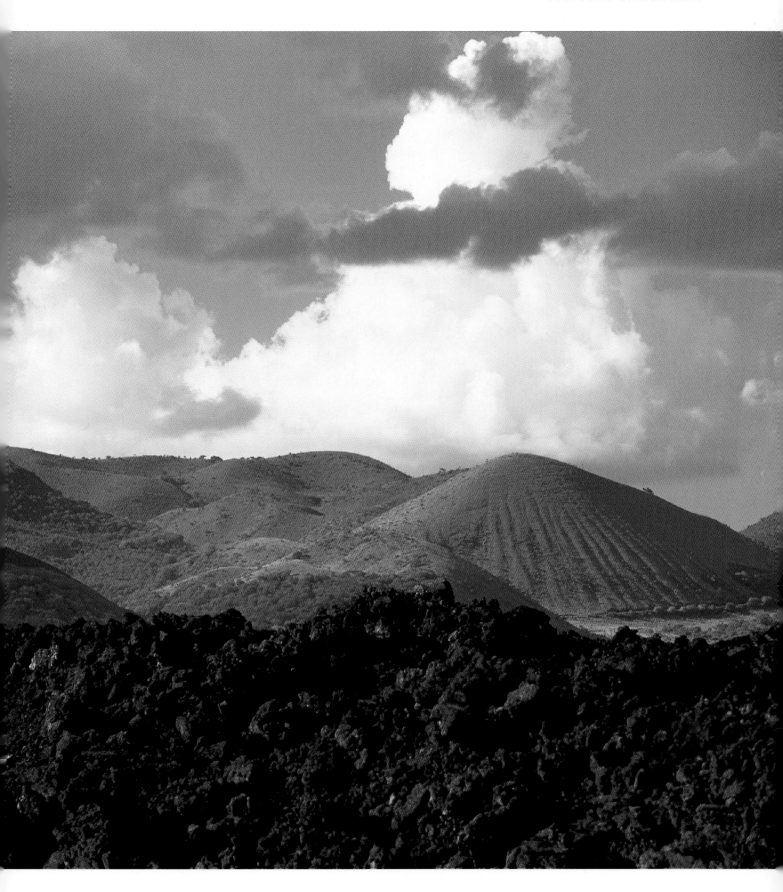

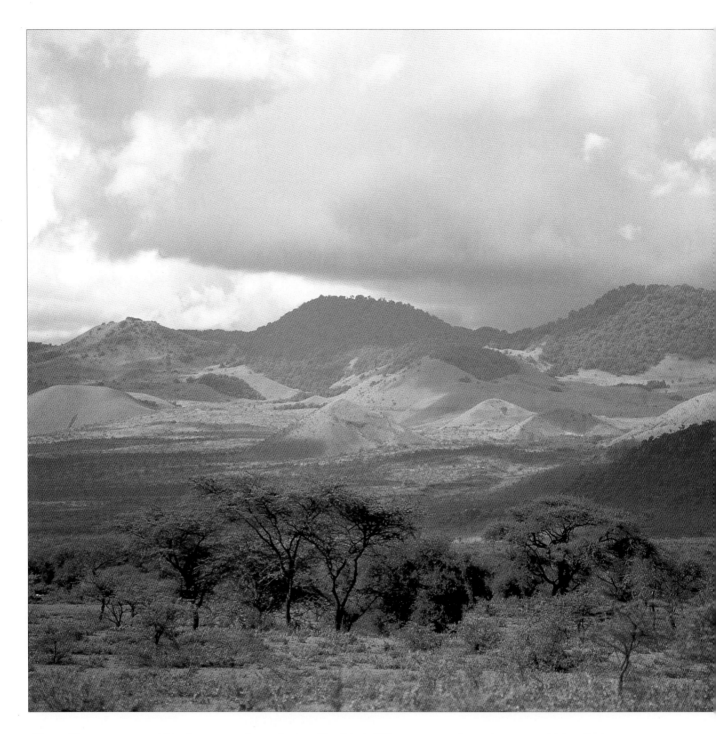

Above: The grass-covered Chyulu Hills run through the Chyulu Hills National Park. During the rainy season, rainwater filters into rivers that flow through the hills. These subterranean rivers join others flowing from Mount Kilimanjaro and re-emerge to feed the Mzima Springs.

Opposite top: The Chyulu Hills have been fairly recently designated as a national park. Few people live in the area as there is no permanent surface water supply, and the road along the top is often impassable. One of the longest caves in the world exists under the hills.

Opposite centre: Mzima Springs is the main attraction in Tsavo West. The spring supplies most of Mombasa's water requirements through a pipeline. It is not artificially maintained, but contains some of the cleanest water in the country, a sign of correct ecological balance.

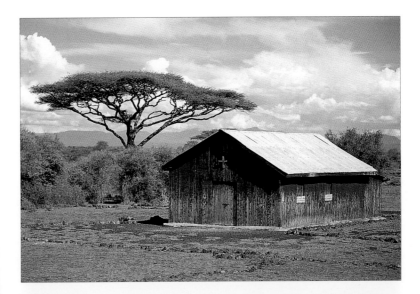

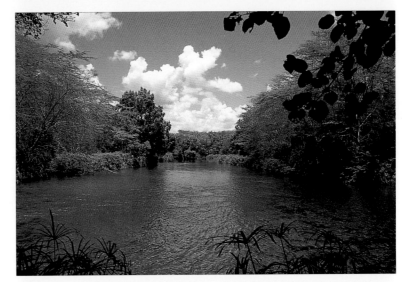

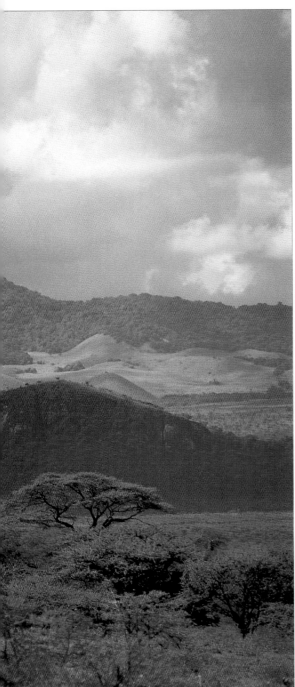

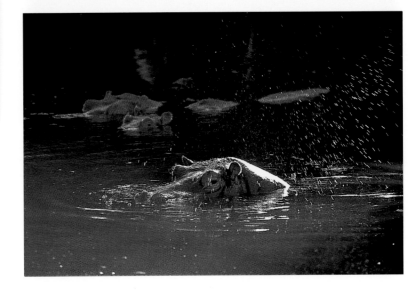

Right: The hippo in the crystal clear Mzima Springs can be viewed underwater through the glass windows of an underground hide. Their droppings provide vital nutrients for the extensive fish life that exists within the spring. The springs are also home to a host of birds.

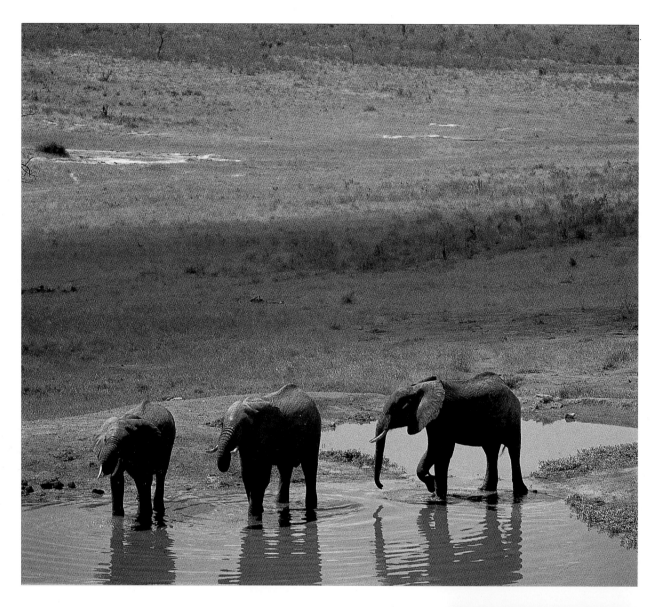

Above: Elephants need to drink up to 200 litres of water every day, and will walk many miles to known sources.
Right: Largest of the bustards, the Kori Bustard occurs in small numbers in dry, open country. When displaying, the male's booming call can be heard for many miles.
Opposite: Tsavo National Park is covered with small volcanic cones, inselbergs and lava flows, evidence of past geological activity.

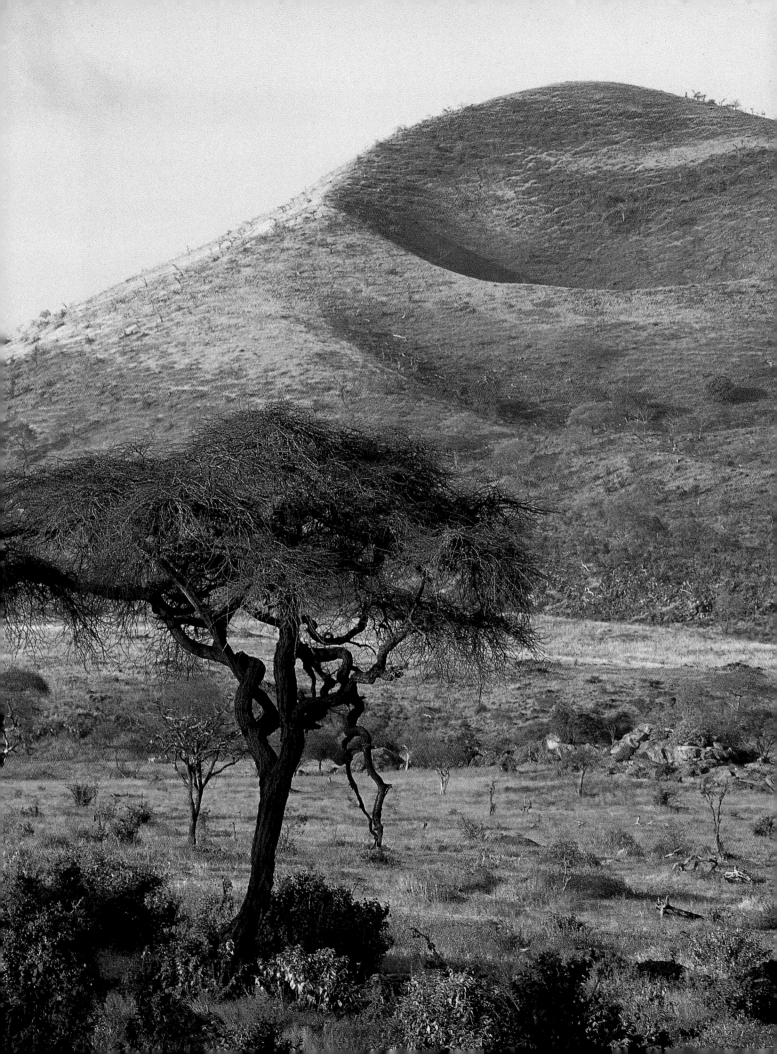

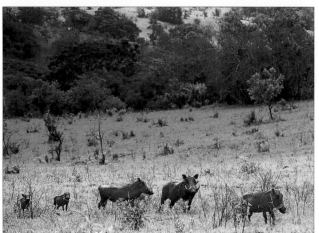

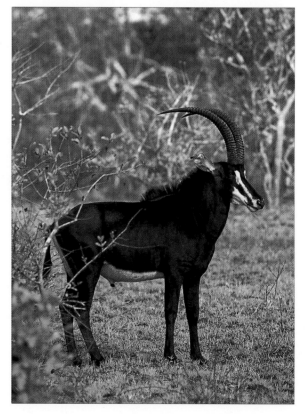

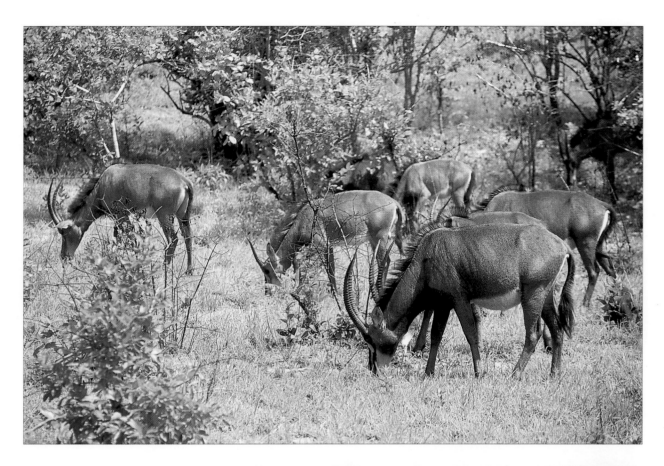

Above: *Roan antelope in the Shimba Hills National Park were translocated from Ruma (previously Lambwe Valley) National Reserve, but only a small population survives.*

Right: *A quotation from the country's first president, Jomo Kenyatta, is displayed at the entrance of most national parks, acknowledging the importance of wildlife to the country.*

Opposite top: *Many animals come to the Shimba Hills Lodge waterhole in search of water and salt. The small park is being fenced, as crops belonging to farmers on the periphery are frequently damaged by wildlife.*

Opposite bottom left: *Warthog are appropriately named – both the males and females have wart-like protuberances.*

Opposite bottom right: *The sable antelope can only be found in Kenya in the Shimba Hills reserve, which is the northernmost limit of its range.*

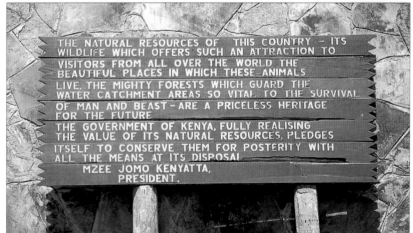

THE NATURAL RESOURCES OF THIS COUNTRY – ITS WILDLIFE WHICH OFFERS SUCH AN ATTRACTION TO VISITORS FROM ALL OVER THE WORLD THE BEAUTIFUL PLACES IN WHICH THESE ANIMALS LIVE, THE MIGHTY FORESTS WHICH GUARD THE WATER CATCHMENT AREAS SO VITAL TO THE SURVIVAL OF MAN AND BEAST – ARE A PRICELESS HERITAGE FOR THE FUTURE
THE GOVERNMENT OF KENYA, FULLY REALISING THE VALUE OF ITS NATURAL RESOURCES, PLEDGES ITSELF TO CONSERVE THEM FOR POSTERITY WITH ALL THE MEANS AT ITS DISPOSAL
MZEE JOMO KENYATTA,
PRESIDENT.

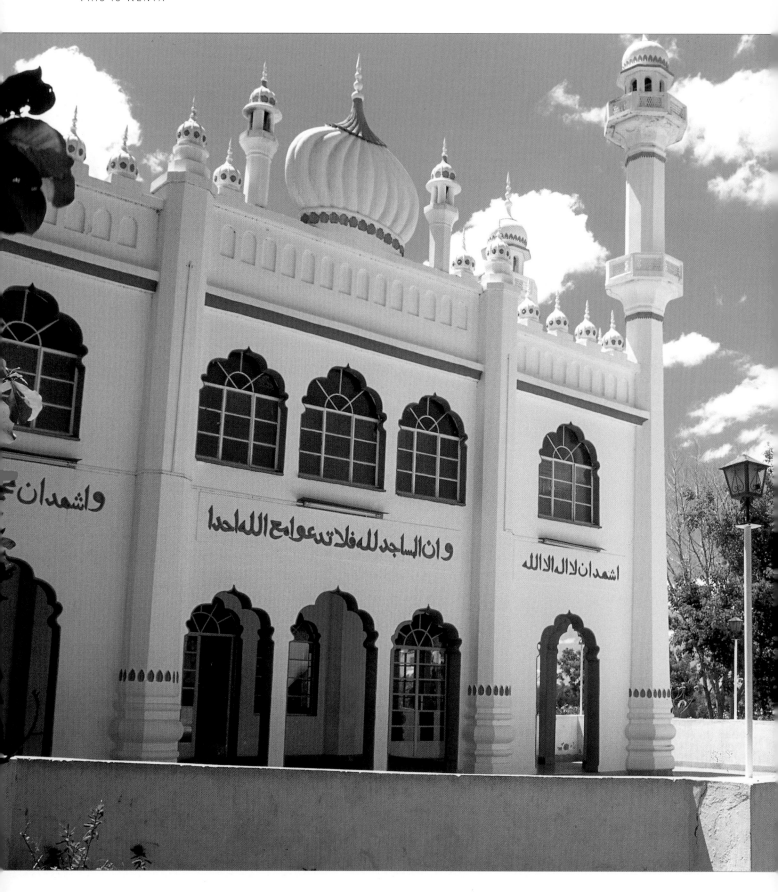

Above: Baobab trees are sacred
in many parts of the country, and
superstition does not allow them to
be cut down, even in the middle of
a plantation. Straight lines of sisal
plants near Kibwezi are broken
wherever a baobab tree is growing.
Top: Advertising billboards line some
of the main thoroughfares in Kenya.
Many Kenyan people prefer their soft
drinks and beer to be served warm,
which is just as well as refrigeration
facilities are rare in the rural areas.
Left: Mosques and temples line
the stretch of road from Mtito Andei
to Kiboko along the Mombasa to
Nairobi highway, where travellers
often stop for food, rest and shelter.
Overleaf: The forested Shimba Hills,
close to the sea but several hundred
feet higher than the beach, attract
moisture from early morning mists
blown in over the ocean.

INDEX

Page references in *italic* refer to photographs.